INSIDE THE MUSEUMS

INSIDE THE MUSEUMS

Toronto's Heritage Sites and Their Most Prized Objects

JOHN GODDARD

DUNDURN
TORONTO

Editor: Michael Melgaard
Design: Jesse Hooper
Printer: Webcom
Cover design by Laura Boyle
Cover image courtesy of the City of Toronto Archives, Map of City of Toronto, 1834, MT63

Library and Archives Canada Cataloguing in Publication

Goddard, John, 1950-, author
 Inside the museums : Toronto's heritage sites and their most prized objects / John Goddard.

Includes bibliographical references and index.
Issued in print and electronic formats.
ISBN 978-1-4597-2375-7 (pbk.).--ISBN 978-1-4597-2376-4 (pdf).--ISBN 978-1-4597-2377-1 (epub)

 1. Toronto (Ont.)--History--Anecdotes. 2. Toronto (Ont.)--Biography--Anecdotes. 3. Historic sites--Ontario--Toronto. 4. Museums--Ontario--Toronto. 5. Cultural property--Ontario--Toronto. I. Title.

FC3097.4.G63 2014 971.3'541 C2014-901023-0
 C2014-901024-9

1 2 3 4 5 18 17 16 15 14

Conseil des Arts Canada Council Canada ONTARIO ARTS COUNCIL
du Canada for the Arts CONSEIL DES ARTS DE L'ONTARIO

We acknowledge the support of the **Canada Council for the Arts** and the **Ontario Arts Council** for our publishing program. We also acknowledge the financial support of the **Government of Canada** through the **Canada Book Fund** and **Livres Canada Books,** and the **Government of Ontario** through the **Ontario Book Publishing Tax Credit** and the **Ontario Media Development Corporation.**

MIX
Paper from
responsible sources
FSC® C004071

VISIT US AT
Dundurn.com | *@dundurnpress* | *Facebook.com/dundurnpress* | *Pinterest.com/Dundurnpress*

Dundurn Gazelle Book Services Limited Dundurn
3 Church Street, Suite 500 White Cross Mills 2250 Military Road
Toronto, Ontario, Canada High Town, Lancaster, England Tonawanda, NY
M5E 1M2 LA1 4XS U.S.A. 14150

To my late godfather, John Wedgewood Green,
whose love and financial support made this book possible.

CONTENTS

PREFACE AND ACKNOWLEDGEMENTS

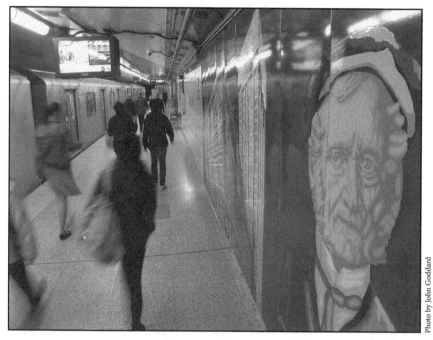

Photo by John Goddard

Thousands of subway riders glimpse it absently every day. A portrait of William Lyon Mackenzie peers from the platform mural at Queen Station, his face as round and orange as a wheel of cheese, his expression as knotted as when he first encountered Upper Canada's stifling elite. Mackenzie served as Toronto's first mayor and led the star-crossed Rebellion of Upper Canada. He was the grandfather of William Lyon Mackenzie King — Canada's tenth prime minister, whose own orange-pink visage graces the Canadian fifty-dollar bill — and died three blocks from his subway-wall portrait, at a house that the city preserves as a museum.

One day I decided to visit the house. Like many people, I knew of Toronto's heritage museums, and had been meaning to get around to seeing them. Mackenzie House, as it is called, proved a revelation. I discovered something called a "Rebellion Box," one of hundreds of small wooden boxes tenderly carved for mothers and sweethearts by accused rebels awaiting trial in Toronto's cold, damp jail. Upstairs, I saw the bedroom where Isabel Grace Mackenzie, nicknamed "Bell," slept during her adolescence and young adulthood, before becoming Mrs. Isabel King and mother to a future prime minister. In a back room, I briefly operated an 1845 Washington rolling flatbed press, of the kind Mackenzie used late in his career to foment against official self-interest and hypocrisy.

I also learned something else. The city's heritage museums are interconnected. The builder of what is now the Spadina House Museum once worked as a teenage apprentice in Mackenzie's print shop. The home of David Gibson, one of Mackenzie's fellow rebels, survives as the Gibson House Museum on Yonge Street, at North York Centre. The builder of Colborne Lodge in High Park led a military detail against Mackenzie, Gibson, and the rebel uprising.

Beyond the Mackenzie link, I saw that the city's heritage-house museums complement each other in many ways. The properties include a townhouse, a stately home, a country inn, an industrial site, a schoolhouse, and a military fort. Ken Purvis, coordinator at Montgomery's Inn, pointed out that the museums, if taken together, begin to form a coherent community, like a lost colonial village reunited.

They also form a single museum institution. In Toronto, people talk of the need for a city history museum, rarely recognizing that the Economic Development and Culture Division already runs a sprawling heritage-museum network. Under a single administration, the division incorporates eight museums in fifty-five buildings and outbuildings on ten sites. It holds 150,000 artifacts in those buildings and two warehouses, and occupies offices at Metro Hall, at the corner of King and John Streets. Full-time staff members sometimes switch places within the museum institution. Part-time personnel sometimes hold jobs at two or three venues at once.

Occasionally the network is threatened. In 2011, as a budgetary measure, Mayor Rob Ford proposed to close four of the venues: Montgomery's

Inn, Gibson House, Zion Schoolhouse, and the Market Gallery. "The unsung gems of our city," councillor Joe Mihevc called them during the protests that followed. Ford withdrew his measure, the museums were saved, and the publicity caused a spike in attendance.

For me, visiting the museums proved a rich experience. Exploring the past deepened my sense of connection to the city. I live downtown, near what was once the Town of York. After a while, I could easily imagine William Lyon Mackenzie walking through the neighbourhood, and such people as Anglican cleric John Strachan, or perhaps Attorney General John Beverly Robinson, crossing the street to avoid him.

I had one complaint. After every museum visit, I always wanted to know more, but there were no books to buy, no pamphlets to take away. Mackenzie has had his biographers, and Fort York its military historians, but otherwise materials relating to the museums proved difficult to find, and nothing at all presented the museums as a community.

I resolved to write the book that I wanted to read. In doing so, I took the freedom to venture beyond the city-run network. Of the eight Economic Development and Culture Division museums, I included six in the book: Mackenzie House, Gibson House (with Zion Schoolhouse), Colborne Lodge, Montgomery's Inn, Spadina House, and Fort York. I also included the Market Gallery, a former city hall, administered by the City of Toronto Archives. I added three others: Campbell House, run by the Advocates' Society with a partial subsidy from the city; The Grange, at the Art Gallery of Ontario; and Toronto's First Post Office, an independent non-profit organization.

To keep the number at ten, I had to cut two Economic Development and Culture Division venues — Todmorden Mills Heritage Site and the Scarborough Museum. Both are worth a visit. Todmorden Mills, nestled in the Don Valley, started as a sawmill in 1793 and developed into a papermaking business, gristmill, brewery, and gin distillery. It is under-going a major reinterpretation to reflect industrial life in the first half of the twentieth century. The Scarborough Museum sits on land cleared in 1799 by Scarborough's first settler, David Thomson. Descendents through his older brother, Archibald, include the late newspaper baron Roy Thomson, after whom Roy Thomson Hall is named. Roy's grandson, David Thomson, is chair of the global media empire Thomson Reuters

and currently Canada's richest person, said in 2013 to be worth more than twenty billion dollars.

Each of the book's chapters divides into four sections:

- Personal Story, such as the appalling instructions that Robert Baldwin left in his will;

- Walk-Through, pointing out highlights of the historic site;

- Prized Object, such as George Lamb's Rebellion Box, or the floor clock that Eliza Gibson rescued from imminent destruction by government militiamen, and;

- Neighbouring Attractions, such as Victoria Memorial Square near Fort York, where the valiant Captain Neal McNeale is buried.

All ten museums can be reached easily by public transit. Even far-flung Gibson House and Montgomery's Inn lie within short walking distance of a subway station.

Admission charges are reasonable, sometimes free. The Market Gallery and Toronto's First Post Office are free (a two-dollar donation is suggested). Art shows at Campbell House are free. The Grange is free on Wednesday evenings. Some venues participate in Doors Open Toronto and the Scotiabank Nuit Blanche arts festival, with free admission on both occasions. A Heritage Toronto membership comes with free museum admission to all the museums except for the Art Gallery of Ontario. The Cultural Access Pass, given to new Canadians for their first year of citizenship, offers free admission to most of the museums, including the AGO. Anybody with a Toronto Public Library card can borrow a free family pass to any of the city-run museums and the AGO, on a first-come first-serve basis.

The title, *Inside the Museums*, comes from a Bob Dylan song, "Visions of Johanna," on the 1966 album *Blonde on Blonde*. About twenty years ago, I found that if I was having trouble writing, the song would free me up. The intimate mood of the music and Dylan's poetic phrasing would somehow help me reconnect with myself, producing a liberating effect.

Sometimes I credit artist John Boyle, who painted the Mackenzie portrait at Queen Station, for inspiring me to seek out Mackenzie House. It is also possible that listening for years to "Visions of Johanna" unconsciously led me inside the Toronto museums.

If so, thank you, Bob Dylan. For special support, I am also grateful to Ronald Blumer, Sylvia Cashmore, Jean Murray Cole, Mary Jane McIntyre, Muffie Meyer, Bob Moenck, Lucie Poling, Ron Poling, and Nargis Tapal. For helpful suggestions, I thank Marianne Ackerman, Tarek Fatah, Ericka Hamburg, David Hayes, Suzanne Jaeger, Craig Lapp, and Carla Lucchetta. Many of the museum experts who helped me are acknowledged in the text. Museums services manager Karen L. Black deserves special mention, as do Roxy Blardony, Lisa Buchanan, Syvalya Elchen, and Michael Dowbenka. I have enjoyed working with Margaret Bryant, who brought me to Dundurn Press, and my editor Michael Melgaard, along with the rest of the Dundurn team. For other acts of kindness I thank Virginia Brooks, Arlene Cieslewisz, Natasha Fatah, Margaret Harrington, Sandra McHugh, Nadine McNulty, Wanda Muszynski, and Otimoi Oyemu. What I owe Lucrezia LaRusso is beyond evaluation.

MACKENZIE HOUSE

Lively, piercing eyes characterize William Lyon Mackenzie in a posthumous portrait by Toronto artist J.W.L. Forster, painted from an 1856 daguerreotype photograph. "The great editor with the little body and massive head," one admirer called Mackenzie.

Address

82 Bond Street, about a block east of Yonge-Dundas Square.

Getting There by TTC

The nearest subway stop is Dundas Station, on the Yonge line, also the stop for the Toronto Eaton Centre and Yonge-Dundas Square. The museum lies minutes from the square by foot — one block east of Yonge Street and just south of Dundas Street East.

THE LITTLE REBEL

William Lyon Mackenzie was a funny-looking man. "The great editor with the little body and massive head," one admirer called him. "A singularly wild-looking man with red hair … fractious in manner," said a detractor. Affectionately and pejoratively, people referred to him as "Little Mac," or "the Little Rebel." Almost invariably, they remarked on the large head, diminutive body, and unusually lively eyes.

"He was of slight build and scarcely of medium height, being only five feet six inches in stature," Charles Lindsey, Mackenzie's son-in-law and first biographer, writes in his two-volume *Life and Times of William Lyon Mackenzie*. "His massive head, high and broad in the frontal region and well rounded, looked too large for the slight wiry frame it surmounted.… His keen, restless, piercing blue eye, which threatened to read your most interior thoughts, and the ceaseless and expressive activity of his fingers, which unconsciously opened and closed, betrayed a temperament that could not brook inaction."

Enemies portrayed the same basic characteristics. "Afraid to look me in the face," Lieutenant-Governor Francis Bond Head writes of a rare Mackenzie visit to Government House in 1835. "[He] sat, with his feet not reaching the ground, and with his countenance averted from me, at an angle of about 70 degrees; while, with the eccentricity, the volubility and indeed the appearance of a madman, the tiny creature raved in all directions about grievances here, and grievances there."

Mackenzie left a mixed legacy, but stands as one of the most extraordinary characters of early Toronto and Upper Canada. Appearance aside, he was best known for his independence of mind. He could not be bought. Money and status meant nothing to him, to the point where he sometimes plunged himself and his family into poverty. In a tiny community where everybody knew everybody else, he said exactly what he thought — sometimes mischievously and satirically, sometimes bluntly and acerbically. Throughout the countryside, his relentless candor made him a heroic figure among the working classes, but in town excluded him from higher social circles. He attracted swarms of admirers, but cultivated few friends.

"He despised the means by which many of his contemporaries sought to obtain wealth," biographer Lindsey writes, "and held of greater

value than stores of gold and silver a reputation unsullied by any stain of corruption."

Mackenzie was born near Dundee, Scotland, in 1795. His father died within four weeks. His mother, a poor but resilient woman, raised him. In 1820, at the age of twenty-five, he sailed for British North America, and after a brief stay in Montreal moved to the colonial settlement of York, now Toronto.

It was a village then. Nominally the capital of Upper Canada, York amounted to a backwater in the wilderness, population 1,250. People called it "Little York," to distinguish it from New York, and sometimes "Muddy York," because it stood on marshy ground. The downtown covered only a few square blocks, roughly between Jarvis and Parliament Streets west to east, and from Adelaide Street East to Front Street north to south.

In 1822 Mackenzie's mother joined him at York, bringing with her Mackenzie's illegitimate son and a prospective bride. She was Isabel Baxter, a hardy and uncomplaining woman, and within three weeks the two were married. She and Mackenzie were to have thirteen children together, eight of whom survived infancy.

In the same year, the Mackenzies moved to nearby Dundas where William ran a general store and lending library. The following year, 1823, they moved to Queenston, at Niagara, where on May 18, 1824, he founded his first and most famous newspaper, the *Colonial Advocate*. A few months later the family returned with the paper to York.

Then things got interesting. York might have been a frontier town, but it was an orderly one. Its only extremes lay in its conservatism. As late as 1842, British novelist Charles Dickens wrote of its "wild and rabid toryism," which he called "appalling." In 1824, York's Toryism was beyond appalling, and deliberately so. Through patronage and other inequities, British administrators nurtured an artificial aristocracy, what they referred to as a colonial "governing class" of judges, clerics, professional men, and military officers, its members often linked through blood and marriage. In exchange, the privileged few supported the British political order and the Anglican Church. They served as a bulwark against democracy and any other influence from the United States.

Mackenzie had not sailed to the New World to be governed by an ersatz gentry. Naturally, he rebelled. He made it his mission to ridicule privilege

and to expose hypocrisy and corruption. He did not hold back. When the government advanced the common good he would voice approval, but mostly he needled, lampooned, scorned, and lambasted the controlling oligarchy, or what in 1833 he was to dub "the Family Compact." With singular energy, passion, and an unrelenting determination, he advocated a government accountable to the people. In the process, Mackenzie pursued one of the most remarkable activist careers imaginable — as a newspaper publisher, member of the legislature, city mayor, and leader of the 1837 Rebellion of Upper Canada. So active and complex a man cannot easily be summarized. A few biographical highlights, however, give a sense of his essential character and historical impact.

Cheeky as a Publisher

From the time he was a child and throughout his life, Mackenzie read widely and voluminously, and was blessed with a good memory. He also wrote prolifically, often in a mocking and quick-witted style.

On arriving in York with his newspaper, he wasted no time displaying his talents. An accidental fire had just burned down the Parliament buildings. With few other choices, the government had moved into the new hospital. Mackenzie made the most of the symbolism, as historian Chris Raible writes in his book *Muddy York Mud: Scandal and Scurrility in Upper Canada*. Mackenzie imagined a doctor addressing York's non-elected legislators as if they were hospital patients:

> "I can assure you, gentlemen, the House will soon become convalescent [the fictitious doctor begins]. In the fever wards, which are large, airy, and capacious, the senators shall be thoroughly physicked, blistered, bled, purged, scoured, and cleansed, from all their corruptions, diseases, impurities, and evil propensities."
>
> "Aye, aye, Doctor [an objecting bystander was said to respond] when you have administered a course or two of your nostrums, you will find, then, that they will recover strength enough to vote large salaries to people who don't deserve them."

In Little York, such satire was taken for insolence. Over time Mackenzie would grow ever bolder — and more personal — rousing emotions to the point where thugs would attack his pressroom in what would become known as the Types Riot, covered in the next chapter. The more the establishment tried to crush Mackenzie, however, the more popular he became, and in 1826 he ran for public office.

Unrelenting as a Member of the Legislative Assembly

Power in Upper Canada rested with the lieutenant-governor appointed by London. To assist him, he drew from the Family Compact to fill seats on two advisory councils. The Executive Council acted as a sort of cabinet. The Legislative Council served as a kind of senate.

Below the Legislative Council came the elected branch of government, the Legislative Assembly. Family Compact types could run for elected office, and did so, usually calling themselves Tories. Others, such as merchants, mechanics, farmers, and newspapermen, invariably ran as Reformers.

Elected politicians, however, held little power. By obtaining a majority in the assembly, Reformers could pass progressive legislation, but the Legislative Council and lieutenant-governor could reject that legislation. "It must be remembered," Lindsey writes, "that the oligarchical system ... reduced the popular branch of the Legislature to a nullity."

Mackenzie looked on the Legislative Assembly not as a true democratic forum, but as a public platform, a soapbox, and stepped onto it. In 1826 he won his first of several terms to office. To begin he attacked the Post Office, whose stiff newspaper rates he had long resented. As chairman of a special postal inquiry, he issued a report saying that rates were too high and profits were going to London. He recommended that the Post Office be run as a local non-profit corporation, a reform that came only many years later.

As one of the assembly's most active members, Mackenzie investigated everything from prison conditions to finances. He chaired an inquiry into cost overruns for the Welland Canal, and argued the fine points of government revenues and currency. "His knowledge of the mysteries of accounts was unrivalled," Lindsey says. Mackenzie also advocated that the Executive Council and Legislative Council be elected. People needed a government, he said, "by which to insure justice, protect property,

establish domestic tranquility, and afford a reasonable prospect that civil and religious liberty will be perpetuated, and the safety and happiness of society effected."

Tories despised Mackenzie. Half a dozen times, elected Tory members threw him out of the assembly on various charges, including libel, and each time he returned triumphant in a by-election. On the first such occasion, twelve sleighs accompanied him through the streets to the polling station at the Red Lion Inn on Yonge Street. After a landslide victory, in which his challenger received only one vote, supporters boisterously awarded him a medal of solid gold on forty links of gold chain. A parade of fifty sleighs and more than a thousand people, Lindsey says, escorted Mackenzie back to the legislature.

Fearless as a Reform Campaigner

With his popular support escalating, and the oligarchy paying no attention to his inquiries, Mackenzie resolved to take his grievances to London. He began by travelling around the colony speaking of injustices and collecting names for a petition to the King and Imperial Parliament. Local authorities grew incensed. They formed a countermovement, holding their own meetings and inviting Mackenzie to attend events that put the campaigner in harm's way.

The most dangerous clash came on March 19, 1832. Tory party members staged a public meeting with Mackenzie in Hamilton. It broke up in disarray. Afterward Mackenzie went to a friend's home for dinner, with plans to take a stagecoach back to York that night. At around nine o'clock, while Mackenzie was writing in an upstairs parlour, two Tory activists entered the house. They forcibly escorted Mackenzie to the front door, where two or three accomplices were waiting. "This is our man," one of them said, as Lindsey tells the story. "Murder!" Mackenzie cried. As he clung to the door, one of the men swung a club at his head. Mackenzie tumbled down the stone steps. The others beat and kicked him until neighbours rushed to the scene, one of them waving a piece of firewood. The assailants fled.

"[Mackenzie] was found to be bleeding profusely, disfigured in the face, injured in the head, and hurt in the chest," Lindsey writes. The first blow likely would have killed Mackenzie, the biographer says, had it not

glanced off the overhead beam of the front door. In the trial that followed, only the gang leader, William Kerr, was convicted. The judge sentenced him to a hundred-dollar fine.

Four days after the assault, still suffering from his injuries, Mackenzie stood on a farmer's wagon in front of York's courthouse to address a rowdy mob. Tory supporters began to throw stones and other objects. Somebody drew a knife and waved it at Mackenzie, and somebody else commandeered the wagon and began to drive away. Mackenzie made it home but part of the mob caught up to him, burning him in effigy and breaking his windows.

Selfless as Mayor of Toronto

On March 6, 1834, the Town of York became the City of Toronto. Three weeks later Mackenzie won a seat as a Toronto alderman, and fellow aldermen chose him as the city's first mayor.

He faced a daunting task. From scratch he had to create a municipal structure, beginning with laying the first sidewalk — a wooden walkway along King Street — and figuring out how to pay for it and other services. To begin, the city borrowed one thousand pounds, which Mackenzie and several other councillors had to personally guarantee. Then they levied a municipal tax, which drew outrage. Nobody likes a new tax. To explain its necessity, on his third day as mayor Mackenzie called a meeting at the market building, where the St. Lawrence Hall now stands. Two thousand people converged, and the session ended prematurely in chaos. On the meeting's resumption the next day, before Mackenzie arrived, the crowd burst into such stamping and cheering at an opposition speech that the balcony above the butchers' stalls collapsed, hurling spectators toward the floor below.

"In their descent some were impaled on the butchers' hooks, others broke their limbs," Lindsey writes. "Seven or eight died."

Soon Mackenzie faced another horror. Cholera broke out, an epidemic that would kill one in twenty residents, or about five hundred people from a population of ten thousand. When nobody could be found to take the victims to hospital, Mackenzie went himself, placing them on a horse cart and driving them. "Day and night he gave himself no rest," Lindsey writes. Eventually the mayor caught cholera himself, but recovered.

Impetuous as a Rebel Leader

The Upper Canada rebellion of 1837 often gets dismissed as a couple of half-hearted marches down Yonge Street by men wielding sticks and bird guns against government muskets. As a military event, it might rank as a joke, but the uprising represented widespread discontent in the colony, and brought hardships and trauma that lasted for years.

Mackenzie never intended to lead the rebellion himself. He had counted on two men with military experience, Anthony Anderson and Anthony Van Egmond, but things did not go as planned. Anderson was shot dead on the eve of the rebellion during a botched arrest outside the rebel headquarters, Montgomery's Tavern on Yonge Street, just north of present-day Eglinton Avenue. Van Egmond had expected the rebellion to start three days later and arrived only during the final rout.

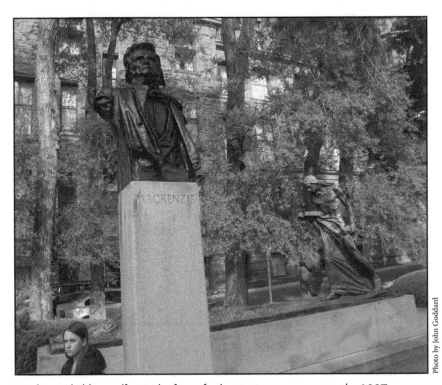

Photo by John Goddard

Mackenzie holds steadfast in the face of adversity in a monument to the 1837 rebels, by Toronto sculptor Walter Allward, outside the west entrance of the Ontario Legislature. Behind Mackenzie, an allegorical figure stands near an abandoned plough. "To commemorate the struggle for responsible government in Upper Canada," the text on the pedestal reads in part.

People close to Mackenzie advised him to call the rebellion off. Instead, he took command.

He had good reason to go ahead. Lieutenant-Governor Francis Bond Head had proven widely unpopular. "Bone Head," the rebels called him. Anti-democratic to the core, he had stacked the previous legislative elections, robbing Reformers of their most effective platform. At the same time, Head could never imagine people rising against him. He had emptied Fort York of British troops, sending them to help quell an uprising in Lower Canada, and leaving the city undefended. Taking advantage of Head's arrogance, Mackenzie planned to seize the Bank of Upper Canada, City Hall, and Government House, and install a provisional government.

The clash that killed Anderson, however, tipped off authorities to the plans. Mackenzie also proved a poor military leader. Beginning on December 5, 1837, with Samuel Lount as second-in-command, the former publisher and mayor led a series of advances down Yonge Street that never got far. He behaved erratically. At one point he barged into the postmaster's home and demanded food. At another point he stopped to burn down the house of the chief teller of the Bank of Upper Canada. He also threatened to torch the home of Sheriff William Botsford Jarvis, but others stopped him. In the meantime, the resident British Colonel James FitzGibbon persuaded Lieutenant-Governor Head of the seriousness of the rebel threat. On December 7, the colonel led a volunteer force of fifteen hundred government loyalists in a counterattack that ended in victory at Montgomery's Tavern.

Resilient as a Fugitive

Even late in life, Mackenzie displayed extraordinary physical endurance. "[He] was blessed with a constitution, such as not one man in ten thousand possesses," Lindsey says. He could work for six days and nights straight without going to bed, refreshing himself by pouring water on his head, or, Lindsey says, "he would sleep a few minutes in his chair, then, waking, would walk round his room a few times" and resume writing.

The same stamina saved him from an almost certain hanging after the rebellion. With the rebels overrun at Montgomery's Tavern, Mackenzie fled by foot up Yonge Street, he recalled shortly afterward in an account reprinted in Lindsey's book. The date was Thursday, December 7, 1837, the

time about half-past noon. Mackenzie was forty-two years old. A friend he encountered on the road gave him an overcoat, another gave him a horse, and he rode off toward the west end of Lake Ontario and the U.S. border in a harrowing four-day escape.

Militiamen fanned over the countryside. They blocked roads and checked farmhouses door-to-door, often returning two or three times. Mackenzie dodged them, but with farmers he never disguised himself. He trusted them, even with one thousand pounds — a fortune — on his head, and his trust was rewarded. Risking jail and worse, farmers hid him, fed him, and gave him clothes and fresh horses. At one point, from a hiding place in a barnyard, he watched a militia commander stand almost directly over him as government loyalists vainly searched barns, cellars, and a garret.

The hardest moment came on the second night. A fellow rebel of about nineteen or twenty, Allan Wilcox, had joined Mackenzie. Somewhere near present-day Oakville, they found themselves surrounded and backed against a stream. They resolved to cross it. In the wintry night they stripped naked, held their clothes above their heads, and walked up to their necks into the current "with the surface of the ice beating against us," Mackenzie wrote. "The cold in that stream caused me the most cruel and intense sensation of pain I ever endured." Unable to continue after the crossing, young Wilcox stopped to hide in a house. Mackenzie kept pushing, and on Monday morning crossed into the United States at Buffalo.

Humble as an Upper Canadian Hero

For twelve years Mackenzie lived in exile in the United States, returning only in 1849 after being pardoned by the Crown. Back in Canada, he resumed his political career, sitting in the Legislative Assembly of the United Province of Canada until his retirement in 1858. By then his health had deteriorated. He was also broke. Friends and supporters formed a committee to raise money for what they called a "Homestead Fund" — "a token of gratitude by the people of Canada, for his unswerving integrity and consistency during a long period of useful public life," they said. They collected more than seven thousand dollars. With $3,550 of that, they bought Mackenzie the townhouse at 82 Bond Street, now the Mackenzie House Museum. The rest presumably went toward furnishing and maintaining the house, says historian Chris Raible in an unpublished paper for museum staff.

Four days after his death on August 28, 1861, a cortège extending more than half a kilometre followed Mackenzie's remains from Bond Street to the Toronto Necropolis, where he was buried. The funeral would have done "honour to the memory of a king," reported the *Ottawa Citizen*. "Radical and Tory walked and rode together," the newspaper said. "All classes of citizens were amply represented." Obituaries praised Mackenzie's honesty, courage, and particularly his independence of mind.

WALK-THROUGH

William Lyon Mackenzie died in the upstairs front bedroom of this grey-brick townhouse, steps from modern Yonge-Dundas Square and the Toronto Eaton Centre. His daughter, Isabel Grace, future mother of Prime Minister Mackenzie King, spent half her teenage years and early adulthood here. The family took up residence in 1859; Mackenzie died in 1861; the family moved out in 1871.

"The house presented to William Lyon Mackenzie by his friends," a stone plaque inside the front door reads. The building occupies four floors, three of which are open to the public. The closed attic once served partly as living quarters to the family's young Irish servant, Catherine Byrns.

Rear Garden

The Mackenzie residence made up the north end of a three-unit rowhouse completed in 1858. The two other units came down in the 1930s, along with a detached house on the other side, leaving Mackenzie House as a lone pocket of nineteenth-century charm set back from what continues to be a quiet, leafy street.

Along the north side of the building runs a path to the museum's rear entrance. You pass two plaques describing the site, then enter a back garden featuring two large bas-relief stone panels.

One depicts Mackenzie in full oratorical flight on April 10, 1835, in the elected but powerless Legislative Assembly. With one hand he points an accusing finger. With the other he clutches his seventh and final Grievances Report, listing the shortcomings of an oligarchy not answerable to the electorate. The second panel pays tribute to Samuel Lount and

Peter Matthews, hung from a public gallows at a spot roughly four blocks south of the museum for their roles in Mackenzie's 1837 Rebellion. Both panels once formed part of a memorial erected at Niagara Falls in 1937 and removed in 1966. The sculptor was Emanuel Hahn, best known for portraying the *Bluenose* racing schooner on the Canadian dime and the caribou head on the quarter.

Printing Shop

In 1967 a rear addition to the house was built as a reception area, gift shop, exhibition gallery, and printing shop showcasing an 1845 Washington rolling flatbed press like the one Mackenzie owned late in his career. Visitors can try it. Go around to the back, grab the handle on the low wheel, and a resident printmaker will lead you through the process. With your final pull, you easily apply two thousand pounds of even pressure between inked typeface and paper.

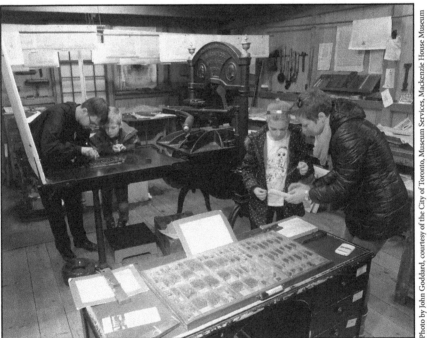

Photo by John Goddard, courtesy of the City of Toronto, Museum Services, Mackenzie House Museum

Historical interpreter Jared Ross, far left, helps visitor Misha Milashevsky prepare a document for printing on an 1845 press, as Natalia Shostak (far right) helps Eva Milashevsky tie her own freshly printed paper. The children composed their texts with types laid out in the box on the front table.

"Even young children can get up and do this — we've got a stool underneath," says program officer Danielle Urquhart. "With earlier presses, the quality of your print depended on the strength of your arm. With this press, it doesn't matter if a five-year-old is using it or a grown man — the pressure is always the same."

Mackenzie's printers and apprentices, who included future Spadina House patriarch James Austin, worked in a bigger space, but the museum workshop gives the idea. Along one wall stands one of Mackenzie's own cabinets, containing shallow drawers of types, the backward letters that a compositor placed by hand into a frame to create a newspaper page. Other cabinets hold other type sizes and fonts. Specialty tables display various frames and cutters, many of which are still used to help print facsimiles of the various newspapers that Mackenzie ran during his tempestuous career.

In the gallery corridor hangs an 1899 painting of Mackenzie by Canadian portrait artist J.W.L. Forster, modeled largely on an 1856 daguerreotype photograph. It shows the disproportionately large head, fiery eyes, firm-set mouth, and, in the background, the 1837 vice-regal proclamation offering a thousand-pound reward for the rebel leader's capture.

Main Floor, Front Parlour

The main floor, the most formal area of the house, features front and back parlours that were reserved for special occasions and guests.

In the front parlour hangs a far different portrait of Mackenzie from the one in the gallery. This one is unsigned, the artist unknown. It shows Mackenzie in the mid-to-late 1820s, when he was mayor of Toronto or slightly afterward, and when portrait artists were hard to come by. A stiff collar constrains his neck. His eyes stare straight at the viewer — not fiercely and passionately, but timidly and self-consciously. He looks almost ready to smile.

On the same wall hangs a matching portrait of Mackenzie's wife, the former Isabel Baxter, the only known image of her. Compared to her husband, she appears assertive, filling the frame better than he does and engaging the viewer with more confidence and composure.

On the opposite wall hangs a portrait of John Montgomery, Mackenzie's long-time friend, fellow rebel, and owner of the tavern

that served as rebel headquarters. Montgomery was captured in the Rebellion and imprisoned for months. On conviction, he was shipped to Fort Henry at Kingston. He escaped, fled to the United States, and later returned to again become a tavern owner. An admirer, like Mackenzie, of U.S. representative government, Montgomery appears in the portrait with what looks to be a copy of either the U.S. Constitution or U.S. Declaration of Independence.

Few heirlooms other than the portraits can be traced directly to the Mackenzies. An exception is the high-backed slipper chair at the foot of the William Lyon Mackenzie portrait. Covering it is a piece of embroidery sewn sometime around 1870 by the Mackenzies' daughter Janet, who lived nearby as the wife of Charles Lindsey, a journalist and Mackenzie's first biographer.

Main Floor, Back Parlour/Dining Room

The family rarely ate dinner in the dining room, but Mackenzie was known to use part of the room as an office. At the back corner, curators have set up a butternut drop-front desk and bookcase. On the dining-room cabinet rests another Mackenzie family heirloom, a silver-plated dish cover. The representative tableware is "Flow Blue," from Staffordshire, England, a type popular during the period with Toronto's middle class.

Toward the back of the room, the papier mâché tilt-top table further reflects middle-class taste. The tabletop bears a reproduction of the 1839 portrait of two dogs, *Dignity and Impudence*, by Sir Edwin Landseer, said to be Queen Victoria's favourite painter. "If Queen Victoria could be sentimental about animals, then it was perfectly acceptable for a middle-class family to be as well," says program officer Urquhart. When not in use, the tabletop tilts vertically to display the portrait clearly.

The mahogany dining table at the room's centre belonged to Francis Hincks, a leading Reform figure, editor of *The Examiner* and minister of finance under Prime Minister Sir John A. Macdonald.

On the wall at the room's exit hangs one of Mackenzie's dearest mementoes. It is an original framed copy of Lieutenant-Governor Francis Bond Head's 1837 Proclamation offering one thousand pounds

for Mackenzie's capture. Mackenzie relished being Public Enemy No. 1. For years he carried a copy with him and flourished it with little provocation. On one occasion, Quebec statesman George-Étienne Cartier was boasting about dining with Queen Victoria at Windsor Castle, the *Globe* newspaper reported in a retrospective in 1900. From his pocket, the *Globe* said, Mackenzie produced the proclamation to show "that Her Majesty valued him more highly than she did Sir George."

Second Floor, Front Bedroom

On the wall hangs a framed childhood "sampler," a piece of embroidery meant to demonstrate the girl's needlework skills. "Isabel Baxter, age 13 years, A.D. 1815," a line near the bottom reads. Mackenzie's wife sewed it in Scotland and treasured it all her life, keeping it with her during her many moves around Ontario, Toronto, and the United States. In a variety of coloured threads, she names her parents, lists the initials of other family members, and quotes Psalm 134, which begins, "Behold bless ye the lord all."

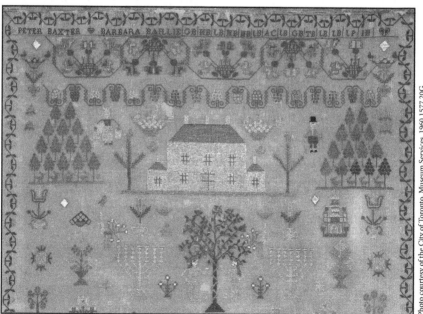

All her life, Mackenzie's wife Isabel treasured the "sampler" she made as a thirteen-year-old in Scotland to showcase her needlework skills. Across the top, she names her parents, and lists the initials of other family members. The lower portion is not shown.

Photo courtesy of the City of Toronto, Museum Services, 1960.1577.20G

Mackenzie spent his last summer mostly confined to bed in this room, reduced in the end to a diet of stewed fruit. He died at the age of sixty-six on August 28, 1861, from what a doctor called "apoplectic seizure," a diagnosis now deemed meaningless as a cause of death. A public visitation took place in the bedroom, rather than downstairs.

Second Floor, Rear Bedroom

Isabel Baxter Mackenzie gave birth to thirteen children. Eight survived infancy. One girl died at twelve after a long illness. The year the family moved to 82 Bond Street, seven were still living. Barbara was confined to the Provincial Lunatic Asylum on Queen Street West and was to kill herself horribly the following year by setting her clothes on fire. She was thirty-two. Janet had married Charles Lindsey and lived nearby. Bill lived in New York. George had left home but sometimes visited. The three youngest daughters shared the back bedroom, with Helen in her own bed, Lybbie and Isabel Grace, or "Bell," in another.

On a bedside table, a photograph shows Isabel in 1867 as a lively, fashion-conscious twenty-four-year-old, with a cascade of false ringlets and headband of artificial braids. "A sprightly girl, taken with the lighter things of life," a friend was to recall in a letter. "She was slight of build, and not tall, but most pretty, and a pet of the family."

In 1872, a year after the family left Bond Street, Isabel married John King, a lawyer. She named her firstborn son William Lyon Mackenzie King, known to the family as "Willie" or "Willy." Isabel never saw him become prime minister. She died in 1917 at seventy-four. Two years later Mackenzie King won the leadership of the federal Liberal Party and went on to win seven out of the next eight federal elections. In the early 1920s he began to dabble in the occult, with a view to contacting his late mother.

"After his mother's death, Willie turned her memory into an unseen presence from which he drew emotional sustenance for the rest of his life," writes Charlotte Gray in *Mrs. King: The Life & Times of Isabel Mackenzie King*.

"In the tense weeks before the outbreak of the Second World War," the biographer also says, "joyous dreams of 'Mother' helped him to deal with the stress. 'Had a vision this a.m. of being near a large snow pile, [King wrote in his diary], on and over the top of which dear Mother came to me, all in white, like a spirit with wings and most joyous.'"

Box Room

A small room off the front hall makes a likely candidate as a storage space, or "box room," for Mackenzie's voluminous newspaper files and other documents.

Downstairs Dayroom and Kitchen

Cool in summer, cozy in winter, the dayroom and adjoining kitchen in the half-basement offered the Mackenzies comfortable everyday living quarters. Plenty of light poured in from large windows front and back. The family ate meals here. The daybed along one wall offered a convenient place to lie down without having to ascend the stairs to colder rooms in winter. The house had no running water, but the gas company piped in fuel for the ceiling lights. Ask your guide, or historical interpreter, to light them. By 1859 a kitchen stove had replaced open-hearth cooking in most Toronto homes.

On the dayroom wall hangs a second Proclamation, this one being Mackenzie's sardonic retort to Lieutenant-Governor Head. Head had posted a thousand-pound reward for Mackenzie. Mackenzie posted an award of five hundred pounds for the lieutenant-governor.

GEORGE LAMB'S REBELLION BOX

The Upper Canada Rebellion inspired a unique type of memento, the "Rebellion Box." Nothing quite like it has been seen before or since. Hundreds were made, each slightly different from the next. All were small, most no bigger than an outstretched hand, and almost all expressed tender sentiments about family, country, and a wish for liberty and peace. Defeated rebels made them in jail while awaiting trial and sentencing, but how they got hold of the sharp tools they needed remains a mystery. Political tensions were running high. A guard of twenty-five soldiers patrolled the Toronto jail constantly.

"When I look at the boxes, I am seeing tool marks that show they had either a file, or a coping saw," says woodworker Darryl Withrow, who has reproduced some of the boxes for school classes. "And they definitely had chisels. I can see half-inch chisel marks in the bottom of the boxes where they haven't been finished off nicely."

A roundup of the rebels began the moment they scattered in defeat from Montgomery's Tavern on December 7, 1837. Lieutenant-Governor Francis Bond Head suspended habeas corpus, giving government troops authority to hold people indefinitely without charge. By the end of the month, more than five hundred men suspected of participating in the revolts at Toronto, and farther west near Brantford, filled jails to capacity.

"There were usually fifty prisoners in the two rooms," one of the inmates, Charles Durand, wrote sixty years after, of his third-floor lockup at Toronto Gaol, in his memoir *Reminiscences of Charles Durand of Toronto*. "The space was always more than full, too much so to afford any comfort."

The prisoners suffered through a cold, damp winter, Durand writes. A routine developed. In the morning, they rose early. They piled their beds neatly against the walls and brought out tables and chairs for breakfast, which they prepared for themselves on a cooking-stove. Wives and mothers helped keep their spirits up by cooking other meals, Durand says, arriving at the prison gates by sleighs or wagons, depending on the weather, "with cooked meats, vast quantities of poultry, fowls, ducks, geese and turkey, with all kinds of pies, vegetables, apples, preserves, and whatever they thought their husbands and sons had liked at their once happy home."

Hidden in such foods, prisoners would often find letters on extra-thin paper, minutely folded, bearing news and expressions of affection. On Sundays they held religious services with visiting clerics, including Anglican leader John Strachan, Methodist Episcopal preacher James Richardson, and John Roaf of the Congregational Church. Outdoor exercise was prohibited. To stay active, the prisoners recited stories and sang songs. They might have been guilty of armed insurrection, but they were not dangerous criminals. They were brothers-in-arms — farmers, mechanics, merchants, and lawyers wishing to build a better country.

On March 31, 1838 — nearly four months into the incarceration — terrible news circulated through the prison. A court had condemned two of the rebel leaders to death by hanging. Both were popular Reformers. Samuel Lount had been an elected member of the Legislative Assembly. "A man of commanding figure," Durand says of him, "something like Abraham Lincoln in appearance, six feet six inches tall." Peter Matthews,

a farmer from Pickering, had fought as a volunteer for the British in the War of 1812. "One of the bravest men in the war," Durand says.

Lount was married with seven children, Matthews married with fifteen. Upwards of thirty thousand people signed petitions pleading with newly arrived Lieutenant-Governor George Arthur to spare the men's lives, and Lount's wife Elizabeth — "upon my bended knee," she later wrote — literally begged Arthur for clemency.

Arthur icily refused. Two weeks later, on the morning of Thursday, April 12, shortly before eight o'clock, Sheriff William Botsford Jarvis arrived to prepare the men for execution. A crowd of nearly ten thousand people waited outside, across from where the King Edward Hotel now stands. As a high Tory and Family Compact figure, Jarvis had often feuded with rebel leader William Lyon Mackenzie, and during the rebellion had personally helped drive back the insurgents on Yonge Street. For Lount and Matthews, however, Jarvis felt compassion. During the uprising, Lount had helped stop Mackenzie from torching Jarvis's house.

"Sheriff Jarvis burst into tears when he entered the room," John Ryerson wrote that day to his brother, the educator Egerton Ryerson. "[Lount and Matthews] said to him very calmly, 'Mr. Jarvis, do your duty; we are prepared to meet death and our Judge.' They then, both of them, put their arms around his neck and kissed him.... They walked to the gallows with entire composure and firmness of step."

Durand, writing in Mackenzie's *Caroline Almanac*, of Rochester, New York, one year after the events, told what happened next.

"We could see all plainly," he said of his view from the prison's third floor. "[Lount and Matthews] ascended the platform with unfaltering steps, like men. Lount turned his head at his friends who were looking through the iron-girt windows, as if to say a 'long farewell!' He and Matthews knelt and prayed, and were launched into eternity without almost a single struggle. Oh! The horror of our feelings! Who can describe them?"

Over the next several weeks, judges condemned more men to death, or to long prison terms, or to banishment in the penal colony Van Diemen's Land, on what is now the Australian island of Tasmania. Later, those death sentences and many of the banishments would be

commuted, and many prisoners would be released on a promise of good behaviour, but for months a pall hung over the prison. A sense of dread set in, leavened only by memories of the serenity shown by Lount and Matthews — the calm strength that comes from acting true to oneself and to one's values.

"[Lount] used to tell us often, in writing, not to be downcast; that he believed 'Canada would yet be free'; that we were 'contending in a good cause,'" Durand wrote in the *Caroline Almanac*. "He said he was not sorry for what he had done."

Matthews apparently felt the same way. "[He] was until death, firm in his opinion of the justice of the cause he had espoused," Durand wrote. "He never recanted."

At some point during the winter, the prisoners began making their Rebellion Boxes. The first known to do so was Charles Doan, twenty-nine years old and a member of the Children of Peace movement that built the Sharon Temple north of Newmarket. He picked up a log beside the cooking-stove, and from that single block of hardwood carved a rectangular box, fitted with an ingenious lid that slid right and left in dovetailed grooves. On top of the lid, he fashioned a square inlay with a lighter coloured wood. On the inlay, in India ink, he drew a rural scene with a house and trees. On the box's sides, he wrote inscriptions, including a poignant dedication to his late infant son: "Memento of David Willson Doan who died Aug. 28, 1837, aged 16 mos. 10 days." When he finished, the carver also wrote the date — March 31, 1838 — which was also the day Lount and Matthews were condemned to death.

Other prisoners followed in the same vein. From the cook-stove woodpile, they almost always chose hardwood, and invariably fitted their box with a sliding lid on dovetailed grooves. Many boxes also featured inlays, and nearly all were signed and dated. Almost all were dedicated to a special recipient — a wife, child, parent, or sweetheart — and all featured inscriptions, usually in verse, written in indelible ink. Unlike Doan's box, however, many of the other mementoes directly paid tribute to Lount, Matthews, and other rebel heroes, and spoke of "freedom," "justice," and "liberty."

"We witness'd from our massey grate/These two martyrs meet their fate," wrote Michael Shepard, a farmer from Willowdale.

"Blessed are they whom in their youth/Are taught to know and love the truth," wrote Alvaro Ladd, a storekeeper and stagecoach operator near London, Ont.

"Tyrants their fetters forge in vain/To crush thy spirit — ," wrote Charles Doan's brother Jesse. "Liberty/Like brittle glass shall burst the chain/From hands now striving to be free."

The prisoners turned out hundreds of such boxes, Durand says. Over the next 165 years, families passed them down from one generation to the next, and a few museums acquired some. Knowledge of who made the boxes and under what circumstances gradually diminished, however, and might have disappeared altogether if not for the work of several enthusiasts.

In 1971 historian Dorothy Duncan wrote one of the first articles about them for *Canadian Antique Collector* magazine.

In 2005 the Market Gallery mounted an exhibition of eighteen boxes called "Heart-Shaped Box: A Poetic Reflection on the Rebellion of 1837," by guest curator Andrew Hunter. It featured a heart-shaped oak box with pine inlays by prisoner Daniel Sheppard.

The following year historians Chris Raible and John Carter co-wrote an article on thirty-nine boxes — including the exhibition's eighteen — for *York Pioneer* magazine. Readers came forward with more, and in 2009 Raible, Carter, and woodworker Withrow documented ninety-four boxes carved by more than fifty inmates. They published their findings as a book that takes its title from Jesse Doan, *From Hands Now Striving to Be Free*.

"We're up to 125 or so boxes and they keep turning up," Raible says. "The funny thing is, we cannot find comparable boxes made before or since. These are unique. I've talked to antique dealers and people who know snuff boxes, and there is nothing else like them."

Raible, Carter, and Withrow established that nearly all the Rebellion Boxes were made during a specific period in 1838 — between mid-April, after the Lount and Matthews hangings, and late July. By August, most prisoners had been either freed on a surety, deported, incarcerated elsewhere, sent to trial in England, or banished to Van Diemen's Land. Of the ninety-four boxes in the book, only three were made in August. The last known box is dated September 21, 1838, one week before its carver, Martin Switzer, was released.

During the team's research, Withrow started making Rebellion Box replicas. He is a high school teacher and former prosthetic technician — a maker of artificial limbs. He also volunteers as a woodworker at Pickering Museum Village. He wanted schoolchildren to be able to handle the boxes, and while reproducing them discovered that inmates could not have used knives and glass, as had been assumed. A knife might successfully cut pine or cedar, but almost all the prisoners chose hardwoods such as maple, birch, walnut, and cherry.

Withrow noticed measurements conforming to exact imperial rules, such as 2.5 inches and 3.75 inches. Corners he discovered to be perfectly square. "On one box we have four perfect circles that are all one and three-sixteenths of an inch in diameter," Withrow says. "That's done with a cutting tool, not free-hand."

The men worked together on the boxes, sharing expertise, Raible and Withrow also conclude in the book. The adopted lid design demands a high degree of skill. The dovetailed edges of the lid fit tightly within dove-tailed grooves in the box, sliding left and right to open, with stoppers preventing the lid from lifting off.

"Every single box is made that way," Withrow says, "which points to the fact that the men were working in conjunction with each other. They weren't all working on individual projects."

He sees other evidence of collaboration.

"We have one box signed by John Graham sent to his sister Hester," Withrow says. "On the bottom are three initials, J.G.P., who is another prisoner, John G. Parker. Parker is making the box and giving it to Graham to send home. We have other boxes signed by the prisoner who is sending it, initialed "J.G.P. [the actual carver]," and on the lid there might be some artwork by a third prisoner and his initials."

In late 2012 Mackenzie House mounted an exhibition of ten Rebellion Boxes owned by the City of Toronto. One remains permanently on display. The carver is George Lamb, a Scottish immigrant who settled in Thornhill in 1834 as a cask and barrel maker, or cooper. Three years later, Lamb joined the rebellion, and on December 15, eight days after the rout at Montgomery's Tavern, government militiamen tracked him down and threw him into the Toronto jail. He stood five foot six, a relatively short man. Six months later, prison authorities recorded his

age as twenty-five. He made several boxes. The one on display makes a fine example of the genre.

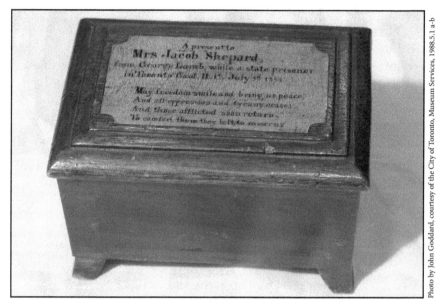

Photo by John Goddard, courtesy of the City of Toronto, Museum Services, 1988.5.1 a-b

Inlays of walnut-on-walnut, and separately carved legs distinguish George Lamb's Rebellion Box of July 3, 1838, dedicated to Mrs. Jacob Shepard. How the prisoners acquired tools necessary to make such boxes remains a mystery.

- Dedication (on lid): "A present to Mrs. Jacob Shepard, from George Lamb, while a state prisoner in Toronto Gaol, U.C. July 3, 1838." The relationship between Lamb and Mrs. Shepard is unknown, Raible says. Perhaps she was a sister, or a cousin. Mrs. Shepard also received a box from her imprisoned husband, Jacob, a Willowdale farmer.

- Inscription (also on lid): "May freedom smile and bring us peace/ And all oppression and tyranny cease;/And those afflicted soon return,/To comfort them they left to mourn."

- Shape: A few boxes include curled handles. Some feature domes. Most are simply rectangular. "I've seen eighty-two boxes and there are quite a variety of shapes," Withrow says. "The Lamb box looks

like a blanket box. If I am sitting in jail, I'm probably going to make something that I already know, whether a miniature blanket box, or a jewelry chest, or whatever. It is my opinion that the men were miniaturizing something that they knew how to build."

- Inlays: For decoration, many box-makers added inlays. They dug heart shapes, stars, or panels, then glued in another piece of wood of the same shape, usually of a lighter shade. Lamb carved his box from walnut. On the lid he inlaid a panel of what looks to be birch or maple, Withrow says. The lighter colour helps highlight the dedication and inscription. On the four sides, however, Lamb added understated inlays of the same wood, walnut on walnut, the only box-maker known to have done so.

- Legs: A few boxes have legs. Almost always, the legs were carved with the box from the solid log. Only Lamb carved separate legs and glued them on. Over time, the legs of other boxes usually snapped off, but not Lamb's. "The George Lamb box is unique," Withrow says. "Lamb is the only one who does the same-colour inlay, and the only one to glue the legs on, either because he knew the other design was going to create a problem, or he put them on as an afterthought."

Lamb was sentenced to three years in prison. On July 13, 1838 — ten days after finishing the box — he was transferred to Kingston Penitentiary. Eight months later, in March 1839, he was released.

Rebellion Boxes seldom come to market, Withrow says. When they do, they sell for between two hundred dollars and six thousand dollars, depending on how much the seller knows about their history.

NEIGHBOURING ATTRACTIONS

One Toronto Street
A plaque on the building at 1 Toronto Street, about three blocks south of the museum, honours rebel leaders Samuel Lount and Peter Matthews.

"In the aftermath of the Rebellion of 1837," the plaque says, "close to ten thousand people stood on this spot to bear witness as Samuel Lount and Peter Matthews ... were hanged on April 12, 1838, on gallows adjacent to the jail." The plaque gives Lount's last words as, "Be of good courage boys, I am not ashamed of anything I've done, I trust in God, and I'm going to die like a man."

CAMPBELL HOUSE

A party animates the upstairs assembly room at Campbell House, a heritage museum that doubles as an arts and cultural centre. "I think we have only begun to scratch the surface," director/curator Elizabeth Driver says of the building's potential for plays, concerts, and art exhibitions.

Address
160 Queen Street West, at the northwest corner of University Avenue.

Getting There by TTC
Campbell House can be easily reached on foot from almost anywhere in central downtown. It is steps from Osgoode subway station, on the north-south University line, and is accessible by the 501 and 502 east-west streetcars.

THE TYPES TRIAL

History remembers Sir William Campbell as a judge with a strict sense of impartiality. Challenging convention, he once stated that the rape of a prostitute is still rape, and that "the most common Prostitute is as much under the protection of the law as the most virtuous woman."

Similarly, Campbell ensured a fair trial for William Lyon Mackenzie. The publisher sought damages from a group of law clerks and other privileged young men who admitted to smashing his newspaper press. Mackenzie was an outsider, a thorn in the side of the influential and well-to-do. His attackers were sons and employees of some of the colony's most powerful figures, people who dined in the judge's home and attended his seasonal balls. Both the attackers and the judge belonged to the same privileged elite, but if anybody thought Mackenzie might not get justice they underestimated William Campbell.

"Gentlemen," he told jury members before they began deliberations, "I need scarcely state to you, that in the administration of justice, our first and paramount duty ... is to divest ourselves of all bias or prejudice for or against any one on trial before us, but to govern ourselves altogether by the evidence, not suffering any previous impression made on our minds by common report or conversation to influence our proceedings here in any degree."

Campbell grew up in Scotland. He fought for the British in the American Revolutionary War, was taken prisoner, and at war's end sought refuge in Nova Scotia, where he married a local woman, Hannah Hadley. Gradually, he improved his standing. He bought a shop and studied law. He got elected by acclamation to the House of Assembly, and with his wife raised a family of six children — four girls and twin boys. In 1811, at fifty-three, he bettered himself again. He accepted an appointment to the Court of King's Bench in Upper Canada, at York. By then he and Hannah were empty nesters. Their adult children had moved elsewhere in Nova Scotia, and to Montreal and the United States. The newly appointed judge and his wife relocated to York, and in 1822 built their dream home — a two-storey Georgian brick mansion on a downtown lot the size of two city blocks.

They built the house at the head of Frederick Street, one and a half kilometres from where it stands today. Their grounds featured woods and

outbuildings, including probably a guesthouse, a coach house, and stables for farm animals. Their view was stunning. From tall windows in the front dining room and drawing room, and from upstairs, the couple could see straight down the street to Lake Ontario, and out over what was then a peninsula, now the Toronto Islands. History does not record what the two were doing at around six o'clock on Thursday, June 8, 1826, but if they were eating dinner they could have looked up to see a gang of young men break into William Lyon Mackenzie's house and print shop two blocks below them at the waterfront. They could have heard the "great noise," as one witness called it, when Mackenzie's *Colonial Advocate* printing press crashed to the floor. They could have witnessed what came to be called the "Types Riot."

The crime took place in clear summer daylight. Mackenzie was away on business. His wife and infant daughter were also out of the house. The only ones home at the time, in living quarters to the rear of the shop and upstairs, were Mackenzie's seventy-eight-year-old mother, Elizabeth; his eleven-year-old son, James; and Mackenzie's brother-in-law and apprentice printer, James Baxter.

The first hint of trouble came when law clerk Samuel Peters Jarvis and law student Peter McDougall were seen walking arm-in-arm toward the Mackenzie property along Palace (now Front) Street. Thirteen others followed in single file. They did not appear angry, witnesses later testified, but some carried clubs and sticks — in case anybody tried to stop them, one offender later said. "A genteel mob," Mackenzie's first biographer, Charles Lindsey, called them in his two-volume *The Life and Times of William Lyon Mackenzie*. Historian Chris Raible, in his 1992 book *Muddy York Mud: Scandal & Scurrility in Upper Canada*, lays out a detailed account of what happened next.

Two minutes after closing shop at six o'clock, looking through a window, apprentice Baxter glimpsed several men entering the yard. Baxter re-entered the shop from the back door, he later testified, and found "men busy breaking open the [front] office door."

Jarvis and McDougall barged through the door and, with the others, started wrecking the place. Charles French, Mackenzie's journeyman printer, arrived in time to see them toppling a new cast-iron patent lever-press to the floor, precipitating the "great noise" described by Mackenzie's

son James, who ran downstairs from his grandmother's room to witness the attack as well.

The rioters knocked over cabinets, upturned the composing stone, pulled apart three finished pages of the next edition the *Colonial Advocate*, and freely scattered around the metal letters, or types. Some rioters tossed types into George Monro's garden next door. Three others ran to the wharf and dumped types into the lake. "All like desolation," passerby Thomas Hamilton later testified. Francis Collins, editor of the rival *Canadian Freeman* newspaper, arrived to see Mackenzie's elderly mother "bathed in tears, and writhing in convulsive agony" at the destruction.

It was a heart-wrenching scene, but three leading York figures appeared to at least condone, if not celebrate, the assault. William Allan, a town magistrate and holder of other high positions, cuddled his youngest child in his arms as he watched from his front fence on Frederick Street, opposite Mackenzie's property. Next to him, equally impassive, stood Clerk of the Peace Stephen Heward. His son Charles turned out to be one of the rioters. The clerk of the peace cheered the rioters on, one witness later testified, and shouted, "Well done, boys!" At one point James Buchanan Macaulay, a prominent lawyer and one of the lieutenant-governor's closest advisors, joined Allan and Heward at the fence, then left apparently amused.

"I met the Honourable J.B. Macaulay coming up … from the scene of the outrage," one passerby later recalled. "[He] was laughing immoderately all the way — he held his hands on his face as if to conceal his emotion … I remarked to [those] who were with me … how pleased he was."

Nobody stood up to the mob. When apprentice Baxter ran out of the shop shouting for help, nobody responded. As William Murray, a passing carpenter, later told the court, "I … thought that as Colonel Allan did nothing, who was a Magistrate, I had better not interfere."

Townsfolk might be forgiven for concluding that Allan, Heward, and Macaulay knew of the attack in advance. That the three had witnessed the act together appeared more than coincidence. The rioters, it turned out, were mostly sons and employees of the colony's power elite, the group that Mackenzie was to dub the "Family Compact" in 1833. Although not all fifteen rioters could be positively identified, of the eight later brought to trial, three worked as law students for Solicitor General Henry John

Boulton. Two others served as law clerks for Attorney General John Beverly Robinson, one of the colony's three most powerful men, along with Anglican Church leader John Strachan and Lieutenant-Governor Sir Peregrine Maitland. Another rioter was Maitland's confidential secretary. When the young secretary's actions became publicly known, the lieutenant-governor had little choice but to fire him, but quickly gave the offender another plush job. From Maitland on down, the conspiracy appeared complete. Nobody laid charges. Nobody made an arrest. The official government newspaper ignored the event, and Maitland said nothing about it to his superiors in London.

"Atrocious Outrage! total destruction of the Printing Office of the Colonial Advocate," wrote *Canadian Freeman* editor Collins, quickly grasping the main issues. "On Thursday last, a set of men holding high and honorable situations under the Colonial Government in this town — a set of men, not irritated by distress, disappointed hopes, or political degradation — but wallowing in ease and comfort — basking in the sun-shine of royal favour — enjoying every right and privilege of freemen — and chased by the toils of a loyal, peaceable and industrious population — formed themselves into a conspiracy against the laws of the country — a conspiracy against THE LIBERTY OF THE PRESS."

The Types Riot marked a defining moment for Upper Canada. The attack showed the Family Compact for what it was, an oligarchy putting itself above the law and crushing democratic rights through violence.

The assault also laid bare the elite's mad frustration with Mackenzie. For weeks, months even, resentment against him had been building. From the first edition of his *Colonial Advocate*, launched in 1824 at Queenston in Niagara, Mackenzie announced himself as an aggressive critic of Lieutenant-Governor Sir Peregrine Maitland's colonial administration. Maitland he characterized as "a humane and an amiable man," but a self-satisfied one. Maitland's noble birth and high connections enabled him "to enjoy himself … in inactivity," Mackenzie wrote. "What road has he made? What Canal has been begun in his time? Of what agricultural society is he the patron, president or benefactor?" Relentlessly, Mackenzie hammered away at the need for an elected, accountable government, replacing the colonial appointment system riddled with cronyism and nepotism.

When establishment figures accused Mackenzie of disloyalty, he shot back. Does not every page of the *Advocate*, he asked indignantly, "speak the language of a free and independent British subject?" Then he continued, "It is true, my loyalty has not descended so low as to degenerate into a base, fawning, cringing servility." Then he went further still. He was not prepared, he said, "to cringe to the funguses that I have beheld in this country, and who are more numerous and more pestilential in the town of York than the marshes and quagmires with which it is environed."

Such impudence shocked colonial officials. Nobody in York had seen anything like it, writes biographer Lindsey, who was also Mackenzie's son-in-law. Before the *Colonial Advocate*, Upper Canada had only "official gazettes containing a little news, and semi-official sheets which had an intense admiration of the ruling oligarchy," Lindsey writes. "To newspaper criticism the Executive had not been inured."

The establishment never liked the *Colonial Advocate*, but in the weeks leading up to the Types Riot, sentiment against the newssheet and its publisher intensified. The shift began with a minor controversy at St. James Anglican Church, the Establishment church, a wooden structure that stood where St. James Cathedral now stands. Biographer Lindsey, in his analysis of the attack on Mackenzie's press, takes the church fuss as his starting point. So does historian Raible.

The church fired its clerk over an indiscretion, then rehired him when he threatened vaguely to expose "the state of the York congregation." Mackenzie reported the news. In response, James Buchanan Macaulay, a churchwarden and the lawyer later seen "laughing immoderately" at the Types Riot, wrote several letters-to-the-editor attacking Mackenzie personally. Mackenzie refused to print them and, clearly annoyed, wrote back to Macaulay. He admonished the churchwarden for trying "to scoff and mock my mother, an old woman of seventy-five winters, [and] to draw my unoffending wife and children before the public to be jeered at about their poverty and the manner in which they are provided for." Unbowed, Macaulay published the entire exchange as a public pamphlet, including letters that Mackenzie had marked "private."

If Macaulay thought the pamphlet would end the argument, he was mistaken. Instead, the booklet stirred Mackenzie to some of the most vicious and incisive satire of his career. Methodically, the publisher set

up his rebuttal. On April 27, 1826, he told readers that he was ceasing all political and religious commentary. On May 4 he announced that he was retiring as managing editor. On May 11 he said that he would continue as sole proprietor, but hand editorial control to a journalist who was not as soft on his critics as he had been.

On May 18 "Patrick Swift" was introduced in the *Colonial Advocate's* pages as the new editor. A long report described him as the grand-nephew of Jonathan Swift, the great Irish satirist who wrote *A Modest Proposal* and *Gulliver's Travels.* To begin the job, the report said, the new editor had invited a dozen associates to Jordan's Hotel for a boozy meeting, which progressed to an equally high-spirited gabfest in the parlour of a nearby home. Mostly, the men went over "the Macaulay correspondence," the newspaper report said. A full account of the purported discussion followed. Under more than a dozen pseudonyms, Mackenzie cleverly heaped ridicule on Macaulay and some of his closest associates and relations.

> Brown.—It is a wonder how so ordinary a fellow as this Macaulay got into the [Executive] Council, or into any situation above that of a bum bailiff.
>
> Doctor Tod.—I can give you a reason for his nose being crooked upwards … His father intended him at first for his own trade of an apothecary [pharmacist] and kept him pounding stinking gum for hysteric pills to old women, until the horrid smell of the drug actually turned his nose into a peg, whereon his grandfather might have safely hung up his fiddle.

A participant named Thomas Moore Jr. alludes to Macaulay's aspirations to run for the elected assembly, saying that if he did so the price of rotten eggs for throwing would skyrocket, and the more rotten the pricier. "Truly if he ever plucks up the assurance enough to appear on the hustings as a Candidate for the good people of this capital," Moore says, "Rotten Eggs, Fish Heads, and Dead Cats will then bear a premium … higher and higher in proportion to the degree of putridity."

At one point a Mr. Caleb Hopkins conjures up a particularly harsh image. "These false aspersions of this fellow Macaulay," he says, "are

only the last howls of a dog dissected alive, as I hope he is in a fair way to be."

In his letters, Macaulay had accused Mackenzie of rising from honourable storekeeper to dishonourable publisher. In his satire, Mackenzie returns the insult many fold to cover many of Macaulay's associates. The publisher refers to St. James Anglican Church, led by John Strachan, as "the turncoat Scotchman's courtly temple," reminding readers that Strachan was originally Presbyterian, and began as "a poor itinerant schoolmaster."

Attorney General John Beverly Robinson is scorned as "the hopeful offspring of mother [Elisha] Beeman who kept the cake and beer shop in King Street." Chief Justice D'Arcy Boulton Sr., whose eldest son built The Grange, is recalled as the former "assistant steersman of a Lake Champlain lumber raft." William Allan, Mackenzie's neighbour across the street, is mocked for his numerous government jobs, too numerous to perform properly, and as a former "shoe black," or shoeshine boy.

Lieutenant-Governor Maitland comes in for special derision. Ignoring the man's heroism in the Battle of Waterloo, which earned him his knighthood, the fictitious gathering dismisses Maitland as "a low born fortune hunter" from a family "who have for centuries been a dead weight on the people of London, and are now likely to become a heavier burden to those of Upper Canada."

Rude, shocking, hyperbolic, offensive — the writings violated all bounds of decorum and good taste, and while they could be bold, they could also be subtle. Mackenzie particularly got under the skin by alluding to hidden family skeletons. Raible, in *Muddy York Mud*, attaches the entire "Patrick Swift Commentaries" as an appendix, so that readers can wade into it all. The May 18, 1826, installment runs to seven thousand words. The May 25 installment runs to another ten thousand.

"[Mackenzie] had stung them to the quick," biographer Lindsey says, but nobody wanted to sue for libel because "it would not be desirable to give additional notoriety by making [the writings] subjects of prosecution." The writings were not seditious, the biographer also says. "What [action] then remained?" he asks. "The sole resource of violence; and violence was used."

William Campbell served as Chief Justice of Upper Canada from 1825 to 1829, and it was as chief justice that he presided over the Types

Trial. With his court position came automatic presidency of the Executive Council, the body of advisors to the lieutenant-governor. In theory, his two high offices made Campbell a pivotal member of the Family Compact, but by that point he had lost his ambition for power. "He seems to have had little desire to win political distinction in Upper Canada," R.J. Morgan and Robert Lochiel Fraser write in the *Dictionary of Canadian Biography*. Mackenzie once mocked Campbell for taking the chief justice job not for political influence but for the hefty pay raise. While he moved in elite circles, the judge preferred to remain at the fringe.

The trial took place over two days in October 1826, in a courthouse so new that the plaster had not yet dried. Long since demolished, the building stood on King Street, between Toronto and Church Streets.

"Every inch of standing room in the Court-house was occupied by spectators, eager to witness a trial which had prospectively excited universal interest," Lindsey writes.

The cast of characters must have reminded some spectators of how small Little York really was. Assisting Campbell on the bench were two associate judges, one of them being William Allan, who had stood at his fence watching impassively as the attack took place. One of the defence lawyers was James Buchanan Macaulay, whose pamphlet is said to have triggered the "Patrick Swift commentaries," and who had been seen "laughing immoderately" as the types were being scattered.

No criminal charges had been laid against the rioters. Instead, Mackenzie was suing eight of the offenders for damages in a civil action. None of the eight denied breaking into Mackenzie's shop and destroying his property. Rather, they said they had acted within their rights. Out of court, one of their lawyers offered a two-hundred-pound settlement. Mackenzie was seeking two thousand pounds.

Today students visiting Campbell House sometimes re-enact the trial. Those playing Mackenzie's lawyers argue that educated people committed a deliberate, planned assault — they were not ignorant thugs acting impulsively — and that a free society demands a free press.

Students playing lawyers for the defence counter that Samuel Peters Jarvis and his companions acted to protect their reputations, which is their right, and that the law should not reward such people as Mackenzie for abusing press freedoms.

Various witnesses are heard from. The evidence piles up. Both sides deliver their closing arguments, and, with tensions running high, the museum staff member playing Chief Justice Campbell reminds jurors of their duty to fairness and impartiality.

In the York courthouse of October 1826, the jury retired to their damp, freshly plastered room. The air was "raw and unpleasant," Lindsey writes. For thirty-two hours they deliberated, and in a compromise announced damages of £625 plus costs — not generous considering the pain caused to Mackenzie and his family, perhaps, but plenty enough to put him back in business.

More important, the victory catapulted Mackenzie to folk hero. He had prevailed over the oligarchy. David had slain Goliath. His triumph won him an instant popular base on which to launch his long, controversial political career as a member of the Legislative Assembly, as Toronto's first mayor, and as leader of the 1837 Rebellion of Upper Canada.

In 1829 Chief Justice Campbell retired and became the first judge in Upper Canada to be knighted. In 1834 he died at the age of seventy-five. His doctor, Walter Henry, says the end came with the fall bird migration.

"My worthy patient became very weak towards the end of the year," the doctor writes in his 1839 memoir *Trifles from My Portfolio*, "his nights were restless — his appetite began to fail."

The doctor administered medicine but nothing worked. The judge ate almost nothing, until he revealed a taste for snipe, a long-beaked marsh bird.

"At the point of the sandy peninsula opposite the [Fort York] barracks are a number of little pools and marshes, frequented by these delectable little birds," the doctor writes, "and here I used to cross over in my skiff and pick up the Chief Justice's panacea. On this delicate food the poor old gentleman was supported for a couple of months; but the frost set in — the snipes flew away, and Sir William died."

At St. James Church, Reverend John Strachan presided over a funeral "of unusual impressiveness," writes Henry Scadding in his 1873 history *Toronto of Old*. Campbell was buried on the church grounds, where he continues to rest in what is now an unmarked grave.

WALK-THROUGH

Campbell House is the oldest surviving building from the Town of York. Sir William Campbell had it constructed in 1822, and 150 years later its owners, the Hallmark greeting-card company, proposed to tear it down for a parking lot. Alternatively, Hallmark offered the house to anybody who could haul it away.

The Advocates' Society rose to the challenge. Sir William had served as Chief Justice of Upper Canada, and the society of trial lawyers

Photo courtesy of the Sir William Campbell Foundation

Sir William Campbell's stately 1822 mansion completes its snail-paced journey over a dozen city blocks, arriving at the corner of University Avenue and Queen Street West on March 31, 1972. At considerable sacrifice, the Advocates' Society saved the home from demolition.

needed a headquarters. The heritage home seemed a good fit. At considerable sacrifice, with some members mortgaging their own houses to fund the project, the society proposed to relocate the building from the head of Frederick Street to an empty lot at Queen Street West and University Avenue.

On Friday, March 31, 1972, everything looked set. Eighty-two streetlights had been pulled up. Overhead trolley-car cables had been cleared and traffic lights removed. Thousands of people lined the streets to watch as a flatbed truck borrowed from New York State inched the three-hundred-tonne house along one and a half kilometres of pavement — a dozen blocks — to the new location. The trip took six and a half hours. In June 1974 Queen Elizabeth the Queen Mother formally declared Campbell House restored and reopened. The mansion that once held a commanding view of Little York settled into an even more exalted spot in downtown Toronto.

Although it faces Queen Street West, the residence also figures in the grand design of University Avenue, the city's ceremonial boulevard. From the Ontario Legislature and its forested park at one end, the avenue proceeds south as a divided thoroughfare, with monuments and statuary, and even the U.S. Consulate, lining the route. At Queen Street West, where the median begins to taper off, Campbell House and the Osgoode Hall law courts anchor the south end, with their matching cast-iron fences, brick walkways, and lush gardens. Other distinguished neighbours include the Four Seasons Centre for the Performing Arts, kitty-corner to Campbell House, and the 1931 Beaux Arts Canada Life building, next door. At the centre of the avenue rises an elegant winged figure on top of Walter Seymour Allward's monument to Canadian soldiers who died in the 1899–1902 Boer War.

The Advocates' Society continues to use the house for private functions. As part of an arrangement with the city, a group calling itself the Sir William Campbell Foundation also runs the place as a museum and, more recently, as an arts and cultural centre. Of particular interest are the furnishings. A volunteer committee has stocked the rooms with genuine treasures, most originating before 1834, the year Chief Justice Campbell died.

Front Entrance

At most of the city's historic-house museums, the public enters at the back, or in one case by a side door descending to a basement. At Campbell House, you enter by the front door, the way York society once did. From Queen Street West, you pass through an ornamental gate, take a brick path that divides symmetrically around a central flower bed, climb the four front steps, and push open a tall door into a foyer bigger than many downtown apartments. A lingering scent of woodsmoke helps to create a good first impression.

"Campbell House is an outstanding example of Georgian architecture," says director/curator Elizabeth Driver of the building's balance and symmetry. "People come through the door and go, 'Ummm.' They take in the proportions. They settle themselves in the space. Then they go [intake of breath], 'Oh, that smells so good.'"

Driver is a culinary historian. In 2008 she released her masterwork, the 1,008-page hardcover *Culinary Landmarks: A Bibliography of Canadian Cookbooks, 1825–1949*, described by its publisher, University of Toronto Press, as "a definitive history and bibliography" of more than 2,200 Canadian cookbooks, beginning with *La cuisinière bourgeoise* of 1825. She also knows her way around a hearth. She once worked at Montgomery's Inn demonstrating historic cooking techniques, and has taught Applied Food History at George Brown College's Chef School. At Campbell House, she still orchestrates special full-course nineteenth-century dinners, including a two-hundredth-anniversary birthday dinner to Charles Dickens in 2012. Under her direction historic homes come alive. On coming to Campbell House in 2008, she re-imagined the place as a museum doubling as a centre for the arts. What better legacy for the judge who presided over the first legal challenge to freedom of the press in Canada, Driver reasoned, than a centre celebrating freedom of artistic expression?

Visitors still take museum tours, but many are also getting to know the house for its art shows, theatre performances, photography exhibitions, outdoor sculptural events, and a seasonal Sunday night concert series called "The Listening Party." Every year, Campbell House participates in the city's Contact Photography Festival, and the overnight Nuit Blanche contemporary art blowout. At the city's annual Doors Open event, the house has drawn up to three thousand people over two days.

"I think we have only begun to scratch the surface," Driver says of the building's potential. "We started with art exhibitions, and I thought we might be able to have a few plays. We've got costumes. We've got props — tables and chairs. I don't let them use the china. We've also got entrances and exits [including servants' stairways and doors]."

"Every theatre troupe finds a different way to use the space," she says. "Down n' Out Productions approached me for a play called *The Dining Room*, but they couldn't find a dining-room table for a prop. I said, 'We have a dining table,' and we let them use the artifact table, one of our prime objects, which was wonderful because it was the focus of the action.'"

At the far end of the foyer stands a mahogany floor clock from the late 1700s, donated by a relative of Lord Durham, known for his report following the 1837 Rebellions of Upper and Lower Canada. Beside it, a particularly elegant staircase spirals clockwise to the second floor.

"My husband [conservation architect Edwin Rowse]," Driver says, "told me that for this small town of York, basically on the frontier, it is incredible to find the level of craftsmanship to build a staircase like this, and a house of this quality."

Basement Level

Colour photographs on the walls at the bottom of the stairs show Campbell House inching through downtown on a flatbed truck in 1972. Periodically, the museum mounts a full photographic display of the move in its ballroom exhibition space.

The basement divides into two rooms. To the left lies the Robinette Dining Room, named for the late J.J. Robinette, the pre-eminent Canadian litigator and legal authority of his day, and the Advocates' Society's founding president. A bronze bust of him stands inside the door on a green marble pedestal.

The other room is the restored 1820s kitchen. "When people come into this room, they kind of go, 'Oh, yes, this is a real place,'" Driver says. Other rooms might evoke the finer elements of the period, she says, but the kitchen conjures up day-to-day cutting, boiling, mashing, and bustle. It feels lived-in. Every kitchen device, from ladles and skimmers to grid-irons and trivets, can be found where they might logically be placed in a working kitchen. To add storage space, Driver installed an attractive spice

cupboard and a kitchen pantry cupboard with its original shelves, both gifts from Parks Canada.

When Down n' Out Productions staged their play *When the Ice Breaks*, dramatizing the 1813 Battle of York from a kitchen servants' point of view, the action revolved around the long, central worktable. Notice the stuffed snipe in a cage on the south windowsill, a droll allusion to Sir William's diet in his dying days.

Main Floor, Front Drawing Room

Back upstairs in the main foyer, notice the twin doors left and right. Choose the right-hand door to the drawing room. Twin portraits of Sir William and Lady Hannah secure pride of place in twin alcoves on the

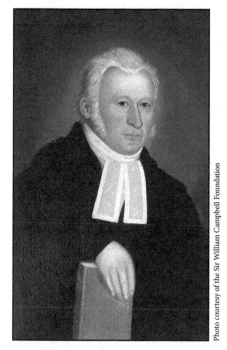

Photo courtesy of the Sir William Campbell Foundation

Photo courtesy of the Sir William Campbell Foundation

Sir William Campbell appears chipper and engaging in a portrait from 1821 by Robert McNaughton. As Chief Justice of Upper Canada, Campbell moved in elite circles but ensured fairness for outsider William Lyon Mackenzie in the landmark Types Trial, affirming freedom of speech.

In a matching 1821 portrait by Robert McNaughton, Lady Hannah looks pleased with herself, from the gold embroidery of her gown to the gold watch on its gold chain. She rose from the backwater of Guysborough, Nova Scotia, to become wife of Upper Canada's chief justice.

west wall. The artist was likely Robert McNaughton. Little is known about him, except that he was not especially good. The works appear two-dimensional. They date to 1821 — one year before the couple moved into the house, and so early in York's development that they were lucky to find any portrait painter at all.

Biographical records describe Sir William as sagging under an onerous workload in 1821, his health faltering. In the painting, he appears chipper and engaging. He wears a neatly coiffed white wig, a black jacket with a white judge's collar, and a childlike, elfin expression, as though keeping an amusing story to himself. A clumsily painted right hand rests on an upright leather-bound book.

Lady Hannah looks as though she has bitten into something sour, or closed her mouth around missing teeth. She has dolled herself up. She wears a blue-green dress with gold embroidery at the neck and cuffs, and a white morning cap teeming with white lace, flowers, and ribbons. Over her shoulders and arms hangs a white lace shawl, and she wears all her best jewellery: an oblong broach at the neck, two rings on the left hand, and a gold pocket watch on a gold chain. In her left hand she holds a blue-green folding fan. For a girl born in 1768 in Guysborough, Nova Scotia, she has done well for herself.

The rest of the room reflects nineteenth-century pastimes, furnished with pieces of exceptional quality. One is the rosewood games table, ingeniously adaptable for playing cards, backgammon, tric trac (a form of backgammon), and chess. Other pieces include the tortoiseshell tea caddy and the sewing table housing a silk sewing basket. Inside the mahogany square piano can be found the hand-painted signature of its maker, "Richard Horsburgh, Edinburgh, 1801."

Main Floor, Dining Room

Walk from the drawing room to the dining room. Notice that the doors are the same size, and precisely opposite each other. The dining room's two tall front windows also match those of the drawing room. All is symmetry and balance. "When you work in a building that's Georgian, you start to become obsessed," Driver says with a laugh. "You go into a room and think, 'Oh, no, this computer is not lined up perfectly with the desk.'"

Sit down at the dining-room table. Turn toward the windows. They start low to the floor, and it is easy to imagine Sir William and Lady Hannah looking down Frederick Street to William Lyon Mackenzie's house and printing shop, and out over the lake. The table is set for eight. Campbell kept no record of his dinner parties, but without question York's upper crust — members of the Family Compact — enjoyed many evenings here. William Allan must certainly have counted among them. He lived two blocks away, witnessed the Types Riot, and presided with Campbell at the trial. So must have John Beverly Robinson, one of the town's most powerful figures, who attended the trial proceedings, and on Campbell's retirement in 1829 succeeded Campbell as chief justice.

Twin portraits face each other on opposite walls. One depicts the Campbells' second daughter, Amelia. The other shows her husband, Dr. William Robertson, one of the founders of what became the McGill University medical school.

Two other objects stand out. One is the convex butler's mirror over the mantel, said to enable the wait staff to survey the entire room from the rear twin doors. Its circular frame supports protruding decorative candle-holders and, at the top, an eagle or phoenix with outspread wings. The other piece lies under the sideboard, a low sarcophagus-shaped "cellarette," which with the help of Lake Ontario ice chips kept the dinner wine chilled.

Upstairs, Master Bedroom

The house has only one family bedroom, at the front with a lake view. Guests likely slept in a guesthouse on the property, the servants in the spacious attic.

With no bathroom in the house, the bathtub sits by the bedroom fireplace. This one is made of tin, painted light blue with reddish swirling designs. It is circular with a raised seat, and a ledge for a bar of soap or a sponge. The bather sits to wash the feet, and stands to sponge the rest.

In the corner can be found a travelling washstand. Sir William frequently travelled the court circuit, and likely used this type of portable washstand — also popular with military generals on the move — with its sliding mirror and ingenious system of lidded compartments and drawers.

Upstairs, Ballroom

Across the hall, the ballroom runs the entire width of the house. In the 1820s no public hall or church hall existed. Private ballrooms offered the largest gathering spaces at York, and Campbell's ranked among the finest.

"The Winter has set in with all its Rigours, and the gay season has commenced in unusual style for York," wrote the young, wealthy land-owner John Elmsley to his mother in December 1827. "His [Excellency] Lt. Govr. gave a most splendid Ball on Friday… His Honor the Chief Just. [Campbell] has issued cards for a Ball Tomorrow."

Today the space serves as a gallery, theatre, and concert room, with a fifty-seat capacity for most shows.

Between the two upstairs rooms, a spacious hallway houses two old-style museum displays. One shows Chief Justice Campbell presiding over the Types Trial, with red-wigged Mackenzie waving papers in the air. The other is Driver's favourite — "You'll fall in love with it," she says — a scale model of central York as it looked in 1825.

YORK 1825 SCALE MODEL

The best view is from a child's height. Crouch down until your nose reaches tabletop level. You are in the lake, looking toward shore past the wharf to Frederick Street. The first building to the left is William Lyon Mackenzie's house and pressroom. Opposite it to the right stands the handsome blue home of William Allan, a leading Family Compact member and hardly a congenial neighbour for Mackenzie. The buildings are well spaced, the streets wide and dusty. Trees and shrubs sprout everywhere. The Town of York of 1825 might be the capital of Upper Canada, but it resembles a poky hamlet. Its population totals 1,677 people. Its houses number 239, its stores 48. Look all the way to the end of the street, and you see one of the most stately residences in town — a two-storey Georgian brick mansion belonging to Chief Justice William Campbell and his wife, Hannah.

"Having it there in three dimensions still beats any kind of video or slides," says David Pepper, creator of the scale model — one of the newest artifacts at Campbell House and one of the most enchanting. "I've done

a lot of different types of exhibits, but somehow when it's in three dimensions — whether full-scale, larger than life, or miniature — people do get absorbed in it. If it is well done and the lighting is good, it puts you back into those times."

Pepper is a professional artist, sculptor, and exhibit designer, now living in Windsor, Ontario. He completed the York model in 1977, after working on it for more than a year on commission from the Advocates' Society. During the same period, Pepper worked as an artist-craftsman at the Royal Ontario Museum, making dioramas, mannequins, replicas of artifacts, and biology displays.

"The research alone took a tremendous amount of time," he recalls of the York model, which focuses on the town core. "I went to every source I could. I found old photographs and drawings of the houses at later periods. I consulted books written in the late nineteenth century by people who had lived in York. Some books would include sketches from memory, or drawings from paintings. Sometimes there would be a description. I found a reference to the courthouse, with the stone walls up but without the roof on, so I showed that, with lumber all around and men working inside. I tried to just glean as much information as I could, and what I had to fudge I tried to keep to the same style."

William Campbell's two-storey Georgian brick mansion commands the head of Frederick Street looking straight to the lake, in David Pepper's superlative model of York as it appeared in 1825. At the waterfront to the left stands William Lyon Mackenzie's house and pressroom, and across the street to the right the handsome blue home of William Allan.

Photo by John Goddard

In Pepper's model, the Bank of Upper Canada appears in its earliest stages, with only the first stones in place. Today it is the only building from 1825 York left standing at its original location. Campbell House is presented with a square-shaped front portico, not the rounded one recreated by the restoration crew. "I did it in the way it appears in a drawing from the 1860s," Pepper says.

Tiny human shapes add vivacity and humour to the work. British soldiers march in formation past the Steamboat Hotel on what is now Front Street East. A redheaded man rushes to the outhouse in Mackenzie's backyard. Scaling the town at forty feet to the inch put the average adult height at one-eighth of an inch, Pepper says.

"I think I made more than one hundred figures altogether," the artist says. "I carved them with an X-Acto knife out of old medical applicator sticks, the ones that nurses used to wrap in cotton and stick into your ears. I did women's figures with full skirts and the men sort of tapered the other way, with little heads, and dabbed them with bits of colour.

"The horse and cart with its rider was a bit more ambitious," he says of the configuration at the water pump near the market. "I managed to get enough detail to make people see things that aren't there."

Working on the project deepened Pepper's appreciation of his own family history. George Duck, his great-great-great-grandfather on his mother's side, served as a British soldier defending the colony in the War of 1812. Afterward, he returned to England, got married, started a family, and in 1833 arrived back at York to claim a land grant to which he was entitled as a war veteran.

"He was a captain or sergeant with the Royal Veterans Battalion, and spent a little time in York before he pushed off to the area around Chatham," Pepper says. "He actually met John Beverly Robinson [one of the colony's most powerful legal and political figures]. I could imagine George with his wife and sons all marching up to Robinson's law office and presenting their papers."

NEIGHBOURING ATTRACTIONS

Canada Life Building, 330 University Avenue

In 1931 the Canada Life insurance company opened its Beaux Arts head-quarters on University Avenue, and twenty years later added its landmark electronic weather beacon. It shows forecasts for rain, snow, and sunshine, and indicates whether the maximum temperature is likely to rise or fall the next day. In the lobby, on request, a receptionist will provide a wallet-size card explaining how to read the beacon.

The South African War Memorial

The statue, mounted by a glorious bronze angel, helps anchor the south end of University Avenue as a ceremonial boulevard. The memorial's sculptor was Walter Seymour Allward, best known for his Vimy Memorial on the First World War battlefield in France. Allward also created the memorial to William Lyon Mackenzie outside the west wall of the Ontario Legislature building at Queen's Park (see Chapter 1), and *The Old Soldier*, a War of 1812 memorial at Victoria Memorial Square (see Chapter 10).

Osgoode Hall, 130 Queen Street West

The courthouse that Chief Justice Campbell knew in 1826 disappeared long ago, but his house now neighbours the Osgoode Hall law courts, built in stages beginning in 1829. Today the buildings house the Ontario Court of Appeal, the Superior Court of Justice, and the offices of the Law Society of Upper Canada. Osgoode Hall's website gives details of every public room of the building. Guided tours can be arranged. A good place to start would be the Osgoode Hall Restaurant, open to the public September through June, noon to two o'clock, Monday to Friday. "Order à la carte or enjoy a three-course menu of seasonal fare from the *prix fixe* menu," the website says, "surrounded by leather-bound law books, stained glass and robed lawyers on their way to court."

GIBSON HOUSE

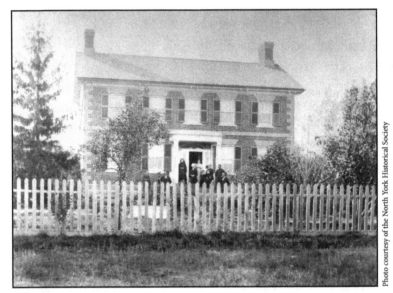

Photo courtesy of the North York Historical Society

Gibson family members gather at the front entrance to the family home in 1873. Matriarch Liza Gibson, dressed in black, stands on the porch at the left. Peter Silas Gibson, the one-time "baby in the snowbank," stands to the left of her on the ground near the porch pillar.

Address

5172 Yonge Street, on the north side of Park Home Avenue, between Sheppard and Finch Avenues.

Getting There by TTC

Gibson House stands minutes away by foot from North York Centre subway station, toward the north end of the Yonge Line. Walk half a block north up Yonge Street to Park Home Avenue. At the northwest corner, newly built condominium towers named Gibson Square obscure the view of the historic home, but it is there behind the towers.

THE CHIVALROUS INSURGENT

David Gibson lived a brave, ethical, and prosperous life, dedicated to the wellbeing of his family and community. At one point he also took up arms against his government. He helped lead the 1837 Rebellion of Upper Canada, aiming to overthrow a smug colonial oligarchy and gain a stronger political voice for the common man. When the cause failed, he behaved gallantly. He herded government prisoners to safety and stopped fellow rebels from killing a man who fired at him during the final rout. Such courtesies, however, went unreciprocated. The lieutenant-governor ordered Gibson's home burned to the ground, left Gibson's wife and four children (including an infant boy) homeless, and posted a reward of five hundred pounds for Gibson's capture for treason, an offence punishable by hanging. The fugitive escaped to the United States, and years later returned in vindication to see the reforms he championed securely in place. Never did he express regret for his actions.

"I have seen considerable in the world," he wrote to a half-brother three years after the rebellion, in 1840. "[I] have acquired considerable property and have in endeavouring to sustain my rights endangered considerable property, but I have no doubt but the final result will be to my credit for all I have done, I am a full believer in the principle of 'do no wrong and suffer no wrong.'"

Gibson grew up with a firm sense of himself. He was born in County Forfarshire, Scotland, not far from William Lyon Mackenzie's hometown of Dundee. The two men never met in Scotland, but grew up holding many of the same values. Both esteemed the kind of reading and education that breed an independence of mind, and both respected the intelligence and abilities of ordinary people. Both also grew up Reform-minded. They sympathized with the demand for democratic change taking place in Great Britain in the early 1800s, a push that culminated in Britain's Reform Act of 1832, which added to Scotland's number of seats in Parliament and extended the franchise to the middle class.

Gibson's father was a weaver. For generations the Forfarshire Gibsons raised sheep and wove wool into cloth, but mechanization of the textile industry during the Industrial Revolution threw most weavers out of work. Young David needed a new career. With his father's help, he secured

a five-year apprenticeship as a land surveyor, and in 1825, at the age of twenty-one, he set sail for a life in British North America.

At first he had trouble finding steady work. He tried Quebec, with mixed success, then moved to Upper Canada, finally landing a job as surveyor of highways for the southern division of the Home District, or what is now south-central Ontario. In 1828 he married his first cousin, Eliza Milne, and in 1829 bought a farm of about one hundred acres between Yonge and Bathurst Streets in what is now North York. On it he built a wood-frame house. In addition to his surveying work, he grew hay and wheat, raised sheep, and planted a large apple orchard. He also took up politics.

"His surveying drew him into areas isolated from the capital where he was able to observe that there were many problems that needed to be addressed," Douglas Fyfe, now program officer at the Spadina House Museum, writes in a 1988 essay titled, "David Gibson's Involvement in the Rebellion of Upper Canada." It is one of two scholarly papers that the Gibson House tour guides, or historic interpreters, draw from when speaking of Gibson as a public figure. The other paper is "Honourable Whatever Might Be the Result: David Gibson and the 1837 Upper Canada Rebellion," by Michael Shelbourn, a Gibson House employee, written in 2012. Both trace Gibson's rise from political novice, to Reform politician, to chivalrous insurgent.

The "many problems" that Gibson observed mostly boiled down to one: political power rested in the hands of a few privileged Upper Canadian families, an elite later dubbed the Family Compact. To them "democracy" was a bad word. To them it meant "American," and to some extent "anti-British."

"I have contended and ever will contend against democratic principles," Sir Peregrine Maitland once said as Lieutenant-Governor of Upper Canada, 1818–28. The lieutenant-governor represented the British monarch and British Parliament. If he chose, he might take advice from his local Executive Council and Legislative Council. Both were made up entirely of appointed Family Compact types, however, and both, like Maitland, worked toward suppressing liberal views. At the same time, the elected Legislative Assembly, representing the general population, functioned as a glorified debating club.

In 1831 Gibson entered public life as a force for change. He became the first president of the York County Temperance Society, advocating self-restraint with alcohol in a colony where beer and whiskey were preferred over the unsafe drinking water. In 1834, on the Reform ticket, he won a seat in the elected Legislative Assembly, the first of two consecutive terms representing York County. While in office Gibson also became a director of the Agricultural Society and of the People's Bank, established to rival the Bank of Upper Canada, which was controlled by the Family Compact. As well, he became the first chairman of the Constitutional Society, a body that Fyfe describes as "devoted to demonstrating that the government in the colony was behaving unconstitutionally by disallowing a large proportion of the Bills of the [Legislative Assembly]."

Once in office Gibson attacked government corruption. With Mackenzie and other Reformers, he attacked patronage and nepotism. He attacked the way infrastructure expenditures went mainly toward canals to improve business and trade, instead of toward roads and bridges to improve agriculture. He especially attacked the Clergy Reserves. The colonial government set aside one-seventh of all unoccupied land for Christian churches, to be used as needed, or sold as a source of revenue. Worse, the ruling elite interpreted "Christian churches" as "the Anglican Church" — the one they attended — excluding all others.

The Anglican Church's plots were scattered everywhere. Often they were not developed or maintained. There might be no road through a clergy plot, or, if there was a road, it might not be kept clear, forcing a farmer to either clear it himself or go around.

Clergy Reserves should be banned, Gibson said. Farmers do not support the reserves, he argued, and neither does the Bible. "The command given to the Apostles when they were sent forth to preach the gospel, was not, 'Get one-seventh of the land where you preach,'" he said in a speech.

In the summer of 1837, Gibson and other Reformers threw down the gauntlet. The lieutenant-governor at the time, Sir Francis Bond Head, appeared oblivious to all criticism and protest. In July Gibson signed a Reform resolution inspired by the American Constitution declaring that "Government ... is instituted for the benefit of a people," and that, "people have a natural right ... to seek after and establish such institutions as will yield the greatest quantity of happiness to the greatest number."

In August Gibson upped the ante. He gathered supporters to his farm, where they dubbed themselves "Radical Reformers" and reiterated demands for a government accountable to the people. That same month, he chaired a similar meeting in neighbouring Vaughan and attended others in Markham, Lloydtown, and Toronto.

In September he again gathered men to his property, several hundred of them. He advertised the event as a "turkey shoot," but referred to it in his diary as military training. In November he held a second shoot. Likely, he intended the gatherings as a show of strength, Fyfe argues in his paper, as a clear display of political discontent. Gibson wanted reform, not revolution, Fyfe says, but after such sabre-rattling events took their own course. On December 5, 1837, Gibson writes in his diary, "Came to Montgomery's [Tavern]in Arms against the government with 150 or 200 others about 6 a.m."

When assessing Gibson as a rebel leader, two particular episodes in the uprising stand out. Both testify to his upright character. The first took place later that day, December 5. Mackenzie and his second-in-command, Samuel Lount, led a contingent south on Yonge Street toward the capital. Gibson marched with them. Just before reaching Bloor Street, Mackenzie stopped in front of a house belonging to Robert Charles Horne, chief teller of the Bank of Upper Canada, a man Mackenzie despised, and set the building on fire. Horne's wife and children fled through the snow. Farther south, when Mackenzie paused at the home of Sheriff William Botsford Jarvis, also intending to burn it down, Gibson and Lount stopped him. They calmed Mackenzie and spared the home.

The second episode occurred two days later. The rebels were in retreat. The final assault on their headquarters, Montgomery's Tavern, appeared imminent, with government forces assured of victory. Gibson was inside, guarding government prisoners. Rather than risk them being killed by their own advancing militia, he hustled them out the back to safety. As he did so, a Judge Jones raced toward him and tried to shoot him. Again Gibson kept his cool.

"Mr. Gibson prevented his men from firing at Mr. Jones, saying that they were beaten, and he entreated them that no more blood should be shed," the government commander, Colonel James FitzGibbon, later told the *Patriot* newspaper. "After this Mr. Gibson permitted his prisoners to depart unhurt."

Once the prisoners were safe, Gibson fled for his life. At three o'clock that afternoon, Lieutenant-Governor Head issued a proclamation offering one thousand pounds for Mackenzie's capture, and five hundred each for Gibson, Lount, and two other leaders — Jesse Lloyd and Silas Fletcher. The lieutenant-governor also ordered Montgomery's Tavern burned to the ground, which it was, and ordered FitzGibbon to torch the Gibson homestead as well.

FitzGibbon objected. Head insisted. Reluctantly, FitzGibbon ordered one of his officers to do the job, and when the officer refused, FitzGibbon rode north himself, with a small detachment, and set the building ablaze. For FitzGibbon the distasteful order was the last straw. The next day, complaining of a long list of Head's mistakes and abuses, the government's military commander resigned his post.

Gibson rode east. He hid in a woodpile at a cousin's sawmill, then hid in a haystack at a friend's farm near Oshawa. After a month or so, he made his way across Lake Ontario to Rochester, New York, in an open boat. From there, he rejoined Mackenzie. He joined the rebel contingent at Navy Island in the Niagara River, where Mackenzie hoped to lead an invasion of York. When the plot fizzled, Gibson remained loyal to the cause, keeping Mackenzie's rebel accounts and helping in other ways. Eventually, however, the two men argued over money, and Mackenzie publicly called Gibson a "coward" for hustling the government prisoners to safety at Montgomery's Tavern.

After that, Gibson had nothing more to do with Mackenzie. The surveyor set up a practice in Lockport, New York, resettled his family, and found work on the Erie Canal. He also bought a farm. In 1843 he ignored a pardon from Queen Victoria, but five years later, when his job at the canal ended, he and his family returned to their former York Township property. Gibson must have felt pleased at the changes he saw. A British-mandated inquiry, the Durham Report, fell short of justifying the rebellion, but condemned the ruling oligarchy for its abuses.

"A monopoly of power so extensive and so lasting could not fail, in process of time, to excite envy, create dissatisfaction, and ultimately provoke attack," the report said.

For the rest of his life, Gibson lived on his York Township farm, one block from present-day Mel Lastman Square. In 1851 he built his

red-brick Georgian home, now the Gibson House Museum. He ran his two farms, in York Township and Lockport. He bought and sold properties throughout the colony, including a sawmill in Parry Sound, and travelled widely to survey lands for settlers as Inspector of Crown Land Agencies and Superintendent of Colonization Roads. Unexpectedly, in 1864 he died of a lung infection while on a business trip to Quebec City. He was fifty-nine.

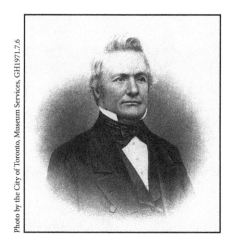

Photo by the City of Toronto, Museum Services, GH1971.7.6

In his high collar and with his firm gaze, David Gibson appears a model of rectitude and courage, consistent with his conduct during the 1837 Rebellion. "I am a full believer in the principle of 'do no wrong and suffer no wrong,'" he wrote to his half-brother after the failed insurrection.

Over time, the names of most 1837 Rebellion leaders have faded. Jesse Lloyd and Silas Fletcher are all but lost to history. Samuel Lount is remembered mostly for having been hung with fellow rebel Peter Matthews. In contrast, William Lyon Mackenzie has his own museum. So does David Gibson. Because of his place in history, conservationists saved Gibson's house. Because the house survives, so does Gibson's place in history.

WALK-THROUGH

High-rise condominiums surround it now, but in the 1850s David Gibson's red-brick Georgian home stood prominently against the rural landscape, near a crossroads settlement that he named Willow Dale. Instead of the fifteen-minute subway ride from present-day Willowdale, a trip downtown would take him three to four hours by horse and cart.

Gibson bought his property in the late 1820s. First he built a wood-frame house, which government troops burned down following the 1837 Rebellion. In 1851, after returning from exile in the United States, he built the residence known today as Gibson House.

"Its design reflects the lifestyle of an established family with a leading place in their community," a City of Toronto Museum Services report says, in part, of the building's significance.

"North York's finest example of Neo-Classical Architecture," says a city parks and recreation report. North York was the municipality now making up north-central Toronto. Neoclassicism was the return to ancient Greek and Roman architectural values.

When David Gibson and his wife Eliza moved into the house, they had seven children, the eldest a daughter of twenty-two. When David died in 1864, the two eldest boys, James and William, took over his surveying business. The third son, Peter, took over the farming operations and inherited the house. He and his family resided here until 1916. His mother, Eliza, lived with them until her death in 1887 at seventy-seven.

Today the Gibson House Museum excels at depicting the mid-Victorian era. Guides, or historical interpreters, are especially trained in the period, and apply their expertise to inform the life of the Gibsons as successful rural mid-Victorian inhabitants of Upper Canada.

One such interpreter is Liam Hanebury, an especially articulate part-time staff member. The following walk-through comes from him. The text has been slightly condensed, but the words are Liam's as he leads a group through the house.

Main Floor, Front and Back Parlours

In Victorian times, because it was a class-based society, people would want to show off to guests a little bit. Houses of this period would have bright colours everywhere. They would have knick-knacks — every surface covered — and pictures over every part of the wall. The Gibsons were a little different. Mr. Gibson was Presbyterian. The family was fairly conservative. They would want to impress guests, but they would also want to show restraint, and their home is not as showy as other Victorian homes of the time.

The parlour is divided into two sections, front and back. The front parlour is the good parlour, reserved for visitors. It has the nicer furniture.

A carpet on the floor would be a sign of wealth, or even having the floor painted a dark colour, because you would have to repaint every season to cover scuff marks, which was an extra expense. Somebody coming here would pick up on that. Visitors would pick up on all sorts of little details as a way to gauge a family's wealth and status.

In the front parlour the Gibsons had a cast-iron stove for their guests. No sparks. No smoke. It gives a nice even heat. Instead of painting the walls, they went to the extra expense of putting up wallpaper, which was new in the 1850s and cost quite a lot of money.

The back parlour was where the family would relax in the evening. Somebody might play the piano. Somebody might read a book. The room is plainer than the front parlour, and instead of a stove they have an open fireplace.

Notice the photographs of David Gibson and his wife, Eliza. Gibson is handsome in a high collar and black tie, a successful surveyor, farmer, and politician. Eliza, in the corner, wears a black bonnet, possibly as an act of mourning after her husband's death. They made a good team. They were very successful together.

The two paintings on the parlour walls are from the city's collection. They show Joseph Lesslie, Toronto's third postmaster, and his wife. He has a letter in his hand. For school groups, the paintings are a good way to show how people would be dressed. Many of the street names around here come from families that settled in this area. "Lesslie" was sometimes spelled "Leslie," giving us Leslie Street. The Sheppards lived down the road and had a store, giving us Sheppard Avenue. The Finches owned an inn up the road, giving us Finch Avenue.

Main Floor, Front Entrance

The Gibsons would want to make a good first impression, and there were a few tricks they could use to enhance the front entrance. One is under our feet. This looks like linoleum, but is actually something called oilcloth — canvas that has been shellacked several times, then painted by hand to imitate marble tile. Are they fooling anyone? I doubt it, but it's a good try, right? And the walls are painted to imitate slate tiles. Maybe, in low evening light, they might have impressed some people.

Historical interpreter Adrianna Prosser, in Victorian dress, indicates the upstairs boys' bedroom. Behind her at the end of the hall lies the sewing room, which doubled as a bedroom for the hired girl, Catherine Flynn.

As you enter the home, you see doorways on either side of the entrance. The way to the left is for gentlemen, the way to the right for ladies. The Victorians believed in strict segregation between a man's world and a woman's world. The man's world was one of business, a world outside the home. It was ruled by logic, and without emotion. It was also seen as competitive and cutthroat, capitalism at its purist. A man was supposed to go out into the world and forge his way and make a living for his family. So if you were a man coming to the Gibson home, you would have been taken straight into Mr. Gibson's office. This area was strictly for men.

If you were a lady, it was the opposite. Your world was inside the home. You were supposed to make a safe, cozy, protected nest for your family. Women were seen to be ruled by emotion and to have no sense of logic whatsoever.

The Victorians believed in the balance of nature. By putting a man and woman together as a couple, they balanced each other out, ready to make a family. Victorian architecture reflects that view. If you were a lady coming to the home, you were not going to be discussing business. You were going to be taken directly into the parlour where Mrs. Gibson would

sit you down, serve you tea, and you would catch up on the latest gossip of the neighbourhood.

Main Floor, Front Office

Here you can see all of Mr. Gibson's original surveying tools and his original desk. The tools were saved from a fire that burned the Gibsons' first house to the ground. Eliza Gibson was a clever lady. She got all the kids out. She had to stash the youngest one in a snowbank. She ran back inside the house and saved all the surveying equipment, as well as all David Gibson's surveyor certificates. She knew that if her husband was alive he would need these things to make a living.

Upstairs, Hired-Man's Bedroom

Upstairs, we go from the public realm to the private area. All of a sudden things look a lot plainer. The floors are bare. There is no longer wallpaper on the walls. That's because only close friends and family members were going to come up here. They didn't need to show off to them.

This is the hired man's room, at the back, over the kitchen. Mr. Gibson would often be gone for two or three weeks at a time, and needed somebody to look after the farm operations. The hired man, John Bosa, lived in this room and looked after all the animals and fields. Most farm hands in this time period would be hired just for the summer. They would sleep in the barn on the floor with the animals. Mr. Bosa had a room in the house, a big comfortable room, even if sparsely furnished, which shows that he was an important member of the family.

We are right above the kitchen. The heat from the fire would come up through that vent in the middle of the floor. These houses were freezing in winter. You would probably have seven or eight quilts on the bed, and you would wake up to a layer of ice on top of the quilts, and your glass of water would be frozen solid beside you.

Mr. Bosa had a rope bed. About once a week, the ropes would have to be tightened on the bed frame or they would sag, and as the holes between the ropes got looser and bigger the mattresses would fall through. Do you know the expression, "Good night, sleep tight, don't let the bedbugs bite"? "Sleep tight" means if you keep your bed ropes tight, you will sleep more comfortably.

Even though Mr. Bosa was a trusted member of the family, it would be a bit taboo to have an unmarried man in your home when your husband was away. He had his own staircase leading down to two doors. One opens to the kitchen, the other to the outside. The door here on the landing also separates his area from the family's area, and you can be sure that every night this door would be locked.

Upstairs, Children's Bedrooms

The four boys slept in this room, two in each bed to save on space, and to keep them nice and cozy in winter. You can see their toy soldiers and sailing boats — toys to encourage a sense of exploration, of going out and conquering the world.

On the other side of the hall, you see the girls' bedroom. The eldest daughter, Elizabeth, or "Libby," was already twenty-two when the Gibsons moved into the house. She had the front part of the bedroom, and the two other girls shared the back part. They needed the skills to become mothers later on, so you see a tea set for practising etiquette, and dolls, which actually belonged to Mr. Gibson's grandchildren. The girls would practise sewing clothes for them.

A back bedroom off a front bedroom was typical of the period. There was the idea that you had to protect your young daughters, so that in many houses you find the parents' bedroom in front, and the daughter's bedroom behind. Anybody wishing to get to the daughters' bedroom would have to go through the parents' bedroom first. In this case, an older sibling had the front part and the two younger girls stayed in the back.

All the Gibson children went to school. Just up the road there was a small brick building, which the children would attend from October through April, when it was quiet on the farm. It was a one-room schoolhouse, boys on one side, girls on the other, taught by one teacher. What boys learned and what girls learned would be entirely different. Boys needed math skills, how to read, geography, economics. Girls learned how to run the household, how to keep accounts, and in a larger household, how to manage a staff. The ideal Victorian woman ran a spotless home, put meals on the table, and quietly sat in the corner sewing.

The two eldest Gibson boys became surveyors. One of the younger boys inherited the farm. The eldest daughter, Elizabeth, or "Libby," and

the youngest, Mary Helen, or "Lella," got married. Margaret Jane, known as "Maggie," died unmarried at twenty-eight. On your way out, as you leave the kitchen, you might want to look at the family tree on the wall.

Upstairs, Master Bedroom

Down the hall to our left is the master bedroom for Mr. and Mrs. Gibson — fancier than the rest, wallpaper on the walls and carpet on the floor. The stovepipe runs into the room from downstairs, carrying heat into the bedroom. The circle in the middle is called a dumb stove. I've never seen another one like it in any museum. As heat rises in the pipe, it reaches the dumb stove, then divides and spreads out over the greater surface area. This would have been the warmest room in the house in winter because of the effectiveness of the dumb stove as a radiator. You could also set a cup of tea on it, or a pair of socks to warm them up before going out on a cold day.

Mr. and Mrs. Gibson have a nice four-poster bed. You could attach curtains around the bed to help keep the warm air close to you in winter, and I always like to point out that quilt. It is 160 years old, and every stitch on it has been done by hand. You can see layers and layers of details, thousands of hours of work. All the quilts in this house are original, from the 1850s or 1860s, most of them in remarkable condition.

Visitors sometimes ask why the beds are so short. They wonder if people were smaller in those days. They weren't. David Gibson was six feet two inches tall. The average height was about the same as today, but often people would sleep propped up by many pillows. Generally, their lungs were not very good because of coal and smoke and different respiratory infections, so they slept propped up.

Upstairs, Sewing Room and Servant Girl's Bedroom

The Gibsons were fairly well off, definitely comfortable. They were considered upper middle class, and they would pay to have somebody make their clothes for them, usually a seamstress, or tailor, or dressmaker.

They also had a hired girl, Catherine Flynn, a young Irish immigrant who came over in her mid-twenties to escape the potato famine of the 1840s. There was a lot of prejudice against the Irish. They were considered the lowest of the low in society, and for an unmarried Irish Catholic girl to get a job with a family would be something that she would want to hold

on to. She would have done most of the mending, spinning, and cleaning. The tiny bed on the right is her bed.

The Gibson daughters also learned to spin, and knit, and create things with their hands — all marriageable skills, and a source of pride to them. A spinning wheel is on the left in this room. The larger six-sided wheel in the middle is for stretching the wool afterwards, because if the wool wasn't stretched and left for several weeks, it would end up as one big knot.

Upstairs, Guest Bedroom

At the end of the hall is the guest room. People of the era needed to be prepared for guests at all times. There was no telephone for friends or family to warn they were coming, and it was considered completely appropriate for people to just show up on somebody's doorstep. And because guests might take weeks to get here, they were not just going to stay for a day or two. They would stay a long time, and hosts always wanted to make sure the guests were comfortable, so that when they returned the visit, they would receive the same treatment.

In the 1850s it was important to impress guests with the accommodations offered. The guest bedroom would be second only to the master bedroom. It was quite common to close all the doors except the master bedroom and guest bedroom, the nicest rooms, to encourage guests to assume that every room was just as well appointed.

This bed has boards underneath, not ropes, so is a bit more comfortable. On the desk, there is a full shaving kit and washbasin. There was no running water in the house during Gibson's time. Outside, the Gibsons had a pump from a well, and an outhouse. At night, guests would use a chamber pot, which would be emptied and scrubbed in the morning by the hired girl. This room is doubly fancy because the chamber pot matches the wash set. If something had broken, the set would be mismatched. Luckily, this set is intact.

Main Floor, Dining Room

Most days, the family would eat in the kitchen around the big table in there. This room would be for guests and special occasions. The museum has set the table for tea, which was a popular way of socializing, especially in winter.

Imagine that you are living on the farm. It's cold. It's snowing. You don't have a car. You don't have a phone. For weeks at a time, the only

people you see are other members of your family, and it drives you crazy, so on Sunday afternoons particularly, you want to visit your neighbours. You want to drop in and say "hello," and you always want to be ready in case they drop in on you, so during the week you bake a cake.

Tea itself was extremely expensive. Today oil makes the economy go around. In the nineteenth century it was tea and sugar, the basic commodities. Tea was so valuable that you kept it locked in a box, and you could make a big show of opening the box to show that you were going to spend all this money.

A few items in this room belonged to the Gibsons. One is the buffet sideboard, made by a local furniture maker, a copy of a famous European design, and very nicely done. The soup tureen is also a Gibson original. Ceramics don't usually survive. In the corner is the clock that Mrs. Gibson saved from the fire. She didn't take the whole clock, just grabbed all the workings from the top, and afterward they had a new case built.

On the wall is a copy of a pledge the Gibsons signed saying they would be moderate in their consumption of alcohol. They were active in the Temperance movement, trying to get other people to stop drinking so much. In the colonies, drinking was a terrible problem. The water supply was seen as unsafe to drink. Nobody drank water. Everybody drank whiskey and beer instead. Much of Toronto was built on the brewing and distilling of beer and whiskey.

At the table, people ate mostly with their knife. You would use the knife and fork to cut the food, then bring the food to your mouth on the edge of your knife, something that today we would consider rude.

Main Floor, Kitchen

The hearth is really the heart of the house. Mrs. Gibson would get up early and start cooking breakfast. Two hours into the day she would serve it, because in the 1850s you would have to earn your breakfast. You would eat after starting your chores. The rest of the morning Mrs. Gibson might spend cleaning, which also means heating water on the hearth, or she might do some baking or preserving.

Almost everything the Gibsons ate came off the farm, and they had to preserve things. The most important preservative was sugar, which came in a cone. Sugar cane was shipped to England from the Caribbean to be refined,

then it was shipped to Canada for use here. It was expensive. This two-pound cone cost the equivalent of $150 in today's money. The alternative was honey and maple sugar, both local and relatively cheap, and brown sugar, also made from sugar cane but much less refined. It did not have to go to England, so was much less expensive, but for preserving you needed white sugar.

Children would help in the kitchen and do other chores. From a young age they would carry water and chop wood. Everybody had quite a bit of work to do.

The dumb stove in David and Eliza's bedroom acts as a radiator, channelling heat from the parlour stove downstairs and spreading it over an expansive surface area. "You could also set a cup of tea on it, or a pair of socks to warm them up before going out on a cold day," says historical interpreter Liam Hanebury.

THOMAS RICHARDSON'S TALL-CASE CLOCK

By far the most valuable item in the Gibsons' home was their tall-case clock, better known today as a grandfather clock. It was hand-built and hand-painted, and through an elaborate array of hands, gears, escapements, and pendulums it kept track of seconds, minutes, hours, and days. "In the 1830s, it was the most sophisticated piece of technology you could

personally own," says Gibson House staff member and historian Michael Shelbourn. It was an item almost worth risking one's life for.

When Gibson fled Montgomery's Tavern on December 7, 1837, he rode east toward Oshawa with a price on his head. Lieutenant-Governor Sir Francis Bond Head ordered both the tavern and Gibson's wood-frame house, seven kilometres north, burned to the ground.

Gibson's grandson Erling Gibson picks up the story. Drawing from oral family history, he writes that as government militia closed in on the house, Gibson's wife, Eliza, wrapped their infant son in a blanket and placed him in a snowbank. She then ran back into the house for the clock. It was heavy. Lifting the entire piece out the door by herself proved out of the question. Instead, she reached inside and grabbed the clock face and inner workings, wrapped them in a second blanket, and shoved them into the snow next to the baby. Then she crawled into the snowbank herself.

"The soldiers shortly afterwards came and burned down the house," grandson Erling recounts in his diary. The baby in the snowbank was Erling's father, Peter Gibson.

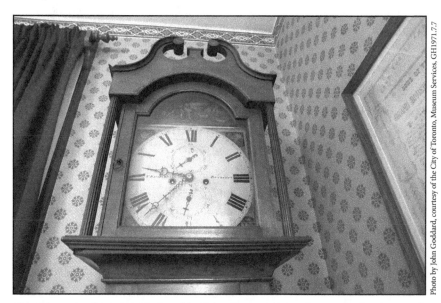

The Gibsons' tall-case clock, hand-built by Thomas Richardson in England around 1830, kept track of seconds, minutes, hours, and days. The replacement cherry-wood case from New York State partly obscures the coloured painting above the dial showing "Patie and Peggy," characters in the popular Scottish play, The Gentle Shepherd.

Photo by John Goddard, courtesy of the City of Toronto, Museum Services, GH1971.7.7

The account skips over several key details. It says nothing of the three other Gibson children born by then: Elizabeth, eight; James, six; and William, four. Maybe Eliza had already sent them ahead to safety. The account also fails to mention Gibson's surveying tools. At some point, Eliza also got them out of the house, knowing that if her husband survived he would need them for his work.

In any case, after government forces set the house on fire, Eliza and the children took refuge with the Cummer family, their neighbours to the north. For weeks, they waited to hear of David Gibson's fate. Finally, he got word to them that he was safe, and the family joined him across the border near Niagara in Lockport, New York.

Eliza brought the clock with her. In New York State, it acquired a new American-made case, and in 1848, when the Gibsons returned to North York, they repatriated the prized clock as well. It stands today in the far corner of the dining room.

An inscription inside identifies the clock's maker as Thomas Richardson of Brampton, northern England. Wishing to know more, the museum curators contacted an authority on historic clocks near Brampton named Tony Nuttall, of Cubria Clock Restoration. They also sent him photographs.

"It is typical of an England two train 8 day long case clock of the late Georgian period," Nuttall wrote back. A two-train clock of the period strikes a bell on the hour, "train" being the term for a series of meshing gears. An eight-day clock needs winding only once a week. A long-case, or tall-case, clock means it stands on its own. The late Georgian period covers the late 1700s to early 1800s.

Richardson worked as a clockmaker between 1790 and 1832, Nuttall said, and appears to have built the Gibsons' clock sometime around 1830. As Richardson was also a cabinetmaker, he would also have fashioned the original case. The dial he likely bought from Scotland. Nuttall especially praised the dial's details — the lacquer work, the waxing, the water-based ink numerals, and the application of gold and silver leaf.

"The net result is an opalescent feel to the art work," Nuttall wrote in his assessment.

In the arch above the dial, a coloured painting appears. It depicts a pastoral scene of a man, a woman, a sheep, and the words "Patie and

Peggy." The names refer to characters in one of Scotland's most popular eighteenth-century plays, *The Gentle Shepherd*, written by Allan Ramsay in 1725. Audiences loved the piece for its "harmony and poetry," as one contemporary critic put it, and for its authentic Scots vernacular.

Commenting on the new cherry-wood case, Nuttall called it "very New York State." He also noted the number of cuts and other adjustments needed to fit the clock parts into the new case. As though in appreciation of the care taken to preserve it, the clock still keeps time.

NEIGHBOURING ATTRACTIONS

David Gibson's Last Apple Tree

It looks as though lightning has struck at least once — the trunk is hollow — but the last surviving tree from David Gibson's 1832 apple orchard clings to life in a parkette on the north corner of Yonge Street and Park Home Avenue. A city arborist identifies the tree as a Tolman Sweet, a variety originating in the early 1800s on the U.S. Eastern Seaboard. "Yellowish skin, blushed with red," the arborist's report says. "Rich, sweet flavour. Best for dessert, cooking, and cider." Perhaps unnecessarily, he adds: "Long-lived tree." In the 1980s several cuttings from two of Gibson's last Tolman Sweets and one of his last Snow Apples grew into trees still gracing nearby Dempsey Park.

Zion Schoolhouse

Built in 1869 for the farm community of L'Amaroux, Zion Schoolhouse serves as a North York sister museum to Gibson House. School classes use the one-room building to conjure up student life in 1910, with an interpreter/guide dressed as the historical figure Miss Coulson. Through music, games, crafts, and spelling and arithmetic contests, each child plays the role of a pupil who attended the school. Zion Schoolhouse also opens to the general public several times a year, including at the annual spring event Doors Open Toronto. The school stands at 1091 Finch Avenue East, near Leslie Street.

TORONTO'S FIRST POST OFFICE

To collect or send mail, almost all leading and lesser figures of the capital of Upper Canada passed through this single entranceway. James Scott Howard opened the post office in late 1833, three months before the Town of York became the City of Toronto.

Address
260 Adelaide Street East.

Getting There by TTC
Take the subway to King Station. Either walk or take the street-car a short distance to Jarvis Street, then walk one block north to Adelaide Street East. Go one more block east. On the corner stands the Bank of Upper Canada. Beyond it, look for the handsome red-brick building flying the Union Jack.

THE FIRING OF JAMES SCOTT HOWARD

Anybody who has lost a job or been cruelly outmanoeuvred in the workplace can identify with Toronto's first postmaster, James Scott Howard. Diligent, conscientious, a man of impeccable uprightness and propriety, he saw his career shatter on the most baseless of innuendos at one of the most highly charged moments in the city's history. A rival who coveted Howard's position hinted at wrongdoing, and got him fired. When Howard protested, he hit a bureaucratic Catch-22: only an open inquiry could quash the rumours, but no inquiry could be granted without a formal accusation against him. Howard never stood a chance. Ultimately, the shadowy prejudices and self-interest of the ruling colonial elite, the Family Compact, conspired to deny justice to a man not part of the in-crowd.

"The best documented drama of the 1837 Rebellion," authors Sheldon and Judy Godfrey say of the Howard affair in their book *Stones, Bricks and History*.

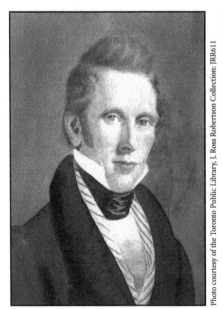

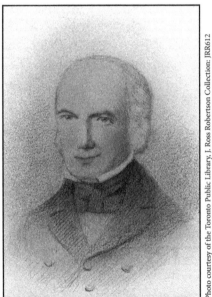

Photo courtesy of the Toronto Public Library, J. Ross Robertson Collection: JRR611

Photo courtesy of the Toronto Public Library, J. Ross Robertson Collection: JRR612

A watercolour from about 1835 shows James Scott Howard at his most prosperous — married with two children, his postal business booming.

Charles Berczy, shown circa 1850, served as Toronto's second postmaster, from 1837 to 1853. If Howard is the hero of the story, Berczy is the villain.

"He fought and fought and fought for a year and a half, and eventually lost his house and farm," says Janet Walters, director of Toronto's First Post Office.

Howard grew up in a staunch Methodist family in County Cork, Ireland, and arrived at York in 1819, when he was twenty-one. He found work as an assistant to William Allan, the customs collector, licences inspector, district treasurer, postmaster, and soon-to-be-named first president of the Bank of Upper Canada. In 1828 Howard took over from Allan in the postmaster role. Certain establishment figures, however, marked the young man as an outsider, a prejudice that was to hurt him later on.

"The Post Master here is a Methodist in whom I have no sort of confidence," the powerful Anglican cleric John Strachan wrote to a friend in 1830. "I am unwilling at times to shew [him] to who I correspond."

Howard enjoyed the job. Being York's postal chief also made him unofficial postmaster for all of Upper Canada. He answered directly to Deputy Postmaster-General Thomas Stayner in Quebec City, who in turn reported straight to London. Howard's duties included supervising other outlets in the colony and finding people to run new ones as they opened. In York alone, he had his hands full. The town was booming. In the five years from 1830 to 1834, the population was to more than triple — from 2,860 people to 9,252. To keep pace, Howard needed to expand his premises.

Postmasters in those days provided their own post office. When Howard first took the job, he worked from a log cabin, and subsequently opened a combined office and residence on George Street. In 1833, with his business still growing, he laid plans for a more substantial building on nearby Duke Street, now Adelaide Street East.

It was a distinguished location. To the east stood Chief Justice William Campbell's stately mansion. To the west rose the impregnable Bank of Upper Canada, keeper of the gold reserves, and financier to the colonial government and ruling elite. Halfway between the two, at an investment of £2,400, Howard erected a handsome three-storey brick building in a symmetrical Georgian design with twin entrances — residence to the right, post office to the left. It opened as York's fourth post office, and a year later, in 1834, became Toronto's first post office when civic leaders incorporated the Town of York as the City of Toronto.

In his personal appearance and comportment, Howard took care to project a sense of trust and political impartiality. He dressed in a well-tailored jacket and vest, sometimes with an olive frock coat. "[Howard] considered himself a neutral in politics, never voting or even going to public meetings," say the Godfreys in their book.

"He kept his nose clean," says museum director Walters.

In his relationship with ardent Reformer and soon-to-be rebel leader William Lyon Mackenzie, Howard took particular care. Every three months, as part of his obligations, he published notices in Mackenzie's *Colonial Advocate*, the town's top-circulation newspaper, listing the names of people who had mail waiting for them. Each time he did so, Howard studiously obtained prior permission from Stayner in Quebec City.

In 1835 Stayner offered Howard a promotion. The deputy post-master-general created the position of "surveyor," to formally oversee all post offices in Upper Canada, and invited Howard to take it. By then, however, Howard had a wife and two children. To allow the business to expand, they had moved out of the post office residence and built a country home, "Olive Grove," on a twelve-acre lot near where Yonge Street now intersects with St. Clair Avenue. Every day Howard commuted to work on horseback.

"Contented and unambitious, I felt settled in my office," he said later about why he turned the surveyor job down. "Relying upon the understood good faith of the British Government, Imperial and Provincial, I felt entitled to expect an enjoyment of my well-earned situation so long as I efficiently discharged its obligations."

The senior post went to Charles Berczy. If Howard is the hero of the story, Berczy is the villain. He was the son of William Berczy, who co-founded York with Lieutenant-Governor John Graves Simcoe and established the farming community of Markham, York's early breadbasket. The younger Berczy had been serving as postmaster in Amherstburg, near Windsor, and moved to Toronto to become Howard's superior.

Over the next two years a strain developed between the two men. Howard alludes to it in later correspondence, but never gives specifics. The 1837 Rebellion brought differences to a head. On Monday,

December 4, a rebel force intent on overrunning Toronto and establishing a democratic government amassed at Montgomery's Tavern on Yonge Street, north of what is now Eglinton Avenue. The Bank of Upper Canada ranked high on the list of rebel targets, both as a treasure vault and symbol of oppression. That first night, in separate encounters, a rebel shot and killed the government's Lieutenant-Colonel Robert Moodie as he rode into the city to warn of the attack, and a government loyalist shot and killed would-be rebel military commander Captain Anthony Anderson.

The next morning, Tuesday, December 5, Howard rode downtown into chaos. Blocks from the post office, where St. Lawrence Hall now stands, a loyalist militia was assembling. At the bank building, volunteers were rolling two nine-pound cannons into place, and in front of the bank a special military guard was organizing defences.

At noon Berczy showed up. He said he would be moving into the post office for a few days, and started opening some of the mail. Details are thin but an argument ensued, with Berczy saying that some of the letters looked suspicious — possibly pro-rebel — and Howard saying that opening mail is against the law. As he later documented, both British and colonial regulations prohibited postal employees from opening mail without authority from Quebec City or London.

Berczy let the matter drop. Both men had more pressing responsibilities. For the next several days, Howard worked almost non-stop as his staff dwindled to three, to two, to one, with only chief assistant John Ballard Jr. remaining on the job during the upheaval. Each night, Howard helped haul mailbags to the bank for safekeeping, and — like Berczy — slept in the post office rather than return home.

"During the disturbance and the excitement produced thereby, it was absolutely necessary for me to remain at my post in order to keep open the communications with the various parts of the country," Howard later wrote of those tense days in a published pamphlet, *A Statement of Facts Relative to the Dismissal of James S. Howard, Esq., Late Postmaster of the City of Toronto, U.C.*

"My ordinary duties were rendered much more arduous and perplexing from the confused state into which the contents of the office were thrown in their transfer to and from the Bank of Upper Canada,"

he also said of his assiduousness. "I vigilantly and carefully preserved all the property, so that out of the numerous letters and paper then in office it cannot be said that one was found missing."

On Thursday, December 7 — day four of the rebellion — while sorting through the morning mail, one letter in particular caught Howard's eye. It was addressed to him. The apparent writer was John Lesslie, postmaster at Dundas, near Hamilton, and a close friend of Mackenzie's. The two had emigrated from Scotland together, and had once opened a druggist shop together in Dundas. Howard was not expecting the letter, and something about the cover looked wrong. For some reason, he took it straight to Berczy, and invited Berczy to open it.

What was Howard thinking? In all his correspondence on the case over the next fifteen months, he never reveals why, if the letter looked suspicious, he gave it to the one person with whom he had tense relations and who exercised direct power over him. Maybe he thought that when he had stopped Berczy from opening the mail, he had looked like a man with something to hide. Maybe Howard wanted to prove his integrity.

In any case, Berczy opened the letter. To both men's surprise, despite appearances, the letter was not from John Lesslie and not written to Howard. Instead, it was meant for a brother, James Lesslie (also one of Mackenzie's closest lifelong friends), and sent by the youngest Lesslie brother, Joseph. Young Joseph, it turned out, had addressed the letter to Howard to help ensure its arrival at Toronto during the troubles. In the message itself, Joseph commented on the rebellion and made casual military observations, references later characterized by authorities as "seditious."

That same day, the immediate rebellion crisis ended. Tensions were to continue over the next four years, with clashes along the U.S. border and elsewhere, but that day government militiamen captured the rebel headquarters at Montgomery's Tavern, and Mackenzie was on the run.

Two days later, on Saturday, December 9, well-placed postal customers informed Howard that his loyalties were being questioned. Alarmed, he started the paper trail that eventually became his published pamphlet. At his first free moment, he wrote to Berczy saying he had heard "that I was either implicated in the calamitous and fearful events which have befallen our country and city within the past few days, or that my opinions were

of such a nature as to warrant such a suspicion." Such suggestions, he said, gave him a "painful state of feeling." To clear his name, he asked Berczy to arrange an investigation through the lieutenant-governor's office.

Berczy forwarded the memo to John Joseph, private secretary to Lieutenant-Governor Sir Francis Bond Head. The next day was Sunday. On Sundays the post office opened only in the morning for one hour, between nine and ten o'clock, and for the first time all week Howard rode home to spend time with his family.

On Monday, December 11, Howard asked to see Joseph's reply. Berczy read him "an extract," Howard later recalled, but it said little, and Berczy would not show him the whole thing. Five times Howard asked to see it and five times Berczy refused.

On Tuesday, December 12, Berczy approached Howard, put a hand on his shoulder, and said that the attorney general wanted him to know that there was no charge against him but that he "had associated too much with those people." Howard protested. An argument erupted.

"I continued to ask Mr. Berczy what was to be done in my case," Howard later recorded in his pamphlet. "At length [Berczy] became heated at my impatience to obtain investigation, and … burst forth into violent accusations. For instance he charged me with entertaining [Reform] opinions favourable to an elective Legislative Council — said that my son (between 10 and 11 years of age) read Mackenzie's and O'Grady's [Reform] papers rather than the others — ascribed to me an opinion that the Lieutenant Governor was a mere citizen, &c, &c."

On Wednesday, December 13, the axe fell. Berczy told Howard "with great sorrow" that he was out of a job. Shortly afterward, a note arrived from Government House confirming the news. "I have it in command to inform you," secretary Joseph wrote in full, "that His Excellency the Lieutenant Governor has thought proper to remove you from the Post Office at this place. Mr. Berczy has been directed to take charge of the office, for the present."

Howard turned to Berczy, saying somebody was out to get him and had been for some time. He did not accuse Berczy directly. "I said to Mr. Berczy, 'Sir, I am convinced this is a plot to deprive me of my office, and one of long standing, irrespective of the events of the last few days,'" Howard recalled. "He assured me of his innocence."

The now former postmaster mounted his horse and rode home up Yonge Street. He returned to his wife, Salome, and two children, Allan and Prudence, who had sustained their own traumas in the rebellion. On the first full day of hostilities, rebel leader Mackenzie had walked through their front door without knocking and demanded dinner for fifty of his men waiting outside. When Salome told him to speak to the servant, Mackenzie shook a horsewhip in Salome's face. The eyewitness account comes from the Howards' twelve-year-old son, Allan, retold in John Charles Dent's 1885 book *The Story of the Upper Canada Rebellion*. As Dent relates the story, Mackenzie denounced the postmaster and withdrew.

Howard was now thirty-nine years old. For eighteen years, he had worked for the Post Office, giving the department "the prime of his life," he said. For the next fifteen months, nursing a profound sense of injury, he petitioned one high official after another. He lobbied for an inquiry, intent on regaining his job. He wrote to Sir Francis Bond Head even as the lieutenant-governor packed his bags for England. He wrote to Thomas Stayner in Quebec City. He wrote to the head of the British Postal Service in London, the Earl of Litchfield, and to the British Colonial Secretary, Lord Glenelg. Some correspondence he copied to other people of influence, challenging the ghostly doubts and phantom complaints against him. The back-and-forth went something like this:

> Complaint: You received a "seditious" letter from Joseph Lesslie.

> Howard: Joseph Lesslie, "a mere youth," was never arrested or interrogated.

> Complaint: The letter was associated with former Mackenzie associates John Lesslie and James Lesslie.

> Howard: John and James Lesslie were questioned and released.

> Complaint: You stopped Charles Berczy from opening suspicious mail.

Howard: The law prohibits a postal official from opening mail without authority from Quebec City or London.

Complaint: You never publicly opposed the Reformers.

Howard: Postmasters are prohibited from voting and attending political meetings.

Complaint: Everybody you hired at the post office was a revolutionary.

Howard: Nobody was hired based on political affiliation, and no staff member has been formally suspected, let alone arrested.

Complaint: Your chief postal assistant, John Ballard, specifically harbours rebel sentiments.

Howard: Ballard was never questioned and continues to hold his job.

As a person who attached such importance to correctness and decency, Howard felt deeply wounded by any hint of impropriety. "The deepest stain has been inflicted upon [my] hitherto irreproachable character," he wrote in his petitions. Never before had anybody complained about his work, he said. In fact, he had been offered a senior promotion. Now he was dismissed "without an open charge against me, and without an investigation."

At the same time, a career in public service had left him poorly suited for other pursuits, Howard said. "I have no private profession," he wrote in one appeal. Worse, most of his capital was tied up in the postal building. With the economy in depression, selling it would have meant taking a steep loss. Without an income, he could not support his family, and without exoneration, he could not get another government job. His situation was "ruinous from every point of view," he wrote. His prospects in life were "completely blighted."

In his petitions, later published in his pamphlet, Howard never explicitly names Berczy as the one who did him in. "I can only conjecture myself to be the victim of some concealed individual who (possibly to obtain favour or office) has poisoned the ear of the Executive," the erstwhile postmaster wrote at one point. At another point he said: "By whom [the suspicions] were advanced, or by what testimony they were sustained, I had no means of ascertaining." Perhaps he was being discreet. Or perhaps he sensed a conspiracy that went beyond Berczy to implicate the wider Family Compact, the powerful political clique aligned with the Anglican Church that had so early pegged him as an outsider. Perhaps he sensed that the authorities wished to put in place one of their own.

"The big wigs are getting frightened out of their lives as they dread another Rebellion," Bank of Upper Canada manager Thomas Ridout wrote nearly a year after the initial uprising, capturing the tension that endured long after the first rebel skirmishes. "You can hardly imagine the alarm that exists," Ridout told his friend. "The Government are employing a number of rascally spies and a most infamous system is established."

"The ruling establishment," the Godfreys conclude in their book, "could not accept anything but supporters in the vicinity of the Bank of Upper Canada."

After six months of petitioning, Howard obtained an audience with the new lieutenant governor, Sir George Arthur. He dismissed all criticisms against Howard but lodged a new one of his own: During the rebellion, the postmaster had not taken up arms against the rebels. What Howard told Arthur is not recorded, but in September 1838 Howard wrote again to Colonial Secretary Glenelg in London explaining that he did not take up arms because:

- He was too near-sighted to "recognize an individual within a few yards distance";

- If he had gone home and confronted Mackenzie on the first day of hostilities, the rebels would have attacked him and his family, and destroyed their home;

- On December 7, Lieutenant-Governor Sir Francis Bond Head himself ordered him to remain on duty as postmaster;

- By British law, "Postmasters are exempted from militia duty"; and

- By Upper Canadian statute, postal duties were considered so essential as to also exempt postmasters from military duty.

But it was no use. The decision had been made: Howard would not get his job back. Arthur said no investigation was necessary because his predecessor, Sir Francis Bond Head, had put nothing against Howard on the record. With no black mark on the record, the lieutenant-governor also said, maybe Howard could get another government job.

"He informed me," Howard said of Arthur, "that ... I might not be considered disqualified to hold some other public situation." When Howard applied for the next vacancy, however, that of Inspector General, Arthur turned him down. By not taking up arms, Arthur repeated, Howard had "put it out of the power of His Excellency to encourage your expectation of returning to Her Majesty's service."

It was bureaucratic stonewalling at its most infuriating, but in all his appeals and protestations never once did Howard's faith in British justice slacken. Ironically for somebody accused of disloyalty, he ardently retained the belief that if he could only get a hearing he would be not only vindicated but also reinstated.

"By birth, by preference, by a sense of duty, by habit I am attached to the British crown, and have no fear of injustice from it," he told his superiors in London. "These injuries are inflicted upon me though a loyal subject and a faithful servant of my sovereign," he also wrote.

In March 1839, Howard put his case to the public in *A Statement of Facts Relative to the Dismissal of James S. Howard, Esq., Late Postmaster of the City of Toronto, U.C.* In his protracted struggle to be heard, he also went broke. He lost his house and farm. He found himself "driven ... to strange places and unknown pursuits to procure bread for my family." In 1842, however, colonial authorities tacitly accepted that he harboured no disloyal sentiments. They appointed him Treasurer of the Home District.

By then Charles Berczy had long since converted his acting-postmaster role into a permanent position. In 1853 he was succeeded by Joseph Lesslie, the man whose letter had precipitated Howard's troubles in the first place.

WALK-THROUGH

The Union Jack flies over the front entrance alongside the Canadian flag, reminding visitors of the building's colonial origins. Below the flags, ten replica letters spell "Post Office" and a sign on the door reads, "Post Office, City of Toronto, Duke Street, Near the Upper Canada Bank, James S. Howard — Postmaster." Howard opened the office in late 1833, three months before the town became a city. His successor, Charles Berczy, relocated the operation in early 1839, meaning that the red-brick building on Duke Street functioned as a post office for barely more than five years. In

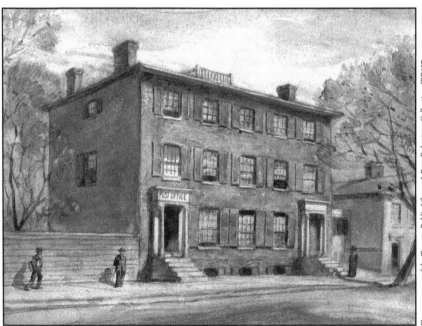

Photo courtesy of the Toronto Public Library, J. Ross Robertson Collection: JRR657

A watercolour based on an 1888 pen-and-ink drawing attributed to Owen Staples shows James Scott Howard's post office as it looked in the 1830s. The handsome brick building occupied a prominent location on Duke Street, now Adelaide Street East, midway between Chief Justice William Campbell's Georgian mansion and the Bank of Upper Canada.

that period, however, it served as Toronto's sole postal station. To collect or send mail, almost all leading and lesser figures of the colonial capital and its hinterland had to pass through this single entranceway.

Back Room

Toronto's First Post Office, a National Historic Site, operates today as a museum and functioning postal outlet. It occupies three rooms. To begin, walk directly to the back. A modest space features a topographical model of Toronto as it looked in 1837, the year William Lyon Mackenzie led his rebellion and Postmaster James Howard summarily lost his job. Notice the miniature Duke Street post office, with Sir William Campbell's brick mansion two doors east, and the greystone Bank of Upper Canada next door to the west. Toronto looks more like a country village than a city, with woodlots and wide-open spaces. Howard kept a cow in his yard.

Next to the installation lies the catalogue *Toronto 1837: A Model City*, which identifies each property. On the wall to the left, an enlarged repro-duction of an 1824 watercolour by architect John George Howard (no relation to the postmaster) shows Toronto's third Parliament Buildings, at Front and Simcoe Streets. To the right, illustrations can be seen of land-mark buildings, including the 1809 residence of William Warren Baldwin, credited with designing the Bank of Upper Canada. Later, at the time of the Types Riot, William Lyon Mackenzie, his family, and his *Colonial Advocate* press occupied the former Baldwin lot.

Reading Room

The middle room features tables, chairs, ink pots, and quill pens. If you were a farmer who spent the whole day riding to town to pick up mail, you would reply to a letter before returning home. If you were illiterate, you would ask the postal staff for help. For a small fee, today's visitors can write a letter with a quill, and seal the letter with authentic Scottish sealing wax.

Wall displays show various coins and writing materials used at the time. A map traces mail routes to Upper Canada. Portraits illustrate four central figures in the James Howard dismissal saga: the dashing postmaster himself, smartly dressed and a picture of rectitude; William Lyon Mackenzie, described here as "Upper Canada's great rebel";

Lieutenant-Governor Sir Francis Bond Head, who said he "thought proper" to fire Howard, giving no reason; and Charles Berczy, villain of the tale, who placed a consoling hand on Howard's shoulder, told him he was through, then took his job.

On the opposite wall can be seen international postal rates, stage-coach times, and an example of Howard's quarterly notices in Mackenzie's *Colonial Advocate*, letting scores of people throughout the district know that they had mail waiting for them.

Front Room

The museum doubles as a working Canada Post outlet, with a clerk serving customers at a replica of the original counter. To one side can be seen dozens of glass-fronted postal boxes of the type used by Toronto's original inhabitants, including bank manager Thomas Ridout from next door, and rebel leader Mackenzie himself.

The front room doubles as a gift shop selling, at rock-bottom prices, some of the best museum souvenirs in town. They include sealing wax from Waterstons of Edinburgh, which has also supplied the Bank of England since 1752. Items include vintage reproduction note cards and postcards from early Toronto, some featuring the post office in the 1830s. Buttons made with used stamps from around the world are for sale — "No two are the same!" — as are colour copies of Henrietta Sewell's 1827 letter to her brother Henry, or Hank.

A LETTER FROM HENRIETTA SEWELL

Five days before Christmas in 1827, the teenaged Henrietta Sewell of Quebec City wrote to her elder brother, Henry, at Oxford University in England. The letter survives both as a deft piece of calligraphy, and as a charming glimpse into elite British North American social life. Although the letter can claim no direct Toronto connection, it commands pride of place among artifacts at the only Canadian museum dedicated to pre-Confederation postal history. For a small fee, the clerk at Toronto's First Post Office will sell you a high-quality colour copy of the letter, along with a printed transcription, with footnotes.

In an elegant, yet disciplined hand, nineteen-year-old Henrietta Sewell writes one line on top of another at right angles, sending news to her brother on December 20, 1827. The first line reads, "I am afraid my dear dear Hank from your silence that you accuse me of wilful neglect in not answering your kind letter a charge of which of all others I should most dislike to have proved against me."

In the letter, Henrietta comes across as lively and flirtatious. She is nineteen years old, from a patrician family. Her father, Jonathan Sewell, played the violin, spoke fluent French, and for thirty years served as Chief Justice of Lower Canada. Her mother, Henrietta Smith, could trace her pedigree to the *Mayflower* and to prominent families throughout the New England states. Daughter Henrietta grew up as one of fourteen children in a spacious Georgian-style home, still occupied at 87 Rue St. Louise, in what is now Old Quebec, near the Ramparts and the Plains of Abraham. At the close of 1827, she sat down to give Henry, or Hank, two years her senior, her latest news.

Janet Walters, director of Toronto's First Post Office, answers questions about the letter's highlights:

> Question: The letter looks so unusual, as if chickens walked all over it. What is going on?

> Walters: It's called cross-writing. It's really just writing one page on top of another page, at right angles. It's not

that rare. Susanna Moodie [author of *Roughing it in the Bush*, 1852] used to cross-write, and it was done to conserve both paper and postage. Those were the days when paper was made from cotton, and because we didn't grow cotton, most paper was made from cotton rags. It wasn't like the homemade rag paper you see now — quite lumpy and horrible. The paper was thin and delicate.

Question: Cross-writing also saved on postage?

Walters: To send a letter to England would have been about half a day's wages for the average person. That's for one sheet of paper. You didn't want to waste paper and you didn't want to pay the extra postage.

Question: The cross-writing looks so skillful. How could it not be rare?

Walters: I don't think it was difficult for them because they had such beautiful handwriting. Most people, most professionals, would have had two hands — a copperplate script that you see on deeds and invoices, very legible and a bit less freeform, and their letter-writing hand. And as freeform as this looks, everybody would have made their characters the same way. They would have been trained. An "f" was an "f" was an "f." They wrote from the shoulder. None of this putting your hand down on the desk. And they wrote in these incredibly straight lines, which is why the grid is so perfect. The skill is not so much in writing it as in reading it, but people did.

Question: Why is she so stingy with punctuation?

Walters: That probably has to do with the materials. You have to keep a quill moving, which means not stopping for little dots and commas. Eventually, pens got designed so that there had to be a sort of pull on the ink, but this was just falling down the crack of the nib. The ink is going to flow, and if you stop you get a blob. She's certainly not stingy on the words.

Question: Yes, she's amusing, isn't she?

Walters: She loves her big brother. She starts pleading for his profile, which was a silhouette. There were no photographs. You went in, you stood against a blank wall. They put a light on you and cut your silhouette out of a piece of paper. A lot of places could do this freehand — cut your profile from a piece of paper without drawing it first. It was a skill. So she starts begging for that, because she has asked him before — "I am now dear Henry going to give you a scolding so prepare yourself." Isn't she lovely? She is just so Jane Austen, and everybody is "Miss" or "Mr." or "Captain" or "Lord and Lady D." [Governor of Lower Canada Lord Dalhousie and his wife].

Question: What is she saying about the dangers of a house she visits? She gets invited to a dance and says, "My plan is to go at eleven and I think by that time it will be sufficiently tried."

Walters: She's nervous about it because the builder makes houses out of recycled building materials. Well, everybody did. I mean it's not like they wasted tumbled down bricks. Bricks would get reused, beams would get repurposed. I don't know if that builder had a reputation for shoddy work but here is a nineteen-year-old

girl going to a party at eleven o'clock at night, and that tells you something.

Question: What does it tell us?

Walters: People danced all the time and parties went all night. You pooled your resources. Light and heat were expensive. You would all be in one place, keep it bright, keep it warm, everybody together dancing. And the dances were like English country dances, where you were often waiting a long time for your twirly whirlies, which gave young people an opportunity to talk and flirt.

Question: She even mentions flirting: "If you should hear of any flirtation that is going on between a young lady by the name of Miss H. Sewell and an officer by the name of Brown I beg your nerves may not be startled for she had taken a great fancy to him and I think it will end in something serious."

Walters: Yes, she's got a crush on somebody, who seems to be a soldier, but she doesn't marry him. She marries a minister.

In 1837, at the age of twenty-nine, Henrietta Sewell married Francis James Lundy, or Frank. "A well educated Yorkshireman with a very fine singing voice and a love of music," their great-great-granddaughter Deborah Carroll writes of him for the family website; *www.robertsewell.ca/sewell.html*. In Quebec, Frank became ordained in the Church of England. The couple moved to Montreal, where he served as vice-principal of McGill College, now McGill University, and later to Niagara-on-the-Lake in Upper Canada. Tragically, in 1847, shortly after giving birth to her seventh child, Henrietta died at thirty-nine of puerperal fever, a bacterial infection often associated with childbirth.

NEIGHBOURING ATTRACTIONS

Bank of Upper Canada

The steps might look worn and cracked, and the front door is locked, but the Bank of Upper Canada of 1827 survives as one of York's earliest and most illustrious structures. In 1844, architect and city surveyor John George Howard (no relation to the postmaster) added the portico, a mammoth front porch with columns, and a roof topped by a grille railing. The feature "contributes to the restrained classicism of the building," says Parks Canada in its assessment of the bank's value as a National Historic Site. Credit for the survival of the bank, the post office, and a former Catholic school built between them in 1872 goes almost entirely to heritage enthusiasts Sheldon and Judy Godfrey. They write of all three sites in their beautifully designed book, *Stones, Bricks, and History: The Corner of "Duke and George."*

Paul Bishop's Houses

Paul Bishop flourished as early Toronto's foremost blacksmith, with a forge on Duke (Adelaide) Street, east of the post office at what is now Sherbourne Street. In 1842, on the southeast corner of Adelaide Street East and Sherbourne Street, he built two handsome semi-detached red-brick homes, which are still functional and protected under the Ontario Heritage Act.

Berczy Park

A few blocks southwest of the post office lies the small, triangular Berczy Park, behind the 1892 Gooderham flatiron building at Front and Church Streets. At the park's west end, under a tree, stands a rudimentary bronze sculpture of a man and woman sheltering two children between them. "A tender and beautiful tribute to the Berczy family and, by extension, a tribute to the concept of family everywhere," novelist Margaret Laurence once generously called it. A plaque dedicates the park and sculpture to York's co-founder William Berczy and his two sons. The elder son was William Bent Berczy, a member of Upper Canada's Legislative Assembly. The younger was Charles Albert Berczy, Toronto's second postmaster, and later first president of the Consumers' Gas Company, from 1847 to 1856.

THE GRANGE
(AT THE ART GALLERY OF ONTARIO)

Frank Gehry's renovation of the Art Gallery of Ontario looms over The Grange, built nearly two hundred years earlier, in 1817. A two-hectare city park occupies what was once the front lawn.

Address
317 Dundas Street West.

Getting There by TTC
By subway, get off at St. Patrick Station, and walk west on Dundas Street West three blocks to McCaul Street. The art gallery is on the left. By streetcar, the number 505 Dundas cars running east and west stop in front of the gallery. North-south 510 Spadina cars stop at Dundas Street West. From there walk three blocks east.

HOUSE OF PRIVILEGE, HOUSE OF THE PEOPLE

More than any other house in Toronto, The Grange testifies to the years when a tiny, colonial elite connected by blood and marriage — the Family Compact — dominated the government and judiciary. The Grange was home to the Boultons. On the Family Compact tree compiled by critic William Lyon Mackenzie, patriarch D'Arcy Boulton Sr. ranked No. 1. Below him appeared his four sons, the eldest of whom built The Grange. Below the sons appeared one of their brothers-in-law, John Beverley Robinson, followed by Robinson's brothers.

In a later analysis, Mackenzie listed the Family Compact slightly differently: "the Robinson branch, the Powell branch, the Jones branch, the Strachan branch, the Boulton twig," mocking the Boultons for their inferior power and influence. The dig implied no contradiction. Consistently, Mackenzie viewed the Boultons both as recipients of official largesse, and as particularly undeserving of it.

To understand The Grange means knowing a bit about the Boultons and their successors, from the building's construction in 1817 to its bequest as a public art gallery in 1910. The tale can be told in four phases, representing four distinct family combinations. All were headed by men, but the story's hero is an American woman who saved The Grange from creditors and turned it into what is now one of the brightest jewels in Toronto's cultural inheritance, the Art Gallery of Ontario, or AGO.

D'Arcy Boulton, Sr. (1759–1834) and Elizabeth Boulton, née Forster (1763–1827):

The first D'Arcy mostly predates The Grange, but he died in the house at seventy-five in 1834. He represents the Family Compact's first generation. He was born in England, studied law, became a businessman, went bankrupt, and, looking for a fresh start, immigrated to the United States with his wife and two boys. One account has him starting a school in Schenectady, New York. Another, cited by Mackenzie in his "Patrick Swift" chronicles, has him working as "assistant steersman of a Lake Champlain lumber raft." Both stories could be true, says John Lownsbrough, in *The Privileged Few: The Grange & Its People in Nineteenth Century Toronto*, published by the AGO in 1980, and a valuable source on all four Grange

periods. D'Arcy Sr. seems to have tried a few jobs, and concluded that life for him might be easier in Upper Canada than in a meritocracy such as the United States. "He would have … heard how sorely men of his background and education were needed [in Upper Canada]," Lownsbrough writes, "while such qualities seemed to count less amid the leveling strain of the new republic."

With his wife and now five children, D'Arcy Sr. arrived in Upper Canada in 1802, near present-day Prescott in eastern Ontario. He applied for and promptly received twelve hundred acres of Crown land. Afterward, other favours fell into his lap. Men educated in law were in such short supply that he was admitted to the bar by Order in Council, without a formal exam or articling period. When a boat went down with the solicitor general aboard, D'Arcy Sr. both got the man's job, and after a by-election took his seat in the Legislative Assembly. In 1814 D'Arcy Sr. rose to attorney general. Finally, in 1818, despite the lack of formal credentials, he landed a well-paid judgeship to which he had long aspired.

"How is Justice Boulton's speeches and addresses like saying Mass?" William Lyon Mackenzie once asked rhetorically in the *Colonial Advocate*. "Because nine-tenths of the audience don't understand their meaning."

D'Arcy Boulton, Jr. (1785–1846) and Sarah Anne Boulton, née Robinson (1789–1863):

Eldest son D'Arcy Jr. built The Grange. In terms of outward success, he was overshadowed by younger brother Henry John Boulton, a smart, ambitious man who rose steadily in prominence as a lawyer, politician, and judge. D'Arcy Jr. never matched Henry's talent, but he was still a Boulton, still a man of privilege.

D'Arcy Jr. was born in England, and became a lawyer. In 1808 he married into one of York's most prominent families, taking as his bride Sarah Anne Robinson, with whom he was to have eight children. Discovering that he did not like law, he switched careers. He opened a large grocery and dry goods business with his brother-in-law Peter Robinson, and gained a reputation as a cutthroat.

"Honest D'Arcy" became his sarcastic nickname, Lownsbrough says. "Boulton," said Peter Robinson, "has his thoughts so completely taken up

with his business that he has not time for the common civil offices of friendship. As to news and the common chit-chat of the town, you never get any from him."

At around the time his father filled the solicitor-general post tragically vacated by his predecessor, D'Arcy Jr. bought one hundred acres of forested land from the estate of the same drowned man. The property, northwest of York proper, stretched north from what is now Queen Street all the way to what is now Bloor Street. On it, in 1817, D'Arcy Jr. built one of the settlement's first brick mansions. While Campbell House counts as York's oldest surviving house, The Grange is older, but built outside the town limits.

"Simple, solid and not unhandsome," the building's restoration architect Peter John Stokes calls The Grange in his introduction to Lownsbrough's *The Privileged Few*. "It typifies the houses of the wealthy and influential of early York, in its classically inspired design and a rather local vernacular."

No likeness of D'Arcy Jr. survives, but the AGO owns a painting of his wife, Sarah Anne. It is from the early 1830s, and was painted by itinerant American portrait artist James Bowman, when Sarah Anne was in her early forties. It shows her as a beauty. Her cheeks are flushed, her smile confident. Her extraordinary black bonnet and gown, abundant with lace trimmings and other refinements, help flesh out her reputation as a talented society hostess.

"Sarah Anne Boulton had already [before The Grange] established a reputation within the York elite as a congenial hostess, whose bright smile and lively conversation put everybody at ease," Charlotte Gray writes in her essay, "At Home on The Grange," part of the 2001 AGO exhibition catalogue *House Guests: The Grange 1817 to Today*. "Now she intended to establish The Grange as one of the most prestigious homes in the colony. The Grange, she had decided, would cement the Boultons' pre-eminence within the political and social life of Upper Canada."

Although his business dealings did not always go well, D'Arcy Jr. obtained a sinecure as Auditor General of Land Patents, giving him access to inside government information and a profitable sideline in buying and selling land.

William Henry Boulton (1812–1874) and Harriet Boulton, née Dixon (1825–1909):

D'Arcy Jr.'s eldest son, William Boulton, took over The Grange on his father's death in 1846. By knocking down bedrooms and creating such party spaces as a second floor concert and assembly hall, he converted a home for a family of eight children to the residence of a socially engaged couple who would remain childless.

Like his father and grandfather, William studied law. He went on to form the partnership of Gamble and Boulton, and entered politics at both the municipal and provincial levels. "Something of a prankster and a bit of a blade," Lownsbrough says of William's performance as a long-time Toronto alderman. William enjoyed the rough and tumble of city politics. Four times, fellow aldermen selected him as Toronto's mayor, including in 1845, when he was the first to preside over a new city hall, now the Market Gallery. In the provincial assembly, his record was seen as less distinguished. At both levels, voters called him "Guzzling Billy" for drinking brandy while delivering speeches. He also enjoyed cricket and horse racing, coaching the Toronto Cricket Team and hosting a race-course on his property north of the house.

In 1846, on assuming responsibility for The Grange, William travelled to Boston and returned with a wife, Harriet Elizabeth Dixon. Her father was a Boston diplomat, her mother a wealthy heiress from an East India merchant family.

As a married man, William continued to be fun-loving and affable. He also ran into trouble with money. Complications from his legal representations for the Bank of Upper Canada left him liable for unexpected debts, and his law firm's bookkeeper vanished with embezzled funds. Creditors came calling, including several banks. He might have lost The Grange except that, at the time of his marriage, the title to the house and twenty immediate acres had been transferred to his wife's name.

"Harriet could sell the land during her lifetime and convey it by will to whomever she wished," Lownsbrough says. She was to convey it to the people of Toronto.

Goldwin Smith (1823–1910) and Harriet Boulton Smith, née Dixon (1825–1909):

William Boulton died in early 1874 at the age of sixty-one. A year and a half later, Harriet remarried. She was fifty years old. Her husband, English-born writer and intellectual Goldwin Smith, was fifty-two. It was his first marriage.

Where William had been gregarious, Smith was aloof and gloomy. Where William had never been much of a thinker, Smith proved cerebral and highbrow. Smith's biographer and former secretary, Arnold Haultain, summed up his subject as conflicted: "Goldwin Smith's character was depicted on his face — grim, thoughtful, disappointed, critical, resentful, tenacious, dogged, lofty, reserved, craving sympathy, yet loath to ask it, shyly looking for acquiescence, yet too proud and too reserved to divulge the search, determined yet distrustful — a warfare between the keenness of his intellect and the deficiency of his emotions, a warfare of which he himself was perhaps dimly aware."

Historian Ramsay Cook, in the *Dictionary of Canadian Biography*, took a lighter view of Smith and his suitability as a marriage partner: "[Harriet] was socially sophisticated and apparently utterly devoted to her austere husband who, in contrast to her first, spent his waking hours in reading, writing, and good talk."

Educated at Eton and Oxford, a former professor at Oxford and at Cornell University, in Ithica, New York, Smith at The Grange became a celebrated writer, journalist, and commentator. He thrived as a public intellectual. In retrospect, his writings suffer from an underlying arrogance, and a pronounced anti-Semitism, but he made an enduring contribution to The Grange. In 1885 he built an addition to serve as his writing room — a grand library with a ceiling nearly two storeys high.

Harriet left a far scantier record of herself. No diaries or letters have been found. Occasionally she turns up in the archived pages of the weekly newspaper *Saturday Night*, attending social events and referred to as an excellent hostess, says Grange coordinator Jennifer Rieger, "but you don't see her as a big cultural player in the city."

Not a player, but in 1902 she proved open to a suggestion. Financier and arts champion Sir Edmund Walker asked if she might bequeath The Grange as an art museum after her death and that of her husband.

The front lawns would become a public park. Harriet modestly agreed. The American heiress ceded the former symbol of the Family Compact as an art gallery open to the public, stipulating only that no announcement of her gift be made during her lifetime.

In 1909 she died at the age of eighty-four. In 1910 her husband followed at eighty-six. In 1913 the Toronto Art Museum opened with the Boulton-Smith art collection as its first exhibition.

WALK-THROUGH

It was never intended that The Grange be the art gallery. The plan was always to let the gallery grow from The Grange, as it has in stages over the past century. In 2008 the Art Gallery of Ontario underwent its most ambitious expansion yet, a transformative redesign by Toronto-born architect Frank Gehry.

To reach the house, a National Historic Site, start from the AGO lobby off Dundas Street West. At the admission point, proceed straight ahead — across Walker Court into a room of European paintings. Pause to admire the room's centrepiece, a 1621 marble sculpture of Pope Gregory XV by Gian Lorenzo Bernini. Continue into the Joey and Toby Tanenbaum Sculpture Atrium. On the far side of the atrium to the left, an opening leads to a short bridge, and to a doorway knocked through The Grange's back wall, an entrance never contemplated by the home's 1817 builders.

Rear-Wall Entrance
Two artworks immediately present themselves. To the left appears a bust of the teenaged Harriet Dixon, who was to become the last private owner of The Grange. When she was young, she lived in Europe for a time as the daughter of Boston's diplomatic consul to the Netherlands. On a trip to Rome, bright-eyed and eager, she sat for an Italian sculptor named Camillo Pirstrucci.

To the right of the entrance hangs a painting titled *The Three Robinson Sisters*, a family treasure. The first people to live at The Grange were D'Arcy Boulton Jr. and his wife Sarah Anne Boulton, neé Robinson. Her older brother was John Beverly Robinson, one of Upper Canada's

Photo by Sean Weaver © 2014 Art Gallery of Ontario

The Three Robinson Sisters, *by George Theodore Berthon, shows Sarah Anne Boulton's three nieces — Augusta in black, Louisa in pale blue-grey, and Emily in pink at the right. Louisa and Emily, soon to be married in a double ceremony, wear their wedding gowns.*

most powerful political and legal figures. The painting shows three of Robinson's daughters — Sarah Anne's nieces — at a pivotal moment in their lives. Augusta, on the left, is already married. Louisa, centre, and Emily are about to be married in a double ceremony. Augusta's husband and the two fiancés commissioned Toronto's high-society portrait artist George Theodore Berthon to paint the portrait of the three sisters.

In the painting, all three women sport the same hairstyle, parted at the centre, with cascading ringlets framing the face on either side. The three also present the same bored, aristocratic expression of young women waiting for life to begin. They wear their best gowns, two of them their wedding gowns — Augusta in black, Louisa in pale blue-grey, Emily in pink. Emily also wears a religious bracelet around the left wrist, and casually holds a prayer book against her lap. After the wedding on April 16, 1846, their parents, the Robinsons, returned home to find the portrait waiting as a surprise in their front hall.

All three sisters were said to have married well, in terms of social position. Augusta married a son of John Strachan, one of the colony's leaders as head of the Anglican Church. Louisa married George William Allan, who was to bequeath Allan Gardens to the city. He was the son of William Allan, the ubiquitous government official who witnessed the smashing of William Lyon Mackenzie's presses and helped preside over the Types Trial. Emily married John Henry Lefroy, a renowned northern explorer and scientist. After their double wedding, Louisa, Emily, and their husbands honeymooned together in Europe.

Front Hall

Walk from the sisters' portrait to the solid front door, with its luminous side windows and fan window above. Turn around and face the wide hall. To the left lies the dining room that comfortably seated fourteen people in the early 1800s, and now serves light meals, wine, and beer to AGO members as part of their lounge privileges. Notice the original black walnut baseboards, fashioned in 1817 from trees felled to clear land for the house, and the original matching sideboards on either side of the brick fireplace.

To the right of the front door lies the drawing room, now the AGO members' lounge. It is also trimmed with black walnut, and also has a

fireplace, but otherwise the room is asymmetrical, breaking the rules for a formal Georgian house. Renovations in the 1840s explain the anomaly. The second owners, William and Harriet, extended the drawing room back into a former hallway. They aligned their ornate 1840s ceiling rosette with the new centre of the enlarged room, throwing it out of line with the fireplace. Ask to see the phantom doorway that William and Harriet abandoned.

Spiral Staircase

Rather than rebuild the angular 1840s stairway preferred by William and Harriet, restoration architects took liberties to create an elegant, spiraling structure that adds drama to the hall and lends prominence to a large window of etched and painted glass. The window, installed by William and Harriet as part of their 1840s renovations, features the droll Boulton family crest. An arrow, or "bolt," from a crossbow pierces a whale-oil barrel, or "tun." Bolt-tun — get it? Below the illustration runs the motto *Dux vitae ratio*, or "The guide to life is reason."

The upstairs floor is closed to visitors. Offices now occupy space once given over to the many bedrooms of the D'Arcy Boulton Jr. family of eight children, and which the second owners used partly as a ballroom. A third-floor attic served as servants' quarters.

West Wing Addition, 1840s

Along the ground-floor corridor, you pass a former butler's pantry on the right. AGO staff members use the room as a modern kitchen to serve patrons in the dining room and lounge. Farther along you come to an 1840s addition to the house possibly designed by family friend Henry Bowyer Lane, architect of the 1845 City Hall and nearby St. George the Martyr Church. The room provided an office for William, who served as a long-time city alderman, four times as Toronto's mayor, and for ten years as a member of the Legislative Assembly of the Province of Canada (present-day Ontario and Quebec). Ask to see his hidden vault, installed partly as a money safe, partly to protect documents in case of fire.

On the wall hangs a portrait of William's wife, the former Harriet Dixon, looking more formidable and less saucy than in her bridal portrait hanging in the AGO (See: Four Paintings).

The Grange foyer, with its spiral staircase and hand-painted window, now serves as the entrance to the AGO membership lounge. The bust at the lower left shows a bright-eyed and eager Harriet Dixon as she sat for Italian sculptor Camillo Pirstrucci on a trip to Rome.

Elsewhere on the walls, curator/coordinator Jennifer Rieger packs in a sweeping history of The Grange in text and pictures, from the people who resided here, to the development of early Toronto's artistic community, to the growth of nearby neighbourhoods, including the hideous slum just west of The Grange known as "the Ward." Other highlights include architectural designs for AGO buildings never built and an image of Mr. Chin, a servant at The Grange for more than fifty years.

West Wing Addition, 1885

Boulton's office apparently did not suit Harriet's second husband, writer and intellectual Goldwin Smith. It was too small. In 1885 he added a library, or what guides sometimes call a "man cave." From outside the house, the addition looks like a two-storey structure, nearly matching the height of William's office wing and the upstairs rooms added in the 1840s. Inside, however, the library ceiling soars to the addition's full height. The library is one big room, with a fireplace at one end and bookshelves climbing the high walls. Along the highest shelves run framed colour reproductions of scenes from Smith's childhood home of Reading, England, replicating part of Smith's original art collection. A large billiard table, typically covered with books and papers, once occupied the centre of the room. At his death, Smith donated his books to the AGO and University of Toronto. Anybody wishing to thumb through the volumes currently on the shelves is welcome to do so.

In this room, Smith did his most serious thinking, composed his works, and received friends. His writing table faced a south window. A replica occupies the space now, but his original chair remains. At an adjoining table sat Smith's secretary and eventual biographer, Arnold Haultain, author of *Goldwin Smith: His Life and Opinions*, published in 1914.

Two busts of Smith stand near the windows. One is by Scottish sculptor Alexander Munro, fashioned when the subject was young, the other by an English-born Canadian sculptor, Hamilton Plantagenet MacCarthy, commissioned when Smith was older.

Notice the fireplace. The Latin inscription in the carved woodwork comes from the Roman philosopher Cicero: *Magna vis veritatis que facile se per se ipsa defendat*, meaning, "Great is the power of truth, which can easily defend itself by its own force." The Victorian Minton tiles around the grate depict scenes from the works of Shakespeare.

Above the mantel hangs an enormous portrait, by Toronto painter J.W.L. Forster, showing a white-haired Smith propping his head against his right hand and looking resolutely dour. The expression fits Haultain's description of Smith's character: "Grim, thoughtful, disappointed, critical, resentful, tenacious, dogged, lofty, reserved, craving sympathy."

When Smith lived in the house, it did not have electricity. He wrote and read by kerosene lamp. Late in life, reaching to extinguish the lamp beside his bed, he tumbled to the floor and broke his hip, precipitating complications that led to his death in 1910, at the age of eighty-six.

Basement Kitchens

A steep staircase leads to the original basement kitchens. The open hearth and brick bake oven from 1817 still function, although cooks now pick their demonstration days carefully. The 2008 AGO redesign by architect Frank Gehry, what gallery staff call "the Transformation," includes a five-storey south wing with air intakes near The Grange kitchen chimney. The first cooking session after the reopening surprised everybody. "It was a very still day outside, the air intakes were wide open, and we smoked out the entire gallery," says Grange coordinator Rieger.

The slow-food movement, the seasonal-food movement, and the local-food movement all contribute to a renewed interest in historic kitchens, Rieger says. At The Grange in the early nineteenth century, preparing a fancy dinner would require enormous effort. Cooks made many courses, each with many dishes. Even ingredients would be made from scratch. To make a cake, a cook would not just measure a cup of sugar, she would first hammer a solid sugar cone. She would grate nutmeg from the nut and sift flour to remove the bran.

AGO chefs for the members' dining room and the public restaurant, FRANK, tend to cook seasonally and locally, Rieger says. They also make preserves and keep them where the Boultons' and Smiths' cooks kept theirs. You can see the jars lining the pantry shelves, not as historic artifacts, but as condiments and desserts ready for the table.

William's 1840s office addition also enlarged the basement, which included a wine cellar, an early type of refrigeration or "cold" room, and a sizeable "servants' hall," where servants took their meals together and presumably worked out their differences below stairs.

Special Notes

Admission to the Art Gallery of Ontario also gets you into The Grange. AGO visitors are free to wander into The Grange's hallways to view *The Three Robinson Sisters* and the bust of Harriet as a teenager in Rome. They may also visit the anteroom, William Boulton's former office, to see displays on The Grange and the AGO. Tours of the Goldwin Smith library and the original basement kitchens, led by volunteers, begin at the main-floor staircase every hour on the hour from noon until four o'clock, Tuesday to Sunday, and from six o'clock to eight o'clock on Wednesdays. The museum is closed Mondays.

The Grange drawing room and dining room serve as AGO members' areas, meaning that an AGO member can freely visit The Grange any time between noon and five o'clock, Tuesday to Sunday. With membership also comes unlimited free admission to the collections and to all special exhibitions.

FOUR PAINTINGS

Four paintings of particular interest to Grange visitors hang on permanent display in the Art Gallery of Ontario.

Portrait of Mrs. William Henry Boulton (Harriette), 1846.

In fact, Harriet spelled her name with one "t" and one "e." She looks pretty with her slim waist, big oval eyes, and plump little mouth, but her head is cocked back at a skeptical, almost sardonic, angle. It is an odd pose for one's wedding day. The work is that of Vienna-born George Theodore Berthon, son of the court painter to Napoleon Bonaparte. The younger Berthon trained in Paris and London, and by 1845 had established himself as the portrait artist to Toronto's high society, painting the likes of Bishop John Strachan and Chief Justice John Beverley Robinson. Berthon also painted *The Three Robinson Sisters* at the entrance to The Grange. The portrait of Harriet can be found in the Margaret Godsoe Gallery, gallery 237 on the AGO floor plan.

Portrait of William Henry Boulton, 1946.

It is hard to take William seriously after seeing this portrait of him in his black silk stockings, frilly sleeves, and white lace exploding out of his chest. All that and his self-satisfied expression make him the poster boy for Family Compact Sense of Entitlement. The painting, also by Berthon and found next to Harriet's portrait, was commissioned to depict William as mayor of Toronto. Writing in the *Dictionary of Canadian Biography*, Carol Lowrey describes the work as "one of the foremost examples of the grand manner tradition in Canadian portraiture." It is characterized, she says, "by tight brushwork, crisp delineation of forms, and fresh, clear colour — hallmarks of French neo-classicism."

The Academy, 2008.

In this fanciful work by Cree artist Kent Monkman, William and Harriet step out of their respective Berthon portraits to join a cast of characters from other AGO paintings on permanent display. "Of both Aboriginal and European ancestry, I created the Academy to muse on the convergence of artistic traditions from Aboriginal and Western cultures," Monkman said of the work in a paper to the AGO. The painting hangs in gallery 238.

Photo by John Goddard

An AGO patron eyes William Henry Boulton, as portrayed in 1846 by high-society Toronto artist George Theodore Berthon. That same year, Berthon also captured Boulton's bride, Harriet, with her head cocked at a skeptical angle.

The Surveyor: Portrait of Captain John Henry Lefroy, circa 1845, also known as *Scene in the Northwest.*

Lefroy married Emily Robinson, one of the women portrayed in *The Three Robinson Sisters,* making him D'Arcy Boulton Jr. and Sarah Anne's nephew-in-law. The painting depicts Lefroy in the Canadian wilderness one year before the wedding, dressed in red leggings, snowshoes, and other fashionable accessories. Professionally, Lefroy distinguished himself as a pioneer in the study of the earth's magnetism. In 1843 he left Montreal on an eight-thousand-kilometre journey to record magnetic readings, travelling as far north as Fort Good Hope on the Mackenzie River near the Arctic Circle. The portrait, by Canadian artist Paul Kane, went up for auction in 2002 after remaining in the Lefroy family for decades. The late billionaire Roy Thomson paid $5,062,500 for it, a price that more than doubled the previous record for a Canadian painting. Thomson donated it to the AGO. It hangs in gallery 206.

NEIGHBOURING ATTRACTIONS

Grange Park

The two-hectare city park occupies what was once The Grange's front lawn. From here, if you ignore the giant blue wall and protruding staircase rising behind the house, you view The Grange as York's visiting elite once did. Near the front door, now locked, two national historic plaques tell of the home and its last resident, the journalist and intellectual Goldwin Smith. When Smith died in 1910, and the art museum inherited the property, planners extended the art galleries behind the home rather than over the front lawn, even though doing so meant expropriating homes along Dundas Street West. A third plaque is dedicated to Sir Edmund Walker, a former bank president and art lover, and founder of the Art Gallery of Ontario.

St. George the Martyr Church

At the southeast end of Grange Park rises the spire of a gothic-style 1845 church designed by architect Henry Bower Lane. D'Arcy Boulton Jr. donated the land. Except for the spire, the church burned down in 1955, replaced in 1987 by a complex of buildings and a cloistered garden. The current church

doubles as home to the Music Gallery, self-described as "Toronto's centre for the creation, development and performance of art music from all genres."

Sharp Centre for Design

"Courageous, bold and just a little insane," said the judges who honoured British architect Will Alsop with the Royal Institute of British Architects Worldwide Award in 2004, for what is popularly called "the Tabletop Building." If the Boultons were to walk out of their front door today, they would see the seemingly airborne structure to their immediate left, on McCaul Street, supported by twelve multi-coloured legs resembling sketch pencils. The building forms the centrepiece of the Ontario College of Art and Design, which in its early days rented space in The Grange.

THE MARKET GALLERY

The outline of Toronto's first purpose-built city hall appears on the barn-like exterior of the St. Lawrence Market. Mayor William Henry Boulton, owner of The Grange, presided over the city council's first meeting in the new chamber on Monday, October 27, 1845.

Address
95 Front Street East, Second Floor.

Getting There by TTC
From King subway station, take the eastbound streetcar or walk east to Jarvis Street. Walk one block south to Jarvis and Front Streets. At the building marked "St. Lawrence Market," enter the main double doors and take the stairs or elevator to the second-floor Market Gallery.

TORONTO'S PHANTOM CITY HALL

You could shop at St. Lawrence Market for years and not notice. On the front façade, a pattern of red and cream-coloured bricks suggests an embedded older structure. The effect is subtle. The shape looks almost intended to brighten an otherwise dull, barn-like expanse of wall. Walk into the market's interior and look back, however, and you clearly see the earlier building. It is the remains of Toronto's first purpose-built city hall.

In 1834, when the Town of York became the City of Toronto, the first civic elections were held. The first council chose the first mayor — William Lyon Mackenzie — and found meeting space in the existing market building at King and Jarvis Streets, where St. Lawrence Hall now stands. As the city grew, so did the administration's need for its own home. In Toronto's first ten years, the population nearly tripled to more than twenty-four thousand residents from nine thousand. The administration needed a city hall, and architect Henry Bowyer Lane won the commission to design one.

Walk through the market's main entrance and look back, and you clearly see Henry Bowyer Lane's former city hall chamber. Its large south-facing fan windows now offer a bird's-eye view of the bustling market stalls below.

Lane is mostly remembered now for his churches. He designed Little Trinity Church, built in 1844 on King Street East, St. George the Martyr Church, erected in 1845 near The Grange, and the Church of the Holy Trinity, constructed in 1847 next to the site now occupied by the Toronto Eaton Centre.

For his city hall, Lane conceived of a dominant central block with east and west wings. The second and third floors of the block he devoted to the council chamber, an impressively lofty room with a balcony as the public gallery. Large south-facing fan windows looked out to Lake Ontario. Waves practically lapped against the building's south end until, years later, construction crews filled in the lakeshore for railway yards.

A decorative pediment and cupola topped the central block, and an imposing square portico framed the main entrance. Police Station No. 1 occupied the street floor. A lockup claimed the basement. The east and west wings provided office space for the mayor, city treasurer, city engineer, city clerk and his assistants, the general inspector of licences, and other municipal staff. Retail shops lined the street floor. The two wings also extended south to partly enclose a large open-air fruit, grain, and vegetable market that served as the city's main food terminal.

"In the old days every house in the city used to send for their vegetables to this market," writes John Ross Robertson in his seminal 1894 work, *Landmarks of Toronto*.

On Monday, October 27, 1845, city council held its first meeting in its new chamber. Presiding from the mayor's chair was William Henry Boulton, owner of The Grange, a longtime alderman who also served four one-year mayoralty terms in 1845, 1846, 1847, and 1858.

"As mayor he was himself a colourful figure with varied interests," historian Hereward Senior writes of Boulton in the *Dictionary of Canadian Biography*. He once ended a debate about his mayor's salary — whether it should be £400 or £450 — by telling council to use the money instead to pave streets in poor neighbourhoods. Money matters seemed not to concern him. Another time, he lavishly entertained the visiting Governor-General Lord Elgin, spending £120 of city funds on triumphal street arches without authorization.

The first purpose-built city hall served for fifty-four years. By 1899, however, the city had swelled to two hundred thousand people, renewing

the demand for civic office space and prompting a move to a massive new building at Queen and Bay Streets, now known as Old City Hall.

The Front Street building was to be torn down, and a fully covered market built in its place. Why any of Lane's central block was saved is not entirely clear. Engineers perhaps needed it for structural support. In any case, the new St. Lawrence Market opened in 1902, with the former council chamber and balcony retained, but left vacant and boarded up.

Only during renovations in the 1970s was the former city hall rediscovered. Debate about a possible use for it began, and in 1979 the space reopened for the first time in eighty years as the Market Gallery, dedicated to exhibitions celebrating the art, culture, and history of Toronto.

Scores of shows have been mounted since. Photo exhibitions have showcased the work of Arthur Goss, the city's prolific official photographer of the early twentieth century, and of William James, whose career spanned roughly the same period. Sometimes collaborations take place. Toronto's First Post Office once presented "Over Any Distance Imaginable," illustrating the importance of letters to long-distance communication in the 1830s. The archival centre Dance Collection Danse produced "Dancing Through Time," exploring the development of the city's dance scene from 1900 to 1980 through costumes, photos, playbills, and other artifacts. In 2005 guest curator Andrew Hunter opened his exhibition of eighteen Rebellion Boxes, titled "Heart-Shaped Box: A Poetic Reflection on the Rebellion of 1837."

As for the original council chamber, its grandeur has been compromised, but some of its charm remains. The two-storey room with its vaulted ceiling and balcony now divide into two separate floors. The top one serves as administration space and houses a climate-controlled vault for the city's art collection.

The lower one, the former council floor, functions as the exhibition gallery. Though renovated with modern materials, it retains an airy, heritage feel, with its dark wooden floorboards and a ceiling still high by today's standards. Henry Bowyer Lane's large south-facing fan windows remain in place, now offering a bird's-eye view of the bustling market stalls below.

MAYOR NED CLARKE'S LEATHER CHAIR

Exhibitions come and go, but one artifact stays permanently on display. It is the mayor's chair used from 1845, when the room first opened as the City Council Chamber, to 1892, when elected colleagues presented the chair as a unique retirement gift to Mayor Edward Frederick Clarke.

"Ned" Clarke, as he was known, established a solid political following in the 1880s as publisher of the *Orange Sentinel*, mouthpiece of Toronto's Orange Order, the Protestant organization that flourished as Upper Canada's leading social institution for decades. In 1886 he won a seat in the Ontario legislature as member for Toronto. Two years after that, while continuing to sit provincially, he ran as the Conservative-backed candidate for Toronto mayor. His nomination came from journalist and historian Goldwin Smith, by then ensconced at The Grange as husband to the widow of former mayor William Henry Boulton.

"Clarke's achievements as Mayor were outstanding," writes historian Victor Russell in his 1982 book *Mayors of Toronto*. As chief magistrate for four consecutive one-year terms, Clarke introduced modern business practices to city administration, strengthened the city solicitor's office by raising salaries, and spent ever-increasing amounts on bridges, sewers,

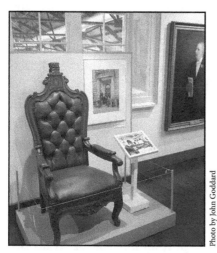

The mayor's chair, used from 1845 to 1892, remains on permanent display in the former city council chamber, now the Market Gallery.

An early version of the city's coat of arms shows a bare-chested man representing the Mississauga First Nation standing opposite the allegorical figure Britannia.

roads, and other public works essential to the growing city. On leaving municipal office, Clarke continued in provincial politics, and in 1894 won the federal seat of West Toronto, which he held until his death from an undisclosed illness at fifty-four in 1905. "The funeral in Toronto was attended by so many," Russell writes, "that even a move to a larger church could not accommodate the throng."

The mayor's chair is made of handsomely carved walnut, with red leather upholstery. High on the chair back, a panel displays an early version of the city's coat of arms. It shows a bare-chested man, representing the Mississauga First Nation, standing to one side. He carries a tomahawk in his right hand, wears two feathers in a headband, and leans his left arm on a longbow. To the other side stands Britannia, with her trident, metal helmet, and oval shield painted with a Union Jack. Between the two figures, a beaver hovers above a crest divided into four sections. Damage to the carving makes the crest symbols difficult to discern, but they appear to depict — clockwise from the first quarter — three lions, a second beaver, a steamship, and a sheaf of wheat. A banner flying beneath the crest reads, "Industry, Integrity, Intelligence," a motto said to have originated in 1834 with the first mayor, William Lyon Mackenzie.

Today's coat of arms bears no resemblance to the earlier one. Redesigned for the city's amalgamation with its suburbs in 1998, the current version features a beaver and bear facing each other on hind legs, drawn like children's storybook characters. Between them hovers an eagle, over a crest bearing a big blue "T" for "Toronto." Along the bottom a banner carries the multiculturalism slogan, "Diversity Our Strength."

Mayor Clarke's grandson donated the chair to the city in 1978 on behalf of the Clarke family. A historic photograph with the display shows the full council in session in 1899, shortly before it vacated the building for what is now called Old City Hall, on Queen Street West. Occupying the mayor's chair is John Shaw, bushy-faced with white muttonchops. On the wall to his left in the photo hangs a portrait of Ned Clarke, dressed formally in white tie and sporting a droopy moustache.

NEIGHBOURING ATTRACTIONS

St. Lawrence Market

Banners out front say, "No. 1 food market in the world: National Geographic." In 2012 an item in *National Geographic Traveler* listed what it said were the world's top ten food markets. The writer ranked St. Lucia's Castries Market third, New York's Union Square Greenmarket second, and Toronto's St. Lawrence Market first. While modern in health and safety standards, the place retains an old-fashioned neighbourliness that can be traced to York's original market square of 1803. In another retro touch, the market still closes on Sundays and Mondays. Peak market day is Saturday. Shoppers come for the fresh produce, cheese, meat, fish, and baked goods. Restaurant stalls sell everything from peameal bacon sandwiches to sushi. For raw-food eaters, CrudaCafé downstairs in the northeast corner sells lunch specials. Nearby can be found an organic grocery and a fruit-and-vegetable juice bar.

Main Entrance

"It's got quite a high ceiling and it's all hard surfaces, so there is a natural reverberation to the space," Celtic star Loreena McKennitt once said of the spacious entrance lobby. Between 1986 and 1989, with her enormous harp and cascading auburn hair, she played for change in the lobby on Saturday mornings from when it opened at six o'clock. "It became a very social thing," she once recalled. "I really loved meeting people week after week, a really diverse range of families and individuals."

On one wall, a permanent photo exhibition tells the history of the 1845 City Hall, worth a look before going upstairs.

Historic Plaque

On the outside front wall of what was then Toronto City Hall, a plaque by the Historic Sites and Monuments Board of Canada commemorates Canada's first telegraph transmission. A telegraph line capable of carrying messages in Morse code was laid in 1846 between Toronto, Hamilton, and Queenston, near Niagara Falls. On December 19 of that year, Toronto's mayor first used "this major development in communications," the plaque says, to send a message to the mayor of Hamilton. Toronto's mayor at the time was William Henry Boulton of The Grange.

North Market

Directly across the street, the "North Market" operates as a farmers' market on Saturdays and an antiques market on Sundays.

St. Lawrence Hall

Star soprano Jenny Lind, "the Swedish Nightingale," the greatest vocalist of her era, packed the third-floor ballroom for two shows on October 21 and 22, 1851. Fathers of Confederation John A. Macdonald and George Brown gave political speeches in the same room, known as the Great Hall. The National Ballet of Canada rehearsed in the hall for forty years, and on February 22, 1971, the Canadian music industry held its first Juno Awards in the same space. Gordon Lightfoot won top male vocalist for "If You Could Read My Mind," and Anne Murray won top female vocalist for her breakout hit "Snowbird."

The building, opened in 1850, stands one block north of St. Lawrence Market at King and Jarvis Streets. Sometimes the doors to the Great Hall are left unlocked. Go to the third floor, turn left at the top of the stairs, pass through a set of doors, and to your immediate right notice the twin set of unmarked double doors. They open to the Great Hall, one of the city's most peaceful and delightful rooms.

Gas Street Lamps

The four lamps in front of St. Lawrence Hall are replicas and not in use, but in the garden patio behind Biagio Ristorante, on the main floor of St. Lawrence Hall, two 1880 gas street lamps remain operational. Even on bright summer afternoons the restaurant keeps them lit.

St. James Park Victorian Garden

The Garden Club of Toronto maintains a lavish nineteenth-century-style garden across from St. Lawrence Hall in St. James Park. Benches, a central water fountain, and a plaque with a short poem titled "God's Garden" complement the scene. Most extraordinary of all, perhaps, an ornamental cast-iron drinking trough, the size of a bathtub, still stands ready to accommodate thirsty horses. An attached smaller basin once provided a cup on a chain for use by human passersby.

St. James Cathedral

Walk through the front doors, take an immediate left, and proceed to a room called the "West Porch." The bust peering imperiously down from the wall depicts John Strachan, one of York's and early Toronto's most powerful and influential figures and Toronto's first Anglican bishop.

COLBORNE LODGE

Based on the architectural style "Regency Picturesque," Colborne Lodge blends with its surroundings. Its modest profile, with a quirky three-pronged chimney, scarcely hints at the home's generous twenty-two-room capacity.

Address
Colborne Lodge Drive, High Park (south end).

Getting There by TTC
Take the Bloor/Danforth subway to High Park Station. Walk south through High Park, about twenty minutes. Or, from downtown, take the 501 Queen streetcar marked Humber/Long Branch to Colborne Lodge Drive. Walk a short distance up the road to Colborne Lodge.

JOHN HOWARD'S UNDERSTATED LEGACY

John George Howard, whose name now scarcely rings a bell, took extraordinary pains to be remembered. A prolific architect, surveyor, and engineer, he built much of early Toronto. He created some of the city's most imposing public buildings, designed many of its best homes, and laid out much of its initial infrastructure, including its first sidewalk — a wooden walkway along muddy King Street in 1834. An enthusiastic watercolour artist, he depicted the city with a view to posterity, painting such classic scenes as cows ambling past the downtown jail and fire hall and skaters amusing themselves on Lake Ontario. For his artworks he built a special gallery, which he bequeathed to the city along with his entire collection. To himself and his wife, he also erected a ten-tonne tomb, topped with marble hauled from Vermont, and encircled with an iron fence purchased at auction from St. Paul's Cathedral, London. Using his land holdings on Humber Bay, he created what is still the city's largest park, and donated his house for the park's use.

Few explicit signs, however, remain of Howard. A portico that he added in 1844 to the Bank of Upper Canada, at George Street and Adelaide Street East, can still be seen. St. John's Anglican Church from 1840 in York Mills also remains in use (with modern additions) near Yonge Street and Wilson Avenue. Anybody can also still walk his paths through St. James Cemetery, at Parliament Street and Bloor Street East. Otherwise, almost every building he designed has disappeared. His art gallery has long since been demolished. His architectural masterpiece, the Provincial Lunatic Asylum at 999 Queen Street West, came down in 1976. His park and museum remain, but he named them "High Park" and "Colborne Lodge," not "John Howard Park" and "Howard Lodge." A nearby street is called "Howard Park Avenue," which led to "Howard Park School" and "Howard Park Tennis Club," but there is no "John Howard" anything, no obvious branding of the Howard legacy. Even his burial monument goes largely ignored. It stands impregnably near the lodge, but off the main path, in a grove of trees. Some park maps do not even show it.

Howard left one further self-testament, a fascinating one yet possibly the most obscure. In 1885, five years before his death at the age of eighty-six, he wrote an autobiography. He called it *Incidents in the Life of John G.*

Howard, and in another nod to posterity gave a copy to the Toronto Public Library. Published on oversized paper with a hard cover, it runs to only thirty-six pages. Nearly half of it deals with his voyage to Upper Canada from England. Another third lists, by year, the buildings and projects he designed over a long career. The remainder tells of odd miscellaneous matters, such as a vacation in Paris and a long-held resentment toward his brother-in-law. Key biographical details go missing. He neglects to mention that, on arriving at York, he changed his name from "John Corby," saying instead that he was a direct descendent of the English nobleman Thomas Howard, the fourth Duke of Norfolk (1536–1572). He also leaves out that, during most of his childless marriage to his wife Jemima, he secretly kept a mistress with whom he had three children. Whatever its eccentricities and shortcomings, however, the memoir helps bring to life one of Toronto's most prolific builders, and one of its greatest early benefactors.

"Mr. Howard was born on the 27th of July, 1803," the book begins. In a few sentences, continuing in the third person, the author tells of attending school outside London and working as a teenage deckhand. He tells of

A jaunty enthusiasm for life radiates from John George Howard as he poses next to the type of classical-style pillar that inspired much of his work.

landing a job with a London architectural firm, marrying Jemima Frances Meikle when they were both twenty-four, and five years later booking a passage together on a vessel bound for British North America.

They missed it. Howard does not explain why. They rebooked and almost missed the second ship as well. They had taken their luggage aboard, but after hearing that the captain would not sail until evening they went shopping, during which time the ship left port.

"I ran down to the beach, and to my utter astonishment … she was sailing away at a rapid rate," Howard writes, switching to the first person. "We jumped into a boat, and gave the men five shillings. After an hour's hard rowing, we came up with the ship, and sailed on with a fine breeze."

The trip to York from London would take eleven weeks and three days — nearly three months — and Howard's account serves as a reminder of the many hardships early immigrants to North America commonly endured. At times the steerage passengers grew mutinous. Occasionally the captain and both mates got drunk. Once, the boom swung unexpectedly and nearly knocked several passengers into the sea, including Howard. "The captain caught hold of one of my legs just as I was going over," the author says.

One calm day, Howard boarded a rowboat with several other men to shoot birds. A breeze sprang up. "Looking round for the ship, we found that she had sailed at least five miles from us," he writes. The light breeze blew into a gale, and the men were nearly lost.

Later a storm arose in the Gulf of St. Lawrence. Again the captain and mates were drunk. A shipwreck against the rocks appeared inevitable, but Howard took charge, organizing an emergency crew and avoiding disaster. "I thank God he has given me confidence and a sort of presence of mind which enables me to act in time of danger," he writes, recognizing qualities in his character that were to resurface at moments of crisis in Upper Canada.

During the voyage, Howard turned twenty-nine. His whole life and career in the colony lay ahead. He spends the next two pages, however, complaining about his brother-in-law. Howard never identifies him by name, but Sidney Mountcastle and his wife Fanny — Jemima Howard's sister — had arrived in York ahead of them. Both couples planned to settle at Goderich, on Lake Huron, but took temporary quarters in York. On the Sunday before Christmas 1832, Sidney invited

Howard to go skating in the harbour, which had frozen solid. From the foot of Frederick Street, they began gliding toward the Gibraltar Point lighthouse, which still stands on the Toronto Islands. Sidney, the better skater, led the way. They passed a schooner frozen in the ice. Beyond it they saw something black. "A seal," Sidney called back. No seals live in the Great Lakes, but the men were new to the area.

"He pushed ahead very fast," Howard writes of Sidney, "and when he was about three hundred yards in advance of me the ice suddenly gave way, and he was struggling in the water."

Howard pulled off his skates, took off both his coats, tied them together, flattened himself outstretched on the ice, and somehow — after twenty minutes — helped Sidney pull himself from the numbing water. On reaching home, both went straight to bed. Howard dreamed that he was diving to the bottom of the lake to rescue Sidney.

"He has been dead several years," Howard writes resentfully, fifty years after the near-drowning, "but I may say that he never shewed any grateful feeling to me for the risk I had run on his account."

Sidney and Fanny Mountcastle moved to Goderich, and struggled financially for the rest of their lives. The Howards settled in York and prospered. For years Howard tried to persuade Sidney to relocate nearby, offering opportunities, partly to alleviate his wife's loneliness for her sister. Sidney stubbornly resisted, and the story of the pre-Christmas rescue seems to stand for a lifetime of the author's irritation toward his brother-in-law.

At York, Howard spent most of his first winter creating a portfolio of architectural drawings. In mid-March 1833 he presented them to Peter Robinson, the colony's chief immigration agent, who immediately noti-fied Government House. Professional architects in the colony were almost non-existent. The next day Lieutenant-Governor John Colborne hired Howard to teach drawing at Upper Canada College, an elite boys' school, and exhibited his designs at Government House to help establish him as an architect designing private homes and churches.

His career was set. Throughout the 1830s and 1840s, Howard became one of the busiest and most productive architects in Upper Canada. In 1834, when York became Toronto, Mayor William Lyon Mackenzie hired him as the city's first surveyor. "I put down the first 11-feet plank side-paths on King St.," Howard writes of one of his first projects.

He divided his time between teaching at UCC, working as the city's surveyor and engineer, and running his own architectural business, which included speculating in land, and building houses for himself to lease and sell. He designed homes, churches, offices, shops, and bridges. He helped lay out the city's landfill extension into Lake Ontario, and surveyed the new lands for railways.

In his autobiography, he lists every project. In 1833 he designed the Chewett Buildings, at the time York's largest structure, which included the British Coffee House hotel, where Union Station now stands. In 1840 he designed Toronto's third jail, replacing the terrible one that held the 1837 Rebellion prisoners. In 1842 he built the Victoria Row retail project on King Street, west of Church Street, and laid out St. James Cemetery at Parliament Street and Bloor Street East. Throughout the colony, he drew plans for private and public buildings — a church on Manitoulin Island, a villa at Brockville, a courthouse in Belleville. In 1846 his masterwork came under construction, the Provincial Lunatic Asylum in Toronto, a monumental building whose main façade Howard styled after the National Gallery in London.

After twenty years, he nearly dropped from exhaustion. "Being over-whelmed with business … I could get little or no sleep for six weeks," he writes of a particularly bad stretch in 1853. A doctor prescribed a vacation. Howard and his wife travelled to London via New York, a trip that took seventeen days, as opposed to their initial one of nearly three months. In London, he saw another doctor. "He examined me thoroughly," Howard writes, "and informed me that in reality I had no disease, but had been overworked." The doctor suggested respite on the Isle of Wight, but after a month Howard grew bored. He and Jemima moved to a hotel on the Rue de Rivoli in Paris, and on his fiftieth birthday, while touring Versailles, he tasted real champagne for the first time.

"Superb," he says.

Howard did not naturally aspire to high living. He never fancied himself an aristocrat, or sought political office, or otherwise made a move to join the ranks of the arriviste Robinsons, Boultons, Ridouts, and others of the colonial oligarchy, even though he knew them all, and built some of their homes. The closest he came to membership in the elite was to accept an appointment as Justice of the Peace and Associate Judge, sitting for four years on the bench with Chief Justice John Beverly Robinson.

Generally, Howard kept to more modest circles, and during his busiest years he kept to himself. In 1836 he designed a stucco retreat well west of the city on a hill overlooking Humber Bay. He named it Colborne Lodge, after the man who gave him his first break. While he also rented or owned various downtown residences over the years, the lodge served as the Howards' abiding refuge, and in 1855 they retired to the rural property. After adding to the house several times, they began to prepare their legacy.

"In 1873 I conveyed 120 acres of land to the corporation of the City of Toronto as a public park for ever," Howard writes in his memoir. "At my decease the corporation are to have Colborne Lodge and 45 acres more." He does not say so, but the agreement also gave him a lifetime pension of twelve hundred dollars a year.

In 1874 he built the tomb. Two years later the city made him the park's honorary Forest Ranger. One year after that Jemima died, and for another thirteen years, until his death, Howard cleared underbrush, surveyed paths and roads, painted watercolours of Grenadier Pond, built his picture gallery, and erected a train station at the lakeshore — "partly at my own expense," he says — to shelter park visitors waiting for the train home.

In 1890, at eighty-six, Howard died. Two episodes of his biographical portrait, however, cry out for elaboration. One concerns his role in the Upper Canada Rebellion, to which his memoir devotes a mere two sentences. The other concerns his unmentioned family.

Howard took an active role in the rebellion. He fought on the government side to defend the city, and proved a valuable asset. As he showed on his immigrant voyage, and on Lake Ontario with Sidney, he could be good in a crisis. He was also a good shot. The love of bird shooting that almost cost him his life on the Atlantic Ocean remained a lifelong passion. He often went shooting at Humber Bay, and had the dead birds stuffed for his collection. In his diary in late 1837, the experienced marksman tells of taking up arms against rebel leader William Lyon Mackenzie, the former mayor and his former boss.

"At ¼ to 9 I was going to [Upper Canada] College as usual when I met the boys returning who told me it was closed," Howard writes of the morning of Tuesday, December 5, 1837, the day the rebels first marched down Yonge Street from Montgomery's Tavern. He and Jemima were

living in the city then. He had heard that radicals had been organizing, and had heard bells the night before warning of an attack.

"I returned, had the pony saddled, and rode through the City to see what was going on," Howard writes in his diary. "I found the shops all shut, the market closed, and almost everyone in arms, expecting to be attacked. It was quite evident they would not attack the city before night, so I came back and got all my guns in order."

At one point a piece of news reached the city that unsettled Howard. Mackenzie was said to have stopped to burn Sheriff William Botsford Jarvis's home, an 1821 farmhouse that Howard had redesigned and enlarged only two years earlier. Jarvis had named the house "Rosedale," a designation later applied to the entire posh garden neighbourhood that exists today. News of the home's destruction, however, proved false. Mackenzie had in fact torched the home of the Bank of Upper Canada's chief teller, and, when he tried to attack Jarvis's house, fellow rebels David Gibson and Samuel Lount stopped him.

Once he got organized, Howard volunteered for what he calls "a skirmishing expedition" that never materialized. Again he returned home, but that evening reported to a rallying point at the city hall/market building, armed with what he called "my double gun loaded with bullets, a brace of pistols, and my long hunting knife thrust into a silk handkerchief and tied round the waist for a belt." With others, he erected barricades in the streets and placed cannons at strategic buildings. At about eleven o'clock, as he was warming himself inside the hall from the wintry cold, word came that insurgents were marching on the Don Bridge, east of the city, to destroy it. Howard volunteered to help repel the attackers.

"Being a pretty good gunner, my services with two recruits I had raised, were very much in request," he writes. With thirty others he "went off at double quick," and after an all-night effort helped saved the bridge.

The next evening, December 6, he joined the guard at the Bank of Upper Canada, known to be a primary rebel target. He spent the night there, and at six the next morning, December 7, he helped organize a militia of fifteen hundred men to march north to confront the rebel army. Somebody promoted him to lieutenant. He led a band of sixteen men through the bush and countryside east of Yonge Street, firing at rebels, scaring them into retreat, taking a couple of them prisoner, and eventually

arriving at Montgomery's Tavern, the rebel headquarters near where Yonge Street now intersects with Eglinton Avenue.

"We battered down Montgomery's Tavern," Howard writes. "The enemy would not come to an engagement which was fortunate."

He means that the rebels would have been massacred. Instead they fled. Mackenzie, Gibson, and other insurgent leaders headed for the U.S. border. Samuel Lount was later caught and hung with fellow rebel Peter Matthews. On December 8, Howard accepted an offer to become a lieutenant in the Queen's Rangers, but soon begged off because a new college term was starting. Six months later he changed his mind and took a commission as lieutenant with the First Regiment of West York. The appointment certificate still hangs in his former office at Colborne Lodge.

Howard's last will and testament revealed his secret family. To the city, he left the lodge and Humber Bay property, but some of his other real-estate holdings, belongings, and money went to his mistress, two sons, and a daughter. Little is known about them. His autobiography ignores them. His diaries leave few clues. His will, however, leaves no doubt as to his double life.

His mistress was Mary Williams. Their firstborn son was named George Corby Howard Williams, picked from Howard's given name "John Corby" and his adopted one "John George Howard." The boy went by "George." The second son appears as Douglas Williams, and the daughter as Anne Jane Williams.

The children were born in 1843, 1847, and 1852 respectively, meaning that the extramarital relationship lasted at least ten years, but in fact endured much longer. Hints found in the diaries suggest that Howard provided for the family financially and marked the children's birthdays. The two youngest predeceased Howard, but he was in touch with Mary Williams and their son George until the end. Williams family descendants have since donated some of Howard's former belongings to the museum, such as the writing desk and bookcase in the library.

"Mistresses were not uncommon but it was important that your wife be given full status, and for you to be as discreet as possible," Colborne Lodge coordinator Cheryl Hart says. "It was a small town. It would be hard for Jemima not to know, but it was important that she not be embarrassed."

On Howard's death a handwritten note regarding the lodge's inventory shows that Mary Williams requested, and was allowed to keep, one of Howard's stuffed birds.

WALK-THROUGH

John Howard poured his affection for landscape and architecture into Colbourne Lodge, built on a hill overlooking Humber Bay. The place looks comfortable and cozy, each room flowing into the next. Based on an architectural style called "Regency Picturesque," it blends with its surroundings, unlike the upright Georgian residences so popular at the time. Its modest profile, with a quirky three-pronged chimney, scarcely hints at the home's twenty-two rooms. Howard's contemporaries often called it "Howard House," but he insisted on naming it "Colborne Lodge," after Sir John Colborne, the lieutenant-governor of Upper Canada, who championed Howard as one of the colony's first professional architects.

The lodge developed in stages. In 1837 Howard designed a drawing room, bedroom, and kitchen around a chimney with three joined fireplaces. Over the years, he added upward, downward, and outward. Mostly, he and his wife used the house as a retreat while renting or owning a series of city residences, but in 1855 they retired to the country property.

As a museum, Colborne Lodge stands out for its original paintings and domestic gadgets. Howard prided himself as a watercolour artist, and his works of early Toronto hang on the walls. He also kept pace with the latest technologies. He built one of Toronto's first indoor toilets, and for his dining-room mantelpiece used newly developed artificial stone. In the same spirit, curators display the kind of Victorian domestic devices that might have appealed to Howard, from an animal-bone crusher to a swivelling teapot.

Drawing Room

Seven of John Howard's original watercolours illustrating the Toronto of the 1830s and 1840s customarily hang in this quiet, tasteful parlour, or what the Howards called the "drawing room," featuring three bay

windows. Howard bequeathed more than one hundred of his paintings to the city. One of his best depicts cows being herded along King Street past the 1824 jail, the 1835 fire hall, the 1824 courthouse, and the 1833 St. James Anglican Church, precursor to St. James Cathedral. Howard designed the fire hall and built the wooden walkway — Toronto's first sidewalk — wide enough for two women to stroll together in full dresses. Other paintings show the third Parliament buildings, with immigrant sheds in the foreground, and people skating on Lake Ontario where the Rogers Centre and CN Tower now stand.

As a watercolourist, Howard ranks somewhere between professional draftsman and folk artist. His buildings come off magnificently, drawn perfectly to scale, while his human figures suffer from a wonky sense of proportion and lack of warmth. Despite their shortcomings, the works offer valuable information about the city's earliest days. Curators rotate the pictures from a selection of about thirty.

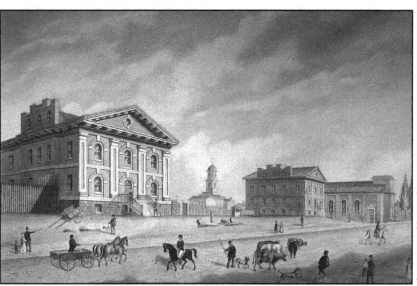

Photo courtesy of the City of Toronto, Museum Services, 1978.41.40

Cows mosey along King Street in a watercolour by John Howard that also features (left to right) the jail, the fire hall, the courthouse, and St. James Anglican Church. As a painter, Howard ranks somewhere between professional draftsman and folk artist, but his works offer valuable information about the city's earliest days.

Anteroom

An odd little room off the drawing room features separate watercolour portraits of John and Jemima Howard painted in 1847. At forty-four years old, John Howard appears in a high collar and dinner jacket, his hair coiffed like that of a Roman emperor, surrounded by classical Greek and Roman columns and statues. Jemima appears equally well turned out, although in a more domestic setting, wearing a formal gown, and her hair parted in the centre with curls down both sides. To practise his brush stroke, Howard sometimes copied works by more established artists. Examples of such copies sometimes hang in the room.

Library

In the home's earliest incarnation, John and Jemima slept here. Their bedroom closets can be seen opposite each other. Later, John claimed the room for painting, reading, and receiving friends. To the right of the entrance, he built a corner cupboard for art supplies. Today the room showcases one of the museum's most outstanding artifacts — Howard's large watercolour map from the 1870s showing his plans to create High Park.

Dining Room

Howard had an eye for gadgets, and the dining room — the former kitchen — displays some that he might have liked. A copper-lined cooler on wheels, called a cellarette, rolls to the table while keeping wine chilled during the meal. A butter dish comes equipped with a tray underneath for holding hot water if the butter is too hard, or ice if it is too soft. A teapot swivels forward on hinges to pour. On the table sits a copy of *Things a Lady Would Like to Know,* by Henry Southgate, first published in the 1870s as a domestic management guide, featuring a full dinner menu for every day of the year. Ask your interpreter/guide to look up the menu plan for your birthday. Oil portraits on the walls, left in the Howard estate, are believed to show members of Jemima's family in England.

Bathroom

Behind a door camouflaged with wallpaper, and without a doorknob, lies Toronto's oldest extant indoor bathroom, complete with shower

and flush toilet. Guests were not necessarily informed that it was there. "Indoor toilets were not immediately accepted," says museum coordinator Cheryl Hart. "They were seen as an unhealthy practice that might bring disease." Howard built it in the 1850s, before indoor plumbing. The gravity-dependent shower connects to a second-floor tank, which was filled with water heated on the stove and hauled upstairs by servants. The toilet within the bathroom has its own door and stall, like an indoor outhouse. A knob next to the seat releases water from a tank (long since dismantled), swooshing waste into a septic tank, or covered pit, next to the house outside.

Upstairs, Master Bedroom

A photograph showing Howard bearded with snowy hair toward the end of his life hangs in the upstairs landing. He died in 1890 at eighty-six.

Like the dining room, the bedroom showcases handy everyday devices. On the washstand, notice the ivory toothbrush fitted with boar hair. Next to it lies a tin with the words "Areca nut cherry tooth paste for removing tartar and whitening the teeth without injury to the enamel, prepared only by J. Robertson, Chemist, Arbroath [Scotland]." Also on display: a basin and sponge, a bar of soap in its dish, several specialized cups, and a polished wooden box containing straight razors for shaving, along with a strop for sharpening them. In the corner, a writing desk comes with a feather quill, ink bottle, and a copy of a letter Howard wrote in straight, even lines, leaving spaces between for a reply.

The four-poster bed was the Howards' own, refitted now with new mattress ropes, three mattresses stuffed separately with feathers, horsehair, and hay, and a cotton canopy for keeping in the heat during the winter. A horsehair-upholstered couch on tiny wheels backs onto one wall. Above it hang two photos. Identities have not been definitively established, but one is believed to show Jemima's sister Frances, or "Fanny," the other Fanny's husband, Sidney Mountcastle. They landed in Upper Canada the same year as the Howards, and settled in Goderich, on Lake Huron.

Girls' Bedrooms

Over the years several Mountcastle children visited the Howards, sometimes for long periods, particularly Clara, who, with help from her Uncle

John, established herself as a poet, novelist, and watercolour painter. She published the first of her three books under the name "Caris Sima," after her childhood nickname "carissima," conferred by a family friend and meaning "most beloved" in Italian. As an adult, she exhibited at top Toronto art shows. Two small rooms across the hall from each other evoke her time at the house with a sister, complete with washstands, chamber pots, dolls, clothes, and books. The museum plans to update the rooms to reflect what they looked like when they were used by two nurses, Mrs. Spitzer and Mrs. Taylor.

Jemima's Sick Room

Of anywhere in the house, Jemima's presence can be felt most strongly here. It was meant as a guest bedroom, but became Jemima's room when she fell seriously ill in 1874. In his diaries, John Howard notes with distress that she spilled the milk and broke the glass in one of picture frames. Several times, she wandered into the woods and got lost. "The dear one still was left with him," he writes in a poem, "Though oftentimes she knew him not."

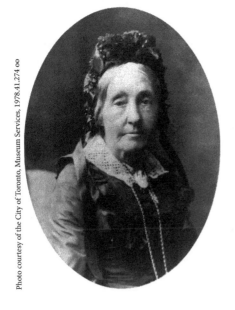

Photo courtesy of the City of Toronto, Museum Services, 1978.41.274.00

In a photo displayed in her sick room, Jemima Howard poses shortly before her death in 1877 at the age of seventy-five. Doctors diagnosed her with one of the region's first cases of breast cancer.

In 1874 he made arrangements to admit her into the Provincial Lunatic Asylum that he had designed, paying for a room on its best ward. When doctors told him that the move might be premature, he refurbished the upstairs room instead. He installed bars on the windows for his wife's security, and a door in the hallway with no inside knob. Nurses referred to in John's diaries as Mrs. Spitzer and Mrs. Taylor moved into the children's bedrooms. Eventually, doctors diagnosed breast cancer, one of the first known cases in the region. Why Jemima also lost her mind was never clear. Perhaps the cancer spread to the brain.

Like her husband, Jemima liked to paint. The watercolour hanging at the head of the bed is hers, an interpretation of *The Tired Soldier*, by contemporary London painter Henry Singleton. Along with some of her husband's paintings, it formed part of the first exhibition of the Artists Society of Toronto in 1834, held at the Parliament Buildings. Tea implements and medicine bottles occupy a nearby table, and on the dresser can be seen a small photograph of Jemima formally dressed and managing a brave half-smile. She posed shortly before her death in 1877 at the age of seventy-five. Ask your interpreter to reveal the room's secret toilet.

Downstairs, Pantry and Summer Kitchen

On the way downstairs into the servants' domain, you pass an open pantry stocked with china. The wide-brimmed breakfast teacups gave the tea a larger surface area on which to cool in the morning rush. Cups of the more familiar size came out in the afternoon. In any case, interpreters say, tea drinkers in Victorian times found it acceptable to cool tea by pouring it from cup to saucer, and slurping.

The kitchen at the back of the house, used in summer, stands over a former well, seventeen metres deep. You can see a square of new flooring installed following archeological explorations. Next to it stands an 1874 cast-iron woodstove, used by the Howards in their later years, and still used today. Victorian kitchen appliances line the shelves: apple peeler, raisin seeder, cherry pitter, meat grinder, sausage maker, and a hinged contraption that closes with a thwack to crush animal bones for soup. A wire mesh holds a piece of dishwashing soap until the last bit is dissolved. A bottle contains a cleanser nicknamed "the Vinegar of the Four Thieves," after a story about the Black Death of medieval times. Vinegar is mixed with lavender,

rosemary, and other spices, and left in the sun for two to four days, then decanted with garlic into bottles for use as an all-purpose cleaner.

By the window stands a wooden icebox. A servant fed it with blocks of ice stored with hay and sawdust in a nearby shed. Two layers of insulation kept the interior of the box cool. To drop the temperature further, the servant opened a vent on top to melt the ice faster. The faster the ice melted, the faster the air cooled. Cool air descended into the box, forcing the warmer air out.

Glass House and Basement Winter Kitchen

A room with a glass roof runs between the summer kitchen and the basement steps. Built in the 1860s as the final addition to the house, the Howards used it as a seasonal greenhouse to start their spring plants.

The basement served as winter kitchen and servants' quarters. Howard designed windows and window-wells to bring natural light into the space. A washerwoman living nearby did the laundry, a labour-intensive job using a tub, paddle, and washboard. A wet Victorian dress, interpreters say, weighed as much as a small child. Over the years, live-in servants came and went, but they would usually include a husband and wife and two or three children. The husband looked after the animals. The wife cooked and cleaned. The children did other chores.

At the centre of the action stands the hearth, and next to it a brick bake oven. Historic interpreter Maria explains to visitors how it works.

"We call this a seven-second bake oven," she says. "You know it's hot enough when you can put your hand in for only seven seconds. If you can hold your hand in for only two seconds it's too hot. The food will be burned on the outside and left raw inside. If you can keep your hand in here past twenty or twenty-five seconds, the oven is not hot enough. You have to build another fire and start again.

"Once the door was closed, the cook used her sense of smell," Maria says. "She wanted to avoid opening the door and letting the heat escape, and run the risk of the oven not being hot enough to bake all the way through. It was a lot of responsibility for a cook, but she knew what she was doing.

"The cook would never want to go to Mr. Howard and say, 'I'm sorry I overdid the pie — can I have more flour and sugar?' Those he would have to purchase, and they were expensive."

Often, small treats can be found on the servants' dining table. On a hot summer day, Raspberry Shrub might be on offer, a refreshingly tart drink made by boiling raspberries and vinegar for six to eight hours, then adding heaps of sugar.

John Howard's Office

The tour finishes in a small front office on the main floor. Notice the relief map Howard carved from wood to show the hills and ravines of what was to become High Park. Pride of place on the wall goes to a framed certificate from Lieutenant-Governor Sir George Arthur, acknowledging Howard's "loyalty, courage and good conduct" in helping to suppress the 1837 Rebellion, and making him a lieutenant in the First Regiment of West York.

WATERCOLOUR MAP

John Howard expressed his vision for High Park on an outsized water-colour map that he painted himself. He proposed a park of more than double the size of his own lands, showing ravines, creeks, woods, and original swaths of black oak savannah, along with walking paths and carriage trails of his imagining.

"This is John Howard's conception of what the public park would look like," Colborne Lodge coordinator Cheryl Hart says of the cartography. "When he and the city were negotiating, he was drawing this map for them."

High Park stands as the jewel in Toronto's parks system, and as Howard's most enduring and magnanimous contribution to the city. In 1873 he deeded 120 acres of his Humber Bay property to what he formally called "the corporation," meaning the city, with the remaining forty-five acres to follow when he died. The total came to 165 acres, but on his map the park includes lands to the east and west. Over time, his vision became reality. In 1876 the city purchased the adjacent Ridout family estate, extending the park to its present eastern boundary. In 1930 the city further acquired the Chapman property to the west. In 1960 the Queensway took away a strip at the south end, leaving the total park area at 399 acres, or 161 hectares.

Photo courtesy of the City of Toronto, Museum Services, 1970.222.19G

Long before the city acquired all the property, John Howard laid out his vision for High Park in a large watercolour map. Although today's roads and trails do not exactly match his specifications, his general approach can still be seen, with park entrances at the north and south and a road loop through the middle.

To begin developing the park in 1875, the city invited surveyors and architects to submit design ideas. Howard disliked them all. "They were way too intrusive," Hart says. "He wanted the park to stay in as natural a state as possible." Again, his vision prevailed. Although the roads and trails the city later developed do not exactly match his specifications, Howard's general approach can still be seen, with park entrances from the north and south and a road loop through the middle.

The museum displays the watercolour map prominently in the library. A close look reveals the property's buildings of the time, including Howard's backyard coach house and other outbuildings, his nearby tenant-farmer accommodations, and homes of his nearest neighbours.

The present-day coach house is a replica, used for community events and meetings. One of the tenant houses, built to Howard's design, still exists, serving as the park office, northwest of Colborne Lodge near the Hillside Gardens. On Howard's map, the former home of John Ellis can also be seen, also a Howard design. Known as a quiet bachelor, Ellis was a friend of the Howards and rumoured to be the city's executioner. His name survives in "Ellis Park Road" and "Ellis Avenue," both running outside the park along the west side of Grenadier Pond. To the east of the park Ridout Road runs through the former Ridout family lands.

NEIGHBOURING ATTRACTIONS

Howards' Tomb

In a grove of trees just north of the lodge, on the left-hand side, stands a ten-tonne monument marking John and Jemima's double grave. A pile of granite boulders rises to a marble pedestal, topped by a Maltese Cross. "To the memory of John George Howard and Jemima Frances his wife," the gravestone reads. It also gives numbers: Jemima Frances 1802–1877, seventy-five years; John George 1803–1890, eighty-six years.

In 1874, while designing the memorial, John Howard also purchased a piece of wrought-iron fence from London, England. "The ground upon which the tomb stands is enclosed by a portion of the massive iron railing which formerly surrounded St. Paul's Cathedral," he writes in his autobiography. "The iron is of very superior quality, having been

smelted with oak wood." On its way to Toronto, the railing sank with a boat in the St. Lawrence River, but enough of the material was salvaged for Howard to complete his project. On a brass plaque wrapped around one of the iron gateposts, he wrote a poem to human impermanence from the railing's point of view.

> St. Paul's Cathedral for 160 years I did enclose.
> Oh! Stranger, look with reverence;
> Man! man! unstable man!
> It was thou who caused the severance.
> Nov. 18, 1875. J.G.H.

Photo by John Goddard

A section of wrought-iron fence from St. Paul's Cathedral, London, surrounds the ten-tonne tomb for John and Jemima Howard. "The iron is of very superior quality, having been smelted with oak wood," he wrote in his autobiography.

High Park

Along with Colborne Lodge and the outsized tomb, High Park counts as John Howard's most enduring creation. It is Toronto's largest park. (Rouge

Park is bigger, but straddles Toronto and Markham.) A park zoo dating to the 1890s accommodates llamas, bison, and other impressive beasts. An outdoor amphitheatre showcases the Canadian Stage Company's summer Shakespeare performances. Nearby, on most summer Sundays, the Toronto English Country Dancers gather for a picnic and perform styles of dancing with which Shakespeare, Jane Austen, Napoleon, and the Howards would have been familiar. Anybody is welcome to join in.

Gardens, picnic areas, children's playgrounds, an off-leash dog run — the list of amenities goes on. Grenadier Pond creates a waterfront along the park's western border, and the Grenadier Café serves as a central eatery, with a patio ice-cream parlour. More than a third of the park remains ungroomed, with walking paths through the woods and grasslands, perfect for the type of restorative country stroll that Howard imagined for citizens of a growing urban centre.

MONTGOMERY'S INN

Photo by John Goddard

In 1830 Thomas Montgomery opened his inn on the Dundas Road, and for twenty-five years ran the place with his wife Margaret. The limestone brick exterior appeals to today's tastes, but Montgomery originally surfaced it with stucco for a more finished look.

Address

4709 Dundas Street West, at Islington Avenue.

Getting There by TTC

Take the Bloor/Danforth subway west to Islington Station, and either take the Islington bus north or walk five hundred metres up Islington Avenue to Dundas Street West.

HARD WORK AND HEARTBREAK

Montgomery's Inn stands on the old Dundas Road, the former main thoroughfare between colonial Toronto and what is now Hamilton. For twenty-five years, beginning in 1830, the hard-working Irish immigrant Thomas Montgomery presided over the place, providing food and lodging to travellers and creating a social hub for the surrounding area. The inn is not to be confused with (John) Montgomery's Tavern on Yonge Street, rebel headquarters of the 1837 Rebellion.

What Thomas Montgomery looked like, nobody knows. Was he lean and ropey? Brutish and stout? No written description or painted portrait of him survives. Of his thoughts and feelings, little can be said. He kept no diary. Almost all that is known about him comes from ledgers and business notebooks, which researchers Bev Hykel and Carl Benn of the Etobicoke Historical Board summarize in their ringed-binder publication of 1980 titled "Thomas Montgomery: Portrait of a Nineteenth Century Businessman."

"He was not well educated and spoke with a thick Irish accent," the researchers conclude from the innkeeper's phonetic spellings. "Height" he spelled as "highth." "Breakfast" he wrote as "brakfast."

What is certain is that Montgomery lived a financially prosperous but personally tragic life. Along with an inn, he ran a sheep, dairy, and vegetable farm spanning four hundred acres and extending as far south as Bloor Street. Over the years, he also acquired more than two hundred properties throughout Upper Canada, most of them rural woodlots, but many of them speculative assets in nine towns. He further acquired a sawmill, four additional taverns, and a drygoods store on Toronto's Queen Street West.

Overshadowing his business successes, however, was an accumulation of heartbreaking personal losses. His wife died at forty-seven of painful and lingering rheumatoid arthritis. Of the seven children born to them, only two grew to adulthood. Olivia died at five days in 1829, Richard at twelve days in 1833, John at eleven years by drowning in 1864, James Henry at five months in 1840, and Margaret Ann at two months in 1842.

Sons William and Robert lived at the inn as teenagers in 1847, the year that Montgomery's Inn Museum presents to visitors, but even Robert

was to die prematurely at the age of twenty-seven, leaving a wife and two sons. In terms of longevity, eldest son William proved the exception, the only child to outlive his father, making it to three months short of his ninetieth birthday. Poignantly, the entire Montgomery family lies interred together in the nearby Islington Burying Grounds.

Thomas Montgomery landed in British North America from northern Ireland in 1812, at the age of twenty-two. One account has him walking all the way from Quebec to the settlement of Talbot, in Upper Canada, near present-day Chatham. He traded in salt and worked as a surveyor throughout much of Peel County. In 1829 he married Margaret Dawson, also from northern Ireland, and eighteen years his junior. In 1830, with infant William, they moved to a piece of land outside the village of Islington, where the Dundas Road crossed Mimico Creek. There he built his business.

The terms "inn," "tavern," and "public house" meant the same thing then, and the government encouraged such enterprises. Beginning in 1792, when Lieutenant-Governor John Graves Simcoe arrived in Upper Canada, authorities viewed taverns as essential infrastructure to growth. They facilitated travel and settlement. In some cases, Simcoe ordered the military to build inns at government expense for lease to private innkeepers.

Three types of lodgings developed, described by University of Waterloo professor Julia Roberts in her 2009 book, *In Mixed Company: Taverns and Public Life in Upper Canada*. At the low end, crude wilderness taverns offered a single room for eating, drinking, and socializing, and sometimes made guests share bedrooms with chickens and pigs. At the high end, hotels, few in number, served haute cuisine in luxury surroundings. Falling somewhere in between lay the taverns, or inns, "places where [patrons] could expect solid meals and access to well-defined rooms appointed with comfort in mind," Roberts writes.

By 1843 at least nine such establishments operated in villages making up what is now Etobicoke. Montgomery's Inn distinguished itself by its handsome stone structure and spacious interior, which eventually included a popular barroom and upstairs assembly hall. "One of the finest examples of late Regency or Loyalist architecture in Ontario," the City of Toronto states of the building's significance.

The design emphasized heft and balance. Rough limestone, instead of less elegant clapboard, formed the basic structure, and Montgomery had the exterior surfaced with pebble-dashed stucco to show a formal, stately façade. Following convention, workers placed the front door at the centre, a large window on either side, three similar-size windows across the second storey, and chimneys at either end to service twin fireplaces on both levels. In 1838, east and south additions threw off the symmetry but more than doubled the square footage.

Licence requirements were strict. To begin, Montgomery needed three public bedrooms with at least three beds in total, apart from his family's rooms. He required a spacious yard, a drive shed to park buggies and carts, and stables for horses and oxen. He needed secure lines of supply to feed travellers and animals, and had to be ready for guests arriving any day of the week, at any time of the day. For such a licence he had to pay a stiff fee, several hundred dollars in today's money. A first application also required references from a church minister or neighbours, swearing to his good character and ability to keep a savory and orderly premises.

"Came to T. Montgomery tavern [sic] on Dundas Street," surveyor and future rebel leader David Gibson wrote in his diary on June 15, 1831, one of the earliest documented references to the place.

The inn grew into a key meeting spot. By the 1840s the Home District Council was holding sessions in the upstairs assembly hall, on issues affecting central Upper Canada as far north as Georgian Bay. During the same period, an Irish and Scottish potato-famine relief effort was organized at the hall. Trials were held in the room, and Branch 138 of the Orange Order regularly assembled in the hall, as did its regional body, the Grand Lodge of the County of York.

Montgomery was an Orangeman. Formally called the Loyal Order of Lodgemen — with the now-humorous abbreviation LOL — the fraternity of Northern Irish Protestants honoured King William of Orange and his victory over James II, a Catholic, in the 1690 Battle of the Boyne. On at least four occasions, records show, Orangemen at the inn marked the battle's July 12 anniversary with a celebratory dinner. "Lodg to have dinner for 22 persons Rec'd 7 ½ $ [£1.17.6]," the inn's ledger of July 12, 1839, reads.

In the 1837 Rebellion, Montgomery sided with the government. Like all able-bodied men, he served in the militia by obligation, but when rebel fighting broke out he volunteered as a militia officer. What action he might have seen is not recorded, but some of his involvement shows up in the ledgers.

On December 14, after a government force routed the rebels from their Yonge Street headquarters, Montgomery advanced £12.17.6 to help round up the fleeing insurgents. "To The Different Vollinteers Going to Defend there Countery and Returning Home Againe," he noted semi-literately. On the same day, he served breakfast to sixteen militiamen. Two days after that, he fed another seventeen soldiers breakfast, and the next day recorded charges of £1.0.8 for "prisoners going home and others." Similar entries continued into the next year.

Margaret Montgomery died in 1855, and shortly afterward Thomas closed the inn. "He was a success and bequeathed a solid fortune to his descendants," say researchers Hykela and Benn, summing up his legacy.

Montgomery can also be praised for his incredible stamina. Tavern keeping could be an unstable business. Most innkeepers in Upper Canada spent fewer than five years in the trade. "Across a ten-year span, between 1827–37, only 15 per cent persisted beyond five years," Roberts says in her study. Montgomery worked for twenty-five years in the role, and over the entire existence of Montgomery's Inn presided as sole proprietor.

WALK-THROUGH

With its street-level barroom and upstairs assembly hall, it is easy to imagine Montgomery's Inn as a welcoming country gathering spot. It has been restored to the way it might have looked in 1847, when Thomas and Margaret's two surviving children, William and Robert, were teenagers and the family was prospering.

Tea Room
A tour of the museum usually ends with the basement tea room, also called the Community Room, but poking your head in right away proves

almost irresistible. At the far end stands the original 1830 hearth and adjoining bake oven, which, combined with a low ceiling and rustic tables and chairs, add to the room's cozy, intimate feel.

For a modest fee, Tuesdays to Sundays between two and four o'clock, a volunteer in period costume will serve you tea in a teapot, and offer a choice between baked desserts and cheese with crackers. Originally, a central staircase led straight upstairs from the kitchen. Its absence leaves an unobstructed view for lectures and other special events, along with regular meetings of the Etobicoke Historical Society, the Duke Ellington Society of Toronto, and the Ontario Jaguar Owners Association.

The Sign of the Plough

Outside the tea room, a stairway leads to the main floor. Look back at the stairwell wall to see one of the museum's most outstanding artifacts. It is the proprietor's original exterior sign announcing "T. Montgomery's Inn," with its faded sketch of a farmer steering a plough behind a team of horses.

Front Hall Entrance

"We will never know exactly how these rooms were furnished," says museum coordinator Ken Purvis. He is standing inside the inn's front entrance as light pours in from the door's sidelights and overhead glass fanlight. "I tell visitors that we are not sure, and that interpretation should be a dialogue," he says. "The way the rooms are arranged is a fantasy but a well-informed fantasy. Tremendous research has gone into this, a lot of work, but it is an ongoing process, too. It shouldn't be static. We are constantly, maybe not revising, but augmenting how we interpret the space as we learn more."

Few of the artifacts on display are original to the inn, Purvis says. The outdoor sign is one. Another is the floor clock, or tall-case clock, at the end of the hall. In the early 1900s a local antique dealer bought it from the Montgomery estate, and his granddaughter later sold it to the city's artifact collection. Apart from such special items, the inn's present furnishings consist of Canadian, English, and American pieces meant to reflect the style of a middle-class Irish-settler farm family.

Sitting Room (Parlour)

In 1846 Montgomery got a bill from George E. Stout for "preparing and papering the sitting room." No wallpaper fragment has survived, but a sample from a neighbouring property, Briarly, where Montgomery's eldest son William lived with his family for many years, was salvaged during its 1990 demolition. The remnant inspired the choice for the sitting-room restoration, a reproduction of a moderately priced ornamental rococo-revival pattern.

"The question is always raised — was this public space or private space?" Purvis says, meaning did the family reserve the room for themselves or open it to guests? "It may have been flexible space."

As an exhibit, the room is arranged to suit the Montgomery family of four on an evening in 1847, when the boys were seventeen and ten years old. The furniture is the fanciest in the house. Four chairs are set at a small table at the centre. Along the front wall runs a couch finished in tightly woven horsehair.

Perhaps Margaret Montgomery also received women friends here and served them tea. Perhaps other women visitors came to relax. In her book *In Mixed Company: Taverns and Public Life in Upper Canada*, University of Waterloo scholar Julia Roberts describes York tavern patrons Mary Thomson and her friend Sophia Beman using a parlour to get away from the crowd. "'Miss T.' and 'Miss B.' gathered with their polite acquaintances to drink tea and wine, making music and conversation, and read aloud in mixed company," Roberts writes, drawing from the diaries of Ely Playter, an innkeeper — and later farmer and volunteer soldier — from the earliest 1800s.

Men, too, often needed private space. "Taverns were great places for business meetings because they were centrally located," Purvis says. "You didn't have to have somebody come to your home, you could have somebody else playing host, so sometimes inn-keepers had discrete areas for that kind of client. They also had their best liquor in those areas. Did that happen in this room? I don't know but it's possible."

Montgomery's Office

A small room off the parlour provides an office where Montgomery might have administered his tavern, farm, and extensive land holdings.

The wall-mounted bookcase displays a replica of his militia officer's sword. The original, not usually on display, lies in the museum's permanent collection. On the desk, accounting tools can be seen — ink bottle, quill pen, blotter, candle.

Ask to see a photocopied page of Montgomery's ledger, kept in one of the drawers. At the top of the page, the innkeeper has written "John Clark," probably a farmhand and boarder. From Clark's wages, sums have been deducted for cotton shirting, boots, trousers, and two glasses "pm," meaning "peppermint," a mixed drink that the inn featured as a house specialty. "One pare of boots, one pare of trousers," Montgomery has written, testimony to his lack of education and habit of spelling phonetically in an Irish accent.

On the wall hangs a framed map of Upper Canada, along with a more subtle geographic reference, a portrait of Henry Dundas, First Viscount Melville. He was a Scottish politician and friend of Upper Canada's first lieutenant-governor, John Graves Simcoe, who gave the name "Dundas" to the town where William Lyon Mackenzie once set up business, and to the main Toronto–Hamilton road.

"Take note," says the facsimile public notice next to the bar. "The creditors of the late John Broton are requested to meet at the Inn of Mr. Thomas Montgomery on the 18th of this month. [Signed] Henry Brown."

Public Room/Dining Room

Across the hall lies a sizable room, easily imagined to be teeming with people. It features a floor painted dark-brown and a long table fitted with a generous white tablecloth. Before the inn's expansion this was the public room for eating, drinking, and congregating. Lodgers, boarders, walk-in customers, and family members used the room, not necessarily all at the same time. On several occasions during the 1837 Rebellion, soldiers stopped here to eat. At least once, two weeks after hostilities broke out, rebel prisoners and their guards stopped, perhaps overnight.

No menu has survived, but at one point Montgomery owned twenty cows and forty-five sheep. He raised veal and ran a smokehouse to make bacon and ham. He grew large amounts of vegetables, including turnips, which he served year-round.

"This was greasy-spoon fare, not haute cuisine," Purvis says. "Imagine savory pies and roasted meats, and vegetables in season. They also served snacks. Typically innkeepers wives made cheese, particularly if the property included a farm, so Montgomery served cheese and crackers, and something that he called his 'cold bite' — cheese, crackers, bread, pickles, and maybe a slice of cold meat, maybe ham."

Such food did not come cheap. A bed for the night could cost as little as three pence. One meal cost one shilling and twopence, or fourteen pence, nearly five times as much as a bed. The price applied whether for breakfast, lunch, or dinner. Boarders paid one shilling and threepence for full board. "The Montgomerys weren't gouging," the museum coordinator says. "Food was just very expensive in pre-industrial Canada."

Upstairs

As you climb the main staircase to the second floor, think of family space to the right, public space to the left. Notice the door at the top of the stairs to the left. It is the entrance to one of the original three rooms for lodgers and boarders, required for the innkeeper's licence. The glass in the door is original, except for the panel second from the bottom on the left, marked by white tape. Staff installed a replica panel, then marked it to avoid future confusion.

Family Side

On the family side of the hall, the smaller of the two bedrooms belonged to the two sons, William and Robert. Next door lies the master bedroom for Thomas and Margaret, complete with commode chair and a canopy bed for retaining heat in winter. The rope beds, the straw-stuffed mattresses, the oil lamps, the washstand — all are typical of nineteenth-century homes. From a chair, Purvis picks up a pair of trousers.

"This is a reproduction based on a pair found in the attic here," he says. "They were balled up and stuffed into a hole, and a conservator was able to open them up and create a pattern, the Montgomery's Inn trouser pattern."

Purvis indicates front pockets, a watch pocket, a gusset for adjusting the waistline, and something called a "fall-front," a flap held by two buttons, popular at the time in place of a buttoned fly.

"This pattern has been shipped off to other museums," Purvis says. "The Montgomery's Inn trouser is worn by staff at other historic sites in Canada and the United States."

Photo by John Goddard, courtesy of the City of Toronto, Museum Services, Montgomery's Inn Museum

Children find the bedrooms of the 1838 south addition especially appealing because of their low ceilings and bunkhouse intimacy. "They imagine a sleepover," says museum coordinator Ken Purvis.

Public Side

Opposite the master bedroom, a door opens to the largest of the original three bedrooms for lodgers and boarders. A lodger was somebody staying overnight or a short time. A boarder might be an inn employee, a farmhand, or an itinerant builder or repairman. According to the 1851 census, four people worked at the inn as servants — Thomas Kengley, William Ringwood, Mary Leighton, and nine-year-old Mary Hamilton.

Notice the unfinished floor and rustic furniture. The large open hearth mirrors that of the master bedroom, except that the mantel is cheaper and less elegantly appointed. The door off the room led to a second bedroom, which after the inn's 1838 expansion Montgomery used for storage.

Assembly Room

Another door from the main public bedroom leads directly into a spacious historic hall, built in 1838. Dances, charity drives, district council meetings, and Orange Lodge assemblies were held here. A British flag, portrait of Queen Victoria, and picture of the British prime minister of the day, Robert Peel, decorate the walls. Court cases might also have been tried in the room.

"We have architectural drawings of the building from the 1930s by University of Toronto students, and one of the features they drew was a speaker's box," Purvis says, meaning a stand that could double as a courtroom prisoner's box. "When the inn was restored there was no sign of a box, but the top boards of it were found in the attic.

"This is where the story gets interesting," he says. "From 1931 to 1945, Chinese families were living here. They were market gardeners, farming the fertile soil around here and selling their produce at the St. Lawrence Market. In the 1980s some of the staff here were able to interview some of the earlier tenants. One person recalled his grandmother, on a cold winter night in the 1940s, breaking up the speaker's box and burning it in the fireplace. So we have the architectural drawing, the oral history, a little bit of the box remaining, and we were able to do a good reconstruction of the box."

Additional Guest Bedrooms

Children find these rooms especially appealing for their low ceilings and bunkhouse intimacy. "They imagine a sleepover in the museum," Purvis

says. These are the lodgings of the south addition, one open room fitted with three double beds, and three smaller, more private rooms off it.

Montgomery charged a sliding scale for a night's sleep. Threepence got you space in one of the dorm beds. Sixpence, the top rate, got you more privacy in one of the side rooms, or slip rooms, as they were called. The question arises: Did threepence get you the whole bed? Or did lodgers go to bed knowing that a late-arriving stranger might join them in the night?

"Sharing a bed was much rarer than sharing a room, but it happened," writes Julia Roberts. In 1854, at Toronto's Clyde Inn, guest William Long expressed distaste at having to share his bed with a stranger. "He neither looked at nor spoke to the other man," Roberts says.

Barroom

Return to the assembly room and head straight downstairs to the inn's top attraction, the barroom. Every St. Patrick's Day, Montgomery's Inn throws a celebration here with a céilidh, a party with live Irish folk music and dancing. The floor is rough. The tables and chairs are mismatched. If a piece of furniture broke at one of Montgomery's parties, no harm was

Photo by John Goddard courtesy of the City of Toronto, Museum Services, Montgomery's Inn Museum

Volunteer Sharon Majik puts out cakes and cookies at a post-Christmas Twelfth Night celebration in the barroom, one of the museum's top attractions. Instead of the familiar counter for sidling up to, the bar itself doubles as a cage that can be locked at night.

done. In one corner stands the bar, not the familiar, modern counter for sidling up to, but a cage with wooden bars that could be locked at night.

From behind it, a barman, or sometimes Montgomery himself, served snacks, cut plugs of tobacco, and poured a range of drinks. Beer and whiskey acted as staples, at two pennies a glass. Montgomery bought beer from the Castle Frank Brewery in the Don Valley and the West Toronto Brewing Company on Garrison Creek just north of Fort York. Whiskey he bought just up the road at Lampton Mills, where William Pierce Howard was establishing the sawmill, flourmill, gristmill, and distillery complex that would make him one of Upper Canada's wealthiest millers and help launch a political career that made him a Father of Confederation and earned him a knighthood.

Montgomery's account books also show that he served rum, brandy, white wine, port, gin, and cider, along with mixed drinks that he called "peppermint" and "shrub." Next to the bar, a public notice lists the government's rules. "No innkeeper shall allow profane swearing, immodest or disloyal songs, or tales on any pretense," it reads. "No gaming at dice, cards or otherwise in this house, except billiards where a licence has been acquired for that purpose."

1838 Kitchen

With its low ceiling, two pantries, and array of equipment efficiently arranged around an open hearth, the second kitchen off the barroom speaks of a busy workplace serving the household, dining room, and bar.

THE SIGN OF THE PLOUGH

From the 1940s until the early 1960s, the former inn served as Kingsway Presbyterian Church. William Graydon and his wife Evelyn worshipped there, along with their young family. William taught chemical engineering and applied chemistry at the University of Toronto, later becoming department chair. He also had an eye for Canadiana.

One Sunday after the service, William noticed an old sign leaning against the back wall of the church, ready to be thrown out with the garbage. "We should take that home," Evelyn said, and they did. It turned out to be the exterior sign once fixed to the top of a pole identifying the

building as "T. Montgomery's Inn." The sign also showed a sketch of a farmer steering a plough behind a team of horses. The image became Montgomery's logo. In the words of his tavern licence of 1848, he was authorized "to keep the House known by the sign of the Plough."

"Dad loved antiques and history," recalls the Graydons' daughter, Jane Marnoch, who tells the rescue story and also remembers attending Sunday School at the inn's former Orangemen's Hall.

"Our whole house was full of antique-y things," she says. "The sign wasn't displayed in the sense of hanging on the wall. We kept it in the basement. Later, when we were moving, Dad said, 'Dear me. What do we do with this big sign?'"

While officially retaining ownership, the Graydons arranged to lend it indefinitely to the Montgomery's Inn Museum.

Photo by John Goddard, courtesy of the City of Toronto, Museum Services, Montgomery's Inn Museum, 977.169.1

A farmer guiding a plough behind a team of horses appears faintly on the original T. Montgomery's Inn sign, rescued by area residents William and Evelyn Graydon. In the words of his tavern licence of 1848, Montgomery was authorized "to keep the House known by the sign of the Plough."

NEIGHBOURING ATTRACTIONS

St. George's On-the-Hill

To the east along Dundas Street West rises the white spire of the aptly named St. George's On-the-Hill Anglican Church. It opened in 1844, a lofty structure with a stucco-plaster exterior. Thomas Montgomery's funeral took place here in 1877. In 1894, fifty years after the church's founding, renovators covered the outer walls with brick and added a front porch, leaving the bright spire to pierce the sky much as before. Inside stands a baptismal font, still in use, dating to 1865 and dedicated by then Bishop of Toronto John Strachan.

Islington Burying Grounds

West of Montgomery's Inn along Dundas Street West, past Cordova Avenue, on the right-hand side, a black grille fence encircles a pioneer cemetery. Like St. George's On-the-Hill, it dates to 1844. Thomas Montgomery and his family are buried here.

"Finished erecting the Monument to my father today at noon," William Montgomery recorded on August 24, 1878, nine months after Thomas died. The monument stands near the far west corner of the compound, commemorating the deaths of Thomas, his wife Margaret, their son Robert, who died at twenty-seven, and son John, who drowned when he was eleven. The saddest panel is reserved for the four infants: Olivia, five days; Richard, twelve days; James Henry, five months; and Margaret Ann, two months. Nearby can be seen a similar monument to William Montgomery and his family. Two rows of Austrian pines still line the cemetery path, planted in 1910 by William's daughter Margaret.

Before leaving the museum, ask to borrow the key to the cemetery gate, in case it is locked.

Heritage Murals Project

Across the street from the burial ground, at 4937 Dundas Street West, a wall mural depicts the home "Briarly," built in the 1840s just east of Montgomery's Inn. It was home to William Montgomery and his family after 1870. It was demolished in 1990.

Between the "Briarly" mural and Montgomery's Inn, also on the south side of the street, a second wall mural can be seen. "The Manse Committee," it is called. It humorously appears to blow out the wall of the building to show its interior as it might have looked in 1888, when it served as the Wesleyan Methodist minister's residence, or manse. Committee members are shown nosily inspecting the house for cleanliness as the minister and his wife sit down to dinner.

Both murals are the work of artist John Kuna, part of a collection depicting historic scenes around town and known collectively as the "Heritage Murals Project."

SPADINA HOUSE

Program officer Douglas Fyfe delivers a talk on the south lawn of Spadina House, at the start of a neighbourhood walking tour in the summer of 2013. In the semi-circular "palm room" at the top of the steps, Albert Austin cultivated tropical plants year-round.

Address
285 Spadina Road, on Davenport Hill.

Getting There by TTC
By subway, take the University line to Dupont Station, walk north on Spadina Avenue two blocks to Davenport Road, and climb the Baldwin Steps. At the top to the right lies the museum grounds, with the front gate a short distance farther on.

FATHERS AND SONS

An unhappy father-son theme runs through the history of Spadina House, a former country mansion overlooking the city from Davenport Hill. The patriarch who built the original house moulded his son to follow in his footsteps, to the substantial benefit of the nation, but at a staggering personal cost to the son. The father who took over the property similarly shaped his son in his own image, with poignant if less dramatic results.

The first pair was William Warren Baldwin and his son Robert, who together articulated and advanced the cause for responsible government in Canada, helping to lay the groundwork for Confederation. The second was James Austin and his son Albert, successive bank- and gas-company presidents. In both families, the third generation crumbled, their broken male heirs unable to sustain a dynasty.

Dr. William Warren Baldwin (1775–1844)

The story begins with William Baldwin. He was a resourceful Irish immigrant and medical graduate from the University of Edinburgh who arrived at York in 1802. The Upper Canadian capital was tiny then. Finding the population too small to support a medical practice, he switched to law. He learned the profession from a borrowed legal textbook, and was called to the bar in 1803. That same year, William married Phoebe Willcocks, daughter of one of his benefactors, and moved into a house at the northwest corner of Front and Frederick Streets. The building would later become famous as William Lyon Mackenzie's residence and printing shop, target of the 1826 Types Riot. In May 1804, however, it gained distinction as the birthplace of William and Phoebe's first child, Robert.

William prospered in York. He built a comfortable law practice, became treasurer of the Law Society of Upper Canada, acquired large tracts of land, partly through inheritances, and became a wealthy and socially prominent member of society. He was also a sometime architect, credited with designing the Bank of Upper Canada and parts of Osgoode Hall. "An urbane, polished gentleman, tough-minded and possessed of a high self-regard," writes historian Robert L. Fraser in the *Dictionary of Canadian Biography*.

In 1813 William's father-in-law left him a two-hundred-acre rural lot that included Davenport Hill. The parcel stretched from what is now Bloor Street north to what is now St. Clair Avenue. Other successful families were building grand homes at the time, replacing some of the ramshackle housing of earlier settlement days. In 1817 D'Arcy Boulton Jr. built one of York's first brick houses, The Grange. The following year, the powerful cleric John Strachan constructed a magnificent brick home called "The Palace," since demolished, at the northwest corner of what is now Front Street and University Avenue. In 1822 Judge William Campbell commissioned his Georgian brick mansion on what is now Adelaide Street East, in York proper. And in 1818, on Davenport Hill, more than four kilometres from the town centre, William Baldwin designed and erected a handsome two-storey wood-frame house to be used mainly as his country estate. He called it "Spadina," from a local Native word meaning "hill," and pronounced "Spa-DEEN-uh," rather than "Spa-DEYE-nuh," which is how people now pronounce Spadina Avenue and Spadina subway station.

Below the hill, he also began subdividing property that he owned between Bloor and Queen Streets. He laid out Spadina Avenue as a wide, tree-lined boulevard, with an ornamental garden crescent above College Street where Old Knox College now stands. Neighbouring streets he named after family members, such as Robert, Phoebe, Willcocks, and Baldwin.

In 1820 William entered politics. Although he ranked among the privileged few, he held a skeptical view of the governing clique, the powerful Family Compact, led by the cleric Strachan and lawyer John Beverley Robinson, top advisors to the lieutenant-governor. William won a seat in the elected Legislative Assembly as an opposition member, and began to articulate a Moderate Reform position. The constitution, he argued, gave the province's elected representatives the right, which they were being denied, "to make laws for their peace, welfare and good government."

William was no radical. He saw a need for a gentlemen's class, a type of landed gentry such as himself, loyal to the British Crown. At the same time, he saw virtue in democratic reforms, which, while reserving certain powers for the King and British Parliament, would make the colonial government more accountable, or "responsible," to electors.

His opposition to government sharpened as he detected lax standards among the elite toward the administration of justice. In 1826 he criticized Robinson, by then attorney general, for failing to reprimand two of his law clerks who had helped destroy Mackenzie's presses in the Types Riot. Two years later William leapt to the defence of Justice John Willis, fired for alleging that the court was acting unconstitutionally. With his actions, William put himself at the forefront of a Reform coalition. He also brought credibility to Reform. Lieutenant-Governor Sir Peregrine Maitland called him the only Reformer who could also be called a "gentleman."

In 1829 William's stand against the Family Compact hardened further. In private correspondence he referred to Strachan, Robinson, Robinson's brother Peter, Henry John Boulton, and James Buchanan Macaulay as "evil." He proposed specific reforms. He conceived of what he called "a provincial ministry," or cabinet, responsible to an elected "provincial parliament," and ultimately to its electors. Such reform, he said, must be lawful and constitutional — armed rebellion was out of the question — principles that helped lay the basis for the ultimately successful push for "responsible government."

Robert Baldwin (1804–1858)

"I intend please God to bring him up to the bar," William wrote of his eldest son, Robert, when the child was fourteen. Robert's destiny was sealed. There would be two other sons in the family, after two died in childhood, and no girls, but to their father the most important son remained the first-born, to whom William would leave his entire inheritance, and into whom he poured all his expectations for success and respectability.

"[William Baldwin's] purpose was to establish in Canada a family, whose head was to be maintained in opulence by the proceeds of an entailed estate," Henry Scadding, who married one of Robert's cousins, wrote in his seminal 1873 book *Toronto of Old*. "There was to be forever a Baldwin of Spadina."

At sixteen, Robert began work as a clerk in his father's law office. He also wrote poetry and yearned for "perfect love," say Michael Cross and Robert Fraser in *The Dictionary of Canadian Biography*. At twenty-one Robert both became a lawyer and fell in love with his first cousin, Eliza, who was fifteen. To keep them apart, Eliza's parents sent the girl to live

with relatives in New York, but the cousins corresponded. As they shared affections, Robert also told her of the pressures on him to succeed.

"When I reflect how much of our happiness depends on my success in my profession," Robert wrote, perhaps also meaning his father's happiness, "I almost tremble with anxiety." On another occasion, he wrote: "I have a horror of not rising above mediocrity." And on another: "Without commanding respect from my profession I never would be worthy of you." In 1827 the couple married. He was twenty-three, she seventeen.

In his political life, Robert followed his father as a Moderate Reformer. When Judge Willis was fired, Robert joined his father in protest. With others, father and son boycotted the court, refusing to argue before it, and in 1829 Robert won a seat along with his father in the Legislative Assembly. For the next several years, the push for responsible government became primarily associated with William and Robert Baldwin, père et fils.

In 1836 Eliza died. The birth of the couple's first child, a son, had left her fragile. She had gone on to give birth to two daughters, and in 1834 to a second son, delivered by Caesarean section. She had never fully recovered, and died at twenty-five, breaking Robert's heart.

"I am left to pursue the remainder of my pilgrimage alone," he wrote. "In the waste that lies before me I can expect to find joy only in the reflected happiness of our darling children, and in looking forward, in the humble hope, to that blessed hour which by God's permission shall forever reunite me to my Eliza."

Through everything, Robert honoured his professional and public obligations. In 1837, caught off guard by the Upper Canada Rebellion, he allowed himself to play a bizarre cameo role. On December 5, rebel leader William Lyon Mackenzie led eight hundred insurgents south on Yonge Street. Lieutenant-Governor Francis Bond Head asked Robert and Dr. John Rolph to approach them with a white flag. The two would-be peacemakers intercepted Mackenzie below present-day St. Clair Avenue to say that if they surrendered, Head would pardon them. Mackenzie refused and the peace envoys withdrew.

The following year Lord Durham arrived to investigate the cause of the rebellion, setting in motion events that were to secure the Baldwins — especially Robert Baldwin — a place in history. Father and son laid out their

formula for "responsible government." In 1841 the two colonies united as Canada West and Canada East and Robert became co-premier with Louis-Hippolyte La Fontaine. For two terms they championed Canadian management of Canadian affairs and achieved responsible government for their co-jurisdictions while helping to lay the groundwork for Confederation. Responsible government without bloodshed would become Robert Baldwin's foremost political legacy.

"This control of government was increased by degrees," historian J.M.S. Careless writes in his "responsible government" entry in the *Canadian Encyclopedia*. "Canadians gradually acquired command of their own political concerns and achieved national self-direction without revolution."

In 1844, after the first La Fontaine-Baldwin government and before the second, William died. Robert was left to carry on his father's work, and out of a sense of duty he did so.

"Robert disliked politics," Cross and Fraser say in their essay.

"He was not a natural politician," they also write. "A poor orator, and a less frequent contributor in parliament than other spokesmen, he even lacked the appearance of a leader. Of above average height, he had a pronounced stoop which made him look shorter, as did the heaviness of his body. His pallid complexion and dull, expressionless eyes gave him a funereal bearing. It was his character which made him outstanding.... He was a gentleman, morally courageous, utterly genuine in his willingness to sacrifice his interests to those of the institutions he revered — the constitution, the law, the church, property, and the family."

A willingness to sacrifice one's own interests for lofty institutions tends to win praise from others, but rarely makes for a happy or healthy individual. Robert, one of the province's richest and most respected men, retired to Spadina in 1851 at the age of forty-seven and in poor health. The original house had burned down in 1835, meaning that he moved into a single-storey Spadina that his father had built on the ruins. In retirement, Robert's health deteriorated further.

"He had temporary problems with motor control and visual perception, shown by shaky handwriting, misspelling, and repetition of words," Cross and Fraser write. "Depression remains the most likely diagnosis."

Robert became a recluse, and although he lived for another seven years, he obsessed about death and reuniting with his dearest Eliza. He

wrote a list of instructions as to how he wished to be buried. Certain letters from his late wife and some of her personal belongings were to be buried with him, and his coffin was to be chained to hers. Most important, apparently guilt-ridden over Eliza's early death, he asked that a surgeon perform a male version of a Caesarean section on his remains. "Let an incision be made into the cavity of the abdomen extending through the two upper thirds of the linea alba," he wrote.

The shocking instructions he left with his daughter, Maria. When he died in January 1859, she ignored the request, but a month later the eldest son, William Willcocks Baldwin, found a copy of the request among Robert's clothes. He had the body exhumed and the surgery performed.

Afterward, William Warren Baldwin's dream of "forever having a Baldwin at Spadina" unravelled. Robert's younger son, Robert Jr., had gone to sea as a young man and returned an invalid, struck with polio. William Willcocks, unsuccessful in business, went deeply into debt. In 1866, the would-be dynasty dissolved when he put Spadina up for auction.

James Austin (1813–1897)

James Austin bought the property. He outbid Robert Baldwin's son-in-law, former Grand Trunk Railway president John Ross, to snag Spadina for £3,550. Immediately, he knocked down the second Baldwin home and, on its foundations, built a third Spadina. Favouring comfort over architectural distinction, he created a rambling, spacious mid-Victorian country house, with lofty ceilings and matching side verandahs. Cleverly, he also preserved the handsome eight-panelled Baldwin front door — complete with elliptical fan transom and sidelights — through which Louis-Hippolyte La Fontaine, John A. Macdonald, Bishop John Strachan, and others once passed. James repurposed it as a rear family entrance, still in use today.

James was on his way up in the world. In 1829 he arrived in York from Ireland, and within two months, at the age of sixteen, landed a job as a printing apprentice to none other than William Lyon Mackenzie. He worked in Mackenzie's shop for four and a half years, politically tumultuous years during which the publisher attained prominence as a fiery Reform politician railing against the Family Compact. By late 1837 young James had become identified with the Radical Reform cause

enough to temporarily flee to the United States, but radicalism did not permanently rub off on him.

"His experiences with his old chief ... left him with an intense distaste for public controversy," writes Austin Seaton Thompson in *Spadina: A Story of Old Toronto*, a bloodless but factually dependable account of the Baldwins and Austins of Spadina. "He preferred to remain in the background."

With the 1843 amnesty James returned, and the following year married Susan Bright, daughter of a military man. The couple would have three sons and two daughters. With a business partner, James established a large retail and wholesale grocery business, which did well, and James invested wisely. Showing a capacity for hard work, and a talent for buying low and selling high, he built his fortune. He speculated in land and mortgages. He invested in the Consumers' Gas Company of Toronto and became its president. He helped found the Dominion Bank, a forerunner of TD Bank, and became its president as well. He helped turn around the troubled Whitby & Port Perry Railway, co-founded the Queen City Fire Insurance Company, and took over as the Canadian chairman of the North of Scotland Canadian Mortgage Company.

"Virtually all of [James] Austin's business activities seem to have been successful," historian Christopher Armstrong writes in the *Dictionary of Canadian Biography*.

In 1897 James Austin died at eighty-three, having risen among Toronto's emerging capitalist elite to establish Spadina as the seat of an anticipated Austin dynasty.

Albert Austin (1857–1934)

Albert Austin was the fifth child of five, and his father's successor. The eldest son, Charles, died at thirteen of a bowel disease. The second son, Jim, managed Spadina from a basement room until his death at thirty-eight of complications from pneumonia. The two other children were girls.

Albert started as a clerk at his father's Dominion Bank, and, like his father, went into the grocery business. In 1880, at twenty-four, he appeared to strike out on his own. He moved to Winnipeg and created an ambitious streetcar system, the Winnipeg Street Railway Company, but Toronto seemed never far from his thoughts. He named one of his

streetcar stops "Spadina," and returned briefly to Toronto to wed Mary Kerr, an amateur painter and pianist. Once back in Winnipeg, he hired his father's architect to build a house similar to Spadina, featuring a replica of his father's drawing room. Twelve years later, when he lost a turf battle to a rival company, he moved back to Toronto with his wife and five children, and into a house twenty minutes away from Spadina by foot. When James died in 1897, Albert acceded to the family estate.

From then on, Albert essentially lived his father's life. In many ways it was a good life. He became president of the Dominion Bank, the Consumers' Gas Company, and of a frontier enterprise called the Canada Northwest Land Company. His wife served as an executive member of the Women's Art Association of Canada, the Toronto Symphony Orchestra, and the Women's Musical Club of Toronto. Together they enjoyed financial success and social respectability, but at some level they appeared trapped in a script that Albert's father had written.

At Spadina, Albert undertook three separate renovations. In 1898, before moving in, he extended the north end of the house to create a new kitchen and a billiards room. He also converted his mother's parlour into the current dining room. In 1905, over the front entrance, he built an extravagant steel and glass cover, called a porte-cochère, and a sweeping south-end terrace. In 1912 he built a third floor with two large bedroom suites, two sitting rooms, and a servants' quarters.

He made Spadina bigger and more lavish, but not essentially different. Long before the city acquired the house as a museum, he retained the centrepiece drawing room as a living memorial to his elders, still furnished with the Victorian tables and chairs that his parents bought downtown at the Jacques & Hay Furniture Gallery in 1866. Somewhere along the line, Albert also began to view his father's self-made riches as old family wealth, and began to view himself as a type of aristocrat. Rekindling an old Family Compact fantasy, he looked on himself and his family as Upper Canadian gentry.

"A love song to every aristocratic pastime there is," Spadina historical interpreter Ann McDougall says of Albert's billiards room. At the time, billiards was considered a gentleman's game. Albert installed cork flooring around the table to help players in leather-soled shoes secure their footing. He also pursued the aristocratic sports of bird shooting and

big-game hunting. In the billiards room, an antelope's head juts from one wall, with a stuffed loon and stuffed peasant on either side. Paintings teem with dead animals and birds. On either side of the home's inside front entrance, two snarling stuffed wolves meet the visitor, and in the downstairs family hallway, giant taxidermy heads of a moose and an Irish Red Stag bear down on every passerby.

Photo courtesy of the City of Toronto, Museum Services, 1982.7.3846.2

A studio photograph on the library wall shows Albert and Mary's children in 1897. Left to right: Bertie, Adele, Anna Kathleen, Percy, and Constance Margaret.

In a special "palm room," Albert cultivated tropical plants and flowers, a high-status hobby, and he became a fanatic golfer — "again a gentleman's sport," McDougall says. On Davenport Hill, he built a private golf course, and later helped establish the Lambton Golf and Country Club, which still operates directly west of Spadina House on the Humber River. In 1904 he even entered the Olympic Games as a golfer at St. Louis, Missouri. His trophy still perches on the billiards room mantel.

"Back then you didn't have to be great at a sport, you just had to be pretty good and pay the entrance fee," McDougall says. "There were seventy-six competitors that year. Albert placed seventy-fourth."

Like the Baldwin succession, the Austin line dissolved at the third generation. Albert died in 1934 at seventy-seven. He and Mary had had two sons and three daughters. The eldest child, Percy, volunteered to fight on the front lines as an artillery gunner in the First World War, and returned home permanently disabled with shellshock. Afterward, he never worked. The third child, Bertie, died of tuberculosis at twenty-four. That left the three girls. Middle daughter Anna Kathleen and her son Austin Seaton Thompson became the last family members to live at Spadina. They vacated the house in 1982, when Kathleen partly sold, partly donated the house and its contents to the Ontario Heritage Foundation and City of Toronto. In 1984 Spadina House Museum opened to the public, the 1866 Jacques & Hay drawing-room furniture exactly where patriarch James Austin had left it.

WALK-THROUGH

Few heritage museums come complete with original furnishings. Usually, conservationists manage to rescue a home only slightly ahead of the wrecking ball, long after the founding family has scattered. Descendents might donate a few heirlooms, but most period objects put on display come from government warehouses picked over by imaginative curators.

Spadina House is different. In 1866 James and Susan Austin built a buff-brick mansion on the Baldwins' 1818 foundations, intending to create a permanent family seat. The couple ranked among Toronto's capitalist elite, but fancied themselves as something more. Spadina was intended to be passed down through successive generations, like a noble title. Instead,

the third generation partly sold, partly bequeathed the property — lock, stock, and barrel — as a heritage museum.

The house is special in another way. At most such museums, former servants' quarters remain off-limits, used for offices or storage. Spadina opened its servants' space to the public in 2013, including the steep stairways and narrow hallways that the domestic staff once used, hidden from family and guests. The inauguration led to the introduction of special *Downton Abbey* tours, named after the British television series depicting the lives of the aristocratic Crawley family and their servants in post-Edwardian England. Spadina is a Toronto brick home, Downton an English castle. Any comparison might sound absurd, but, partly by opening the servants' quarters, the Spadina museum staff make compelling associations.

In its presentation, Spadina House has been restored to how it looked in the 1920s and 1930s. Entering the home means crossing into the domestic world of the second and third generations, Albert and Mary Austin, and some their adult children. By the 1920s Albert and Mary were in their sixties. They had had five children — two boys and three girls. It helps to get everybody's name straight at the outset.

- Albert Austin (1857–1934), second-generation patriarch, president of the Dominion Bank, the Consumers' Gas Company, and the Canada Northwest Land Company.

- Mary Austin (1860–1942), society hostess, served on the Women's Art Association of Canada, the Toronto Symphony Orchestra, and the Women's Musical Club of Toronto.

- Percy (1885–1954), eldest child, fought as part of an artillery crew in the First World War, and returned home disabled with shell-shock. Following the war, he moved to Barrie, north of Toronto, and in 1934 moved back to Spadina, spending much of his time reading in the main-floor library. Loud noises unsettled him. He would "fall to pieces," the museum staff say. He never married and never worked.

- Adele (1886–1968), the second child, lived in the house until 1934, when she married at the age of forty-eight.

- Bertie (1888–1913), his father's would-be successor, died of tuberculosis at the age of twenty-four, a tragedy that permanently hung over the household.

- Anna Kathleen (1892–1983) married and moved out in 1912, raised a family of three children, and in 1942 moved back to Spadina, long since separated from her husband. She was the last Austin to occupy the family estate, vacating it for the last time in 1982. The museum opened in 1984.

- Constance Margaret (1894–1966), the youngest of Albert and Mary's children, remained unmarried and lived in the house until her death.

In the 1920s and 1930s, the period presented, Albert and Mary shared the house variously with Percy, Adele, and Constance Margaret.

Servants' Entrance

Visitors enter the house through the former servants' side door, which leads straight to the basement. From the reception desk, head across the hall to the former laundry room. Wall panels tell of the Baldwins and the Austins. The tour begins with a ten-minute video of Spadina and Toronto in the 1920s.

Before or after a tour, visitors can wander through the basement. In the 1980s museum archeologists excavated portions of the original Baldwin foundations, exposing walls and floors. They also mounted a permanent exhibit, with explanatory panels, centred on archeological processes and conservation techniques. At the end of the hall can be found an exhibit on early nineteenth-century rugs. Understandably, as the original Baldwin homes no longer exist, the museum focuses not the Baldwins, but on the Austins. The original Baldwin kitchen, with its 1818 hearth and bake oven, remains off-limits as a storage room.

Vestibule

Walk upstairs to the front vestibule, between the front and inside main entrance. Two menacing stuffed wolves stand on opposite sides, one grey, one black. Albert killed two just like them and displayed them the same way. "This was to show how powerful you were," the tour guide, or historic interpreter, explains.

Outside, two gas lamps perpetually burn. Neighbour Henry Pellatt, of Casa Loma across the street, ran the electric company. Albert ran the gas company at a time when gas lighting was on the wane, except at the Austin house.

Main Hallway

In the entrance hall, a grand staircase leads the eye to Mary's blue sitting room at the top, where she hung part of her art collection, rotating the paintings from time to time.

"So you get two messages right away," says the interpreter. "We are powerful, and we are civilized."

To the right of the door hangs a portrait of Albert as a bank president. To the left, the mounted plaster head of his father James hangs over the dining-room entranceway. The plaster image served as a model for one carved into the stone edifice of the Queen City Fire Insurance Company building on Church Street, since demolished. James co-founded the company. Next to the plaster head hangs a painted portrait of James, with a white beard and no moustache, painted by Mary Austin, his daughter-in-law.

Notice the three small "demi-lune," or half-moon, chairs in the entrance hall. Each has a lid that can be lifted for storing ladies' white gloves. It is said that Anna Kathleen, the home's last resident, waited on the forward chair while her chauffeur brought the car around.

Drawing Room

In season two of the television series *Downton Abbey*, Lady Mary and her fiancé, the self-made newspaper magnate Sir Richard Carlisle, are looking through a mansion that they might buy. The place is empty.

"What'll we do about furniture, and pictures, and everything?" Lady Mary asks.

Photo courtesy of the City of Toronto, Museum Services, 1982.7.1082

Albert Austin followed his father as president of the Dominion Bank and the Consumers' Gas Company.

"What does anyone do?" Sir Richard replies. "Buy it [all], I presume."

"Your lot buys it," Lady Mary says. "My lot inherits it."

Albert Austin was like Sir Richard, he still had to work for a living, but he fancied himself more like Lord Grantham, Lady Mary's father and patriarch of a family of established wealth. He treasured family heirlooms. At Spadina in the mid-1920s, he maintained the drawing room exactly as his parents had left it, with the same furnishings they bought at the Jacques & Hay Furniture Gallery in 1866.

Generally, the room overwhelms the eye. Highlights include Mary Austin's Steinway grand piano, which her father-in-law, James, gave her as a wedding gift in 1882. It remains in prime playing condition. In a far corner of the room can be seen one of the home's fourteen ornately

decorated cast-iron radiator grilles. Look closely and you see miniature figures such as owls and squirrels, representing Victorian virtues of wisdom and industry respectively. The two gas chandeliers, or gasoliers, are among five still found in the house. They can be turned on and off almost like a light switch.

Palm Room

A trap door in the floor allowed the gardener, Mr. Small, to enter the room from the basement to water the plants. Visitors love this story. He could come and go without bothering the family or house guests and without tracking dirt from outside. Current Spadina gardeners continue to keep a large outdoor Edwardian-style vegetable and flower garden, two apple orchards, and a spacious croquet pitch on the south lawn.

Albert built the Palm Room circa 1900 for cultivating tropical plants and flowers, an especially showy pastime as it meant heating a room that had wrap-around windows all winter. Fortunately, he was president of the gas company. The tiffany lamp, since refitted with electric light bulbs, dates to the 1930s.

Reception and Tea Room

With doors off the main hallway and drawing room, this smaller room, lined with red silk damask wallpaper, served as a reception area for Mary Austin's many debutante balls and society soirées. She would also receive lady friends here for tea. Souvenirs from European holidays decorate the shelves. On the table to the immediate left of the hallway door stand three exquisite hand-made vases from the Daume glass shop in Paris. The large urn in front of the mirror dates to the 1900 Paris Exhibition.

Dining Room

A portrait of Mary Austin catches the eye almost immediately. Painted by Toronto society artist John Colin Forbes, Mary sits in her buttoned-up wedding dress next to her new Steinway. To the left hangs a portrait of Frank Smith, a businessman mentor to Albert Austin when he was young. To the right hangs an image of Bertie, the second son, looking handsome and banker-like prior to dying of tuberculosis at twenty-four. John Colin

Photo by John Goddard, courtesy of the City of Toronto, Museum Services, Spadina Museum

Historical interpreter Ann McDougall holds up a photo of Downton Abbey characters Lady Edith and Sir Anthony at the entrance to the main floor reception room. On the "Downton Abbey tour," a parallel is drawn between Edith's difficulty in finding a husband after the war and that of Austin daughters Adele, who married at forty-eight, and Constance Margaret, who remained single.

Forbes also painted the Bertie portrait, along with the separate likenesses of James and Susan Austin on the right-hand wall.

In 1938, four years after Albert's death, Mary redesigned the space in the way curators present it today. "The room is more plainly decorated than it might have looked before the 1930s," says program officer Douglas Fyfe, "with less pattern and fewer colours."

The family used the room for breakfast, lunch, and dinner, and for formal dinner parties. With a button at her feet under the carpet, Mary could sound a buzzer in the kitchen to summon the next course.

Family heirlooms abound. The sideboard along the right-hand wall dates to the 1860s. The silver teapot, which tips without being lifted, dates to the 1880s. To the extreme left, a series of colourful art deco vases line the marble top of the radiator grille.

"In 2011 a pipe burst right above the beautiful plaster detail in the ceiling, and a third of it melted like sugar," says staff interpreter McDougall. "We thought we had lost it, but we did a little research and found the great-great — maybe one more 'great' — grandson of the man who did the original plaster work. He came in and fixed the damage, and it is perfect."

Telephone Room

Soundproofed with green felt, the booth next to the dining room houses two telephones. The small one on the right served as a hotline to the chauffeur, who lived with his family in an apartment on the first and second floors of the garage. The larger phone connected to an outside line.

"The telephone room dates to the 1890s," says interpreter McDougall. "Most places in the world didn't get dial service until the mid-1930s. Toronto got it in 1924."

Library

To this point in the tour, all the rooms functioned as formal family areas into which guests would also be invited to dine, party, or sip tea. The rest of the house divides into private family rooms and servants quarters. Normally, the door off the main hallway to the left would be closed. It opens to a corridor, and, to the immediate right, the library.

Although the Austins read avidly, they kept most of their books in their bedrooms, but few in the library, with its one small bookcase. "Radio room" might be the better name. "They loved the radio," McDougall says of the family. "It cost them about five hundred dollars, which would be like dropping six thousand dollars today."

Elder son Percy spent much of his time in the library after returning to Spadina in 1934, still shellshocked from the war. A small painting on the wall shows him in uniform. Youngest child Constance Margaret also volunteered in the war. She trained as a nurse and worked overseas at an English convalescent hospital. A studio black-and-white photograph on the same wall shows her at the age of three with her brothers and sisters.

Billiards Room

This was Albert's room — "A love song to every aristocratic pastime there is," McDougall calls it. Before moving into the house in 1898, Albert built a northern addition to create this aristocratic den, with a large billiards table as its centrepiece, stuffed birds and animals decorating the walls, and golf trophies littering the mantel.

The room's most outstanding artistic feature can be seen along the upper portion of the walls. An art nouveau frieze, or wall painting, sometimes attributed to interior decorator and muralist Gustav Hahn, evokes the Austin apple orchards beyond the windows.

To the left of the doorway hangs a painting of Albert's elder brother, Jim, regally mounted on a horse, done by Jim's artist friend Edward Scrope Shrapnel. Jim managed Spadina until his death in 1891, but showed no ambition to succeed his father as head of the family. Below the painting, Albert and Jim's sister, Anne Arthurs, poses in a photograph with friends in front of the Egyptian pyramids at Giza.

Kitchen

During his 1898 renovation, Albert built a bright, modern kitchen with high ceilings. Two stoves line one wall, a cast-iron model that once burned both wood and coal and a more modern Moffat gas stove that still works after more than ninety years. During Christmas events, staff members use it to heat apple cider.

Processed foods, with reproduced period labels, stock the kitchen cupboards, everything from Kraft cheese and Puffed Rice to tinned salmon and Carnation condensed milk. Around the corner looms a gigantic four-door icebox. In an early recycling innovation, Albert arranged for the melted ice to be piped outside to water the flowers.

Baldwin Door

People entered Spadina in one of three ways — the front main entrance, the servants' side door, or the family's rear door. The rear door is the former front door to William Warren Baldwin's 1835 Spadina, a solid eight-panelled green door with overhead window and sidelights intact. Outside in the yard, the former Baldwin hand-crank water pump can also be seen in its original spot.

Second Floor: Master Bedroom and Blue Room

Part of the corridor remains roped off where the children's bedrooms and a former nanny's room have been converted for administrative use. The en suite master bedroom and Mary's sitting room, known as her "blue room," feature as the floor's two main public attractions.

Albert and Mary shared a bedroom, or "bedchamber" as it was called, although Albert also kept a third-floor bedroom for himself, the one originally built for Bertie as a hospital room.

In the shared bedroom, the high ceiling and giant headboard create an optical illusion, making the marital bed appear short and small, although it takes a modern double mattress. The large walk-in closet, built before hangers became popular, displays sample reproductions of Mary's outfits on mannequins.

The bathroom features a shower, advanced for the time, and a sitz bath, a tub for soaking to the hips to relieve hemorrhoids and other problems. Both in the conjugal bedroom and his own room upstairs, Albert installed an innovative gas-fired contraption on the wall next to the sink to heat his shaving soap.

The especially beautiful and elegant blue room, visible from the downstairs entrance hall, served as Mary's sitting room and picture gallery. She collected art, and rotated her paintings on walls covered in blue damask wallpaper.

Third Floor: Servants' Quarters

In early 2013 Spadina House opened its third floor to the public for the first time, prompted by popular interest in how servants lived. Led by Ann McDougall, the museum inaugurated its *Downton Abbey* tour, drawing parallels between life at the fictional Downton Abbey and the much more modest Spadina. Regular tours also now include a look at the third floor.

Albert had the floor added in 1913, partly as a private hospital to treat Bertie's tuberculosis. Big windows and a generous skylight were to offer plenty of fresh air and sunlight to help his recovery, but the construction dust proved intolerable for Bertie. Feeling strong enough, he decided to escape with friends to Italy and Egypt, but in Cairo he fell gravely ill and died, and the Austin dynasty died with him.

The third-floor family rooms, including what would have been Bertie's room, do not meet modern building codes and remain off-limits, but the servants' rooms can be seen. In the 1930s, three women occupied them — a cook named Mrs. Wallace, and two housemaids. Each had her own room. The chauffeur lived in an apartment in the garage. The gardener, Mr. Small, lived in a cottage beside it. Other occasional servants lived offsite and could arrive as needed — two part-time cleaning women, an assistant gardener, and special caterers for grand occasions.

"It's like a time capsule," McDougall says of the live-in servants' quarters. The wallpaper is original — untouched for a hundred years. Building standards are high. The bathroom has a flush toilet. The ceilings are generous, the rooms bright. Two mannequins at the end of the hall show reproductions of the morning and afternoon Spadina maids' uniforms circa 1925. For scrubbing and dusting, a maid wore the plain uniform on the left, with its brown blouse and white smock. For the more public afternoon and evening work, which might include serving tea, the maid would change into the smarter clothes, with a navy-blue top of wool crepe. Both outfits feature a low waist and big triangular shapes with an art deco influence.

On the *Downton Abbey* tour, which includes negotiating narrow passageways and steep staircases, McDougall tells of a shocking but common practice, never shown in the TV series. It is called "giving room."

"If a lower servant — a housemaid or lower — was to pass a family member in a hallway of a house like this," McDougall says, "they were expected to give room. This wasn't just stepping back. Giving room meant turning and resting your forehead against the wall so that the family member could pass without making eye contact with you. The practice was normal for the time.

"This is a tiny hallway," she says of one of the servants' passages. "I don't have a long reach and I can touch both walls. This is a teeny space. But if you were to use the family hallways and gave room every time a family member passed, you wouldn't get anything done."

From that standpoint, she says, servants felt grateful to have their own hallways, however cramped.

JACQUES & HAY CENTRE OTTOMAN

The eye-catching chair in the middle of the drawing room is called a "centre ottoman." The wide space on either side allows a woman to sit in a bulky crinoline-lined mid-Victorian gown. The narrower spot at either end seats a man. Tiny ceramic castors at the feet allow the chair to roll away. On party occasions, when Mary Austin might play the piano, the ottoman could be moved to create a dance floor. The wood of the chair is walnut, masterfully carved with a repeating husk, or bellflower, motif by workers at Toronto's Jacques & Hay Furniture Gallery.

"It has been said that the firm hired sailors from the Great Lakes in the off-season to do furniture carving," writes Ruth Cathcart in her 1986 book *Jacques & Hay: 19th Century Toronto Furniture Makers.*

The first-generation Austins, James and Susan, bought the chair in 1866, the year James bought Spadina at auction and rebuilt it. By then, Jacques & Hay enjoyed by far the largest furniture manufacturing business

Photo by John Goddard, courtesy of the City of Toronto, Museum Services, 1982.7.250

The eye-catching "centre ottoman" in the drawing room provides wide spaces for women in bulky crinoline-lined Victorian gowns, and narrower spots for men. The first-generation Austins bought the chair in 1866, the year James Austin purchased Spadina and rebuilt it.

in British North America, with a five-storey brick factory south of Front Street between Bay and York Streets.

The company's biggest order that year perhaps came from Ottawa's Rideau Hall, which the Canadian government had leased as a residence for the Viscount Monck, last governor-general of Canada East and Canada West. The following year, in 1867, he also became the first governor-general of Canada. For him at Rideau Hall, government officials ordered an array of drawing-room settees, tables, and chairs, including a centre ottoman and furnishings for the dining room and seven bedrooms.

James and Susan Austin continued to favour the store. Cathcart's book teems with pictures of their purchases. Most can still be found throughout the house, including a serving sideboard in the dining room, the half-moon chairs in the front hallway, the Rococo Revival mirror to the left of the reception-room entrance, and an array of drawing-room chairs that match the centre ottoman.

NEIGHBOURING ATTRACTIONS

Casa Loma

Albert Austin must have regretted selling the field across from his house to Henry Pellatt, the narcissistic financier who used the site to build a fanciful medieval-style castle. In full view of the Austin parlour, Pellatt built Casa Loma, a ninety-eight-room pile ranked as Canada's biggest monster home. Before finishing it, Pellatt ran out of money and had to vacate the premises. Not knowing what else to do with the place, successive city administrations have maintained it as a tourist attraction. Pellatt ran the electric company, Austin ran the gas company. Did they hate each other? Nobody at Spadina House suggests that they were anything but congenial neighbours.

E. J. Lennox House

Toronto architect Edward James Lennox, designer of Casa Loma, the King Edward Hotel, Old City Hall, and dozens of other Toronto houses and buildings, erected his dream home near Casa Loma at 5 Austin

Terrace. He finished it in 1915, and called it "Lenwil," a combination of Lennox and Wilson, his wife's maiden name. Set on a substantial property, with a brick gate at the entrance, it now serves as residence for an order of Ukrainian Catholic nuns, the Sisters Servants of Mary Immaculate of Christ the King. The nuns also run a music school on the premises.

The Baldwin Steps

A stairway of 110 steps, adored by fitness enthusiasts, leads from Davenport Road up the sharp rise to Spadina House on the right and Casa Loma on the left. Two plaques can be found at the foot of the stairs. One is to William and Robert Baldwin, "whose drive for peaceful change brought about major constitutional and administrative reform." The other honours Casa Loma builder Henry Pellatt. "A flamboyant entrepreneur, he was fascinated by the Middle Ages," it says. Two more plaques to the Baldwins and Pellatt can be seen at the top.

Spadina Line

A curious public art project stretches for half a block along the west side of Spadina Avenue, between the Baldwin Steps and a railroad underpass. Mounted in 1991 by Toronto artists Brad Golden and Norman Richards, the work features a series of seven capitalized words embedded in the sidewalk in bronze, each word marked by a futuristic sculptured lamp-post. "Iroquois" refers to prehistoric Lake Iroquois, which had its shore-line at Davenport Hill. "Furrow" evokes a former local market garden. "Survey" pays tribute to the land allotments of Lieutenant-Governor John Graves Simcoe. "Avenue" recalls William Warren Baldwin's creation of his grand Spadina Avenue. "Power" alludes to Henry Pellatt's harnessing of Niagara Falls for hydroelectricity. "Dairy" memorializes the former nearby Acme Farmers Dairy. "Archive" gives a nod to the Toronto Archives complex across the street. In the underpass itself, an explanatory plaque of the art project appears, along with other words, and a digital clock. Directly across the street, also in the underpass, three metal bars mark where the sun's rays fall at the summer and winter solstices and spring and fall equinoxes.

City of Toronto Archives

In addition to being an essential stop for researchers, the archives employees at 255 Spadina Road, across from the Spadina Line installation, regularly stage photography and other exhibitions. Admission is free.

FORT YORK NATIONAL HISTORIC SITE

The Toronto Signals Band marches past Fort York over the Bathurst Street bridge on April 27, 2013 — exactly two hundred years after American troops overran the fort to capture the capital of Upper Canada in the War of 1812. Although they fled, the British troops under General Sir Roger Sheaffe lived to fight another day.

Address
250 Fort York Boulevard, near Bathurst Street and Lake Shore Boulevard West.

Getting There by TTC
Take the Bloor/Danforth subway line to Bathurst Station. Transfer to the 511 streetcar south. Get off at Bathurst Street and Fort York Boulevard West and walk west to the fort's main entrance.

THE BATTLE OF YORK

What a climax. As the Americans advanced, the British fell back. With a final assault imminent, with precious seconds ticking away, the British improvised a fuse to ignite their own gunpowder magazine, creating an explosion so powerful that it killed and wounded more of the enemy than had fallen so far in the entire campaign. Smoke and debris rose like "a vast balloon," one onlooker said. The blast rattled windows sixty-seven kilometres away at Niagara. It hurled a shock wave at the Americans, then rained rocks, timber, and cannon and musket balls on them. In a movie scenario, the British might have seized the moment to rush the dazed American army. At the Battle of York in 1813, however, the British merely snatched their chance to make a full retreat. In exploding their magazine, the British had never intended to kill anybody. The British commander only wanted to stop the invaders from looting his powder cache as he and his army fled.

"He appears on the occasion to have acted without judgment or any fixed plan," British historian Gilbert Auchinleck writes in 1855 of the overall conduct of General Sir Roger Sheaffe, the British commander and lieutenant-governor of Upper Canada.

Put more positively, Sheaffe and his troops lived to fight another day. By acting as he did, Sheaffe left nothing for the Americans to capture. Not only did he destroy his own magazine, he also burned the *Sir Isaac Brock*, a newly built British gunship designed to dominate the Great Lakes, preventing it from falling into American hands.

"If Sheaffe had stayed and defended the town to the last man, he still would have lost the battle," says Fort York program officer René Malagón. "It was a difficult decision [to retreat], but probably a wise one."

Fort York might be said to have a long history. It began in 1793 as a military outpost at what was to become Toronto, and served as a barracks as recently as the First World War. At the same time, the fort saw limited action. During the 1837 Rebellion it stood empty, all the soldiers having left to quell disturbances in Lower Canada. Only once did the fortifications face a ground invasion, and the Grand Magazine explosion counts by far as the site's most dramatic moment.

The date was April 27, 1813. One year earlier, U.S. president Thomas Jefferson declared war against Great Britain and attacked Upper Canada,

a British colony. In battle after battle, the British defenders prevailed, and by the spring of 1813 the Americans badly needed a victory. From their naval port at Sackets Harbor, New York, opposite Kingston on Lake Ontario, the U.S. generals waited for the ice to break. They prepared to invade York. They set themselves three goals: overrun the fort, occupy the capital, and seize the *Sir Isaac Brock*. The ship was nearing completion in the boatyard and, once built, would be equipped to carry thirty guns.

York was still a village then. Its chief attribute was a naturally defended harbour. A peninsula, since broken into the Toronto Islands, arched westward around the lakeshore protecting it from storms and would-be invaders. The fort guarded the harbour's entrance, at the foot of what is now Bathurst Street. Two kilometres east, at the edge of the Don River Valley, lay the beginnings of a town, population six hundred. On the evening of April 26, a flotilla of fourteen tall-masted warships could be seen off the Scarborough Bluffs east of the capital. In the early morning of April 27, they were spotted at full sail off Gibraltar Point, opposite the fort.

"Could see the American fleet when it came light," York farmer and volunteer soldier Ely Playter wrote in his diary. "We heard the Guns begin to fire just after we started back we came double-Quick all the way."

American odds for victory looked excellent. Their ships carried 2,700 sailors and soldiers, including 1,700 ground troops to face a defence contingent numbering perhaps 700 men — a mix of British regulars, local volunteer militia, and a few dozen Mississauga, Chippewa, and other tribes of the Anishinaabe First Nations. The invaders possessed ninety large guns on their ships and in the field. The British could marshal barely twelve, not all in good repair. Over the next eight hours, the battle unfolded in six main stages.

Stage One

Shortly after 7:00 a.m. the first wave of American troops landed in longboats, two or three kilometres west of the fort near High Park, where Sunnyside Beach is now. The Native fighters engaged them, suffered heavy casualties, then dispersed.

Stage Two

At 7:20 a.m., with their ships providing cover with cannon fire, American troops continued to come ashore. British regulars, led by Captain Neal McNeale, lined up to stop them at the western end of what is now the Canadian National Exhibition grounds.

"Almost immediately McNeale was shot through the head and died on the spot," Canadian historian Robert Malcomson writes in his comprehensive 2008 account, *The American Attack on York, 1813*. The well-trained British troops fired one volley, then surged forward with bayonets. Soon, however, they were "being cut to ribbons," Malcomson says, and they too retreated.

Stage Three

After that, the battle progressed more slowly. The overall U.S. commander, General Henry Dearborn, remained aboard his ship, the *Madison*. Responsibility for leading the ground attack fell to Brigadier-General Zebulon Pike, an energetic and intelligent leader and a former explorer of the American Southwest. Pike's Peak in the Colorado Rockies takes his name.

By 10:00 a.m. Pike was assembling his American troops near where British captain McNeale had fallen, preparing an assault on the fort. Nearly all his men were ashore with their equipment and provisions. Twice, British general Sheaffe attempted assaults against the invaders, and twice he was driven back.

Stage Four

On the water, at least six American ships were firing on the fort itself, and the fort's four batteries, or gun positions, were replying in kind. The British became rattled. Sheaffe, inexperienced on the battlefield, dithered. He stopped giving orders, and discipline among his troops deteriorated. At the largest and most westerly British gun position, the Western Battery, one of the gunners accidentally dropped a match into a box of cartridges, blowing up the battery, and killing himself and nineteen others outright. Body parts flew everywhere. Survivors hauled away the wounded. Twelve-year-old Patrick Finan watched some of them arrive at the garrison hospital, and described the scene in his memoir, *Recollections of Canada*, when he was twenty-eight.

"One man in particular presented an awful spectacle," Finan writes of the horror. "He was brought in a wheel-barrow, and from his appearance I should be inclined to suppose that almost every bone in his body was broken; he was lying in a powerless heap, shaking about with every motion of the barrow, from which his legs hung dangling down, as if only connected with his body by the skin while his cries and groans were of the most heart-rending description."

With the main gun position destroyed, Finan concludes, "a retreat towards the garrison became inevitable."

Stage Five

By 11:00 a.m. the Americans had landed their artillery. Methodically, Pike advanced toward the disabled Western Battery, leading his men through the woods and across small streams unopposed. From the battery, four remaining British gunners uselessly fired over the enemy's heads, their guns mounted high for firing at ships.

At about 12:30 p.m. the British gunners dispersed, and Pike took the battery. He led his men toward the next British position, the Half-Moon Battery, and found it abandoned. The route lay open to Government House, seat of British rule in Upper Canada. Pike ordered his artillery forward. He waited "hopefully for a white flag and proposals of surrender," says Toronto historian C.P. Stacey, in his lucid 1963 reconstruction, *The Battle of Little York.*

Instead, British general Sheaffe pretended to hang on. He left the Union Jack flying over the fort, and the Royal Standard flying over Government House. It was to be the only Royal Standard, symbol of British sovereignty, ever lost in battle and never recovered, says the 2012 History Channel documentary about the war, *Explosion 1812.* The flag now resides at the United States Naval Academy in Annapolis, Maryland.

Stage Six

Without officially surrendering, Sheaffe ordered a withdrawal. He also ordered a detail to ignite the Grand Magazine. Leadership for the task fell to sixty-year-old Captain Tito LeLièvre, a Frenchman by birth, then serving with the Royal Newfoundland Regiment. With him were likely "a couple of trustworthy hands, one of whom may have been Ensign James

Robins of the Glengarries," says historian Malcomson. Other accounts identify the soldier who actually lit the fuse as a Sergeant Marshall.

Had the explosion been planned in advance, LeLièvre might have used a "saucisson," Malcomson says, a hose made of heavy fabric, an inch and a half in diameter, packed with half a pound of gunpowder per foot to be used as a fuse. No saucisson, however, appears in any record.

"It is likely that LeLièvre had to improvise," Malcomson says.

The most obvious way to improvise a fuse would be to spill gunpowder on the magazine floor and run a thick trail of powder out the door long enough to ensure a head start. The moment must have been tense. Pike's men were on the brink of attacking. American ships were still firing their cannons. With Captain LeLièvre and perhaps Ensign James on the run, Sergeant Marshall struck a spark and sprinted for cover as a flame ran down the line of powder toward the magazine.

The magazine was built of stone and timber and was sunk deep into the embankment at the edge of the fort, at the lakeshore. Some accounts say it held five hundred barrels of gunpowder. Some say two hundred. Most go with three hundred, or as Malcomson puts it, the equivalent of "about seven tons of TNT," along with ten thousand cannonballs, an undocumented number of musket balls, and related materiel such as explosive musket and cannon cartridges.

The magazine did not blow straight into the air. In a re-enactment by explosives experts, the makers of the History Channel film show that the main force of the blast would have shot west out of the magazine's door — straight at the American troops. The most forward of the troops, poised to rush the fort, stood only 180 metres away.

Eyewitnesses recorded the devastation. One of the most poignant accounts comes from the boy Finan, who, after watching the Western Battery casualties, went with his mother to stay at a militia officer's house, then returned.

> Feeling anxious to know the fate of the day, I left the house without the knowledge of my mother, and was proceeding towards the garrison, when the explosion took place. I heard the report, and felt a tremulous motion of the earth, resembling the shock of an earthquake; and

looking towards the spot I saw an immense cloud ascend into the air. I was not aware at the moment what it had been occasioned by, but it had an awfully grand effect; at first it was a great confused mass of smoke, timber, men, earth, &c. but as it rose, in a most majestic manner, it assumed the shape of a vast balloon.

The most distant account comes from U.S. colonel George McFeely, at Fort Niagara, New York, opposite what is now Niagara-on-the-Lake.

"A tremendous explosion took place," he writes, "which shook the building in Fort Niagara and made the glass in the windows rattle like what rolling thunder will do sometimes, although this place is forty-two miles from York across the lake."

Others described the carnage.

"Hardly a man escaped without a bruise," U.S. major Abraham Eustis wrote to his uncle a few days later, quoted in Fort York's exhibit on the battle.

"A stone as big as your fist struck me on the head, and nocked [sic] off a piece of my scalp as broad as your hand!" U.S. corporal Samuel Stubbs recalled two years later, counting himself lucky. "I didn't mind much, but waddled on with the rest over dead bodies as thick as cowslops."

"The Surgeons wading in blood, cutting off arms, legs, and trepanning heads to rescue their fellow creatures from untimely deaths," U.S. surgeon's mate William Beaumont recorded in his diary the day of the explosion. "To hear the poor creatures crying 'Oh, Dear! Oh, Dear! Oh, my God, my God! Do Doctor, Doctor! Do cut off my leg, my arm, my head, to relieve me from misery! I can't live, I can't live.' Would have rent the heart of steel, and shocked the insensibility of the most hardened assassin and the crudest savage."

Witnesses counted 38 killed outright and another 222 seriously wounded, many of whom would die later of their injuries, a total of 260 casualties. The blast also wounded a few British soldiers who had not heard the order to retreat.

Pike himself lay near death. He had been interrogating a British sergeant who had been taken prisoner. The blast had killed the sergeant outright, along with an American officer next to Pike. "I am mortally

wounded — my ribs and back are stove in," Pike said, as later recorded by his aide-de-camp, Lieutenant Fraser.

Fraser helped Pike to a boat. As they reached General Dearborn's ship, the *Madison*, they heard cheers from the shore. Pike turned his head. "What does it mean?" he asked, as Fraser recalled the moment. "Victory," came the reply, and somebody rowed across to them with the British flag, and put it under the general's head for a pillow as he died. Fraser recalled the flag as the Union Jack. Others identified it as the Royal Standard.

British General Sheaffe retreated. He sent a second detail to torch the *Sir Isaac Brock* and the naval storehouse, then led his men across the Don River, and burned the bridge behind him. From there he and his army began the hard slog by foot in the April cold all the way to Fort Henry at Kingston.

Soldiers who fell in the War of 1812 are remembered along with those of First and Second World Wars in a ceremony November 11, 2013, at the Strachan Avenue Military Burying Grounds adjacent to Fort York. The commemoration takes place annually.

For five days, the Americans occupied the tiny capital. They looted homes abandoned by fleeing citizens, and burned almost every public building in town, including the fort, the Parliament Buildings, and Government House. A year and a half later, on November 8, 1814, the British took their revenge. A British naval force captured Washington, D.C., and in explicit retaliation set fire to the Capitol building and the White House.

Ultimately, the British successfully defended their colonies of Upper and Lower Canada. The Treaty of Ghent, signed on Christmas Eve 1814, restored the borders with the United States to what they had been before the war, and with the reconfirmed boundary came the beginnings of a sense of Canadian identity. General Sheaffe never returned to York. "[He] had lost entirely the confidence of the regulars and militia and his very name is odious to all ranks of people," Reverend John Strachan wrote to London after the battle. Plaques at Niagara commemorate Sheaffe, however, for taking command the year before from the fallen Sir Isaac Brock to win the Battle of Queenston Heights.

WALK-THROUGH

Fort York now stands victorious against an invasion of waterfront condominium developments. With its cannons and stone walls, not to mention a National Heritage designation, it valiantly holds out as a calm, green redoubt against an otherwise triumphal march of concrete and glass apartment towers. Reinforcements are also on the way. A grand visitors' centre is about to open outside the main gate, a Fort York library branch is opening across the street, and artist drawings show plans to build pedestrian bridges linking parkland west of the fort to other green spaces. Arts organizations have discovered the site. The 2012 Luminato festival mounted "The Encampment" exhibition on the fort's grounds, featuring two hundred white canvas tents. The seminal American alt-rock band the Replacements also used the fort to stage its first gig in twenty-two years as part of the 2013 Riot Fest. Both events drew new audiences to the historic military compound, as did commemorative celebrations of the bicentennial of the War of 1812.

The term "Fort York" cannot be found in any historic document. Fort Henry defended the border at Kingston. Fort George defended Niagara. What Lieutenant-Governor John Graves Simcoe created at Toronto in 1793 he called a "military garrison," or "post," and since he preferred English names over local Native terms such as "Toronto," he called the place "York."

Simcoe founded York as a shipbuilding and naval centre. The garrison, he thought would help defend the already naturally protected harbour from enemy naval attack, but not from the type of overwhelming land invasion that the Americans mounted in 1813. Simcoe also moved the administrative capital of Upper Canada to York from Niagara.

He built his garrison where Fort York stands now. His rough-hewed buildings quickly rotted, however, and the British soon rebuilt them on the east side of Garrison Creek, or the east side of present-day Bathurst Street. This was the "Fort York" that the Americans overran and burned in 1813, although Government House, the Government House artillery battery, the Grand Magazine, and a few other defences occupied the current Fort York site. Almost immediately after the Americans left, the British began rebuilding on Simcoe's original site, the current museum compound.

Eight buildings stand on the site today. One, the "blue barracks," is a reconstruction. The other seven date to the period of 1812–14, all among the oldest surviving buildings of British settlement at Toronto. Familiarity with the grounds requires more than one visit, but a basic tour can cover both the military history of the "fort" and what life might have been like for the soldiers and others who lived there.

Blockhouse Number Two

As a school project in 1934, sixteen-year-old Sheila Wherry built a model of what Fort York and its surroundings looked like after the post-1813 reconstruction. The museum has displayed the model ever since. With the opening of the visitors' centre it might move, but traditionally it has drawn crowds to the main floor of the large, white, central building called Blockhouse Number Two.

"Try to imagine what things looked like after the reconstruction," a guided tour often begins. The model shows the fort at the water's edge protecting the sole entrance to the harbour, with the Gibraltar Point lighthouse at the end of a peninsula opposite. At the harbour's other end, two

kilometres from the fort, lies the little town of York, supplier to the garrison and capital of Upper Canada.

Today, the fort and lighthouse remain in place, but everything else has changed. In the 1850s city engineers started filling in the lakefront for railway lands. In 1858 a violent storm opened the peninsula at its eastern end, creating the Toronto Islands. Since then, the islands have been shifting, making Gibraltar Point today appear far removed from the harbour entrance.

Next to Sheila Wherry's project, a second model, dating to the 1950s, shows the fort up close, with more than twice as many buildings as stand today. The main gate, unlike now, opens at the east end, facing town. Two key buildings look unfamiliar, as they no longer exist. One is the guardhouse, busily monitoring traffic in and out. The other is the commandant 's quarters, a red-brick Georgian mansion resplendent against the garrison's generally austere military look.

Photo by John Goddard, courtesy of the City of Toronto, Museum Services, Fort York National Historic Site

Fort York program officer René Malagón holds up a drawing of Fort York as it looked in 1812 and indicates the American attack from the west in the 1812 Battle of York. Sixteen-year-old Sheila Wherry created the scale model of Upper Canada's capital and its defences as a school project in 1934.

Other permanent exhibits on two floors display muskets, swords, uniforms, and regimental accoutrements, illuminating the British period at Fort York from its founding in 1793 to Canadian Confederation in 1867.

The most impressive artifact might be the blockhouse itself. Built as a kind of fort-within-a-fort, it once housed up to 160 people behind walls built of square timbers, which were filled with up to one metre of rubble, mainly rocks and gravel. Narrow slits, instead of windows, allowed for firing at the enemy while staying protected, and the second floor overhang meant that a soldier could fire down on would-be intruders.

On the way out, notice the two battered cannons. One is from the mid-1700s. The other, nearest the door, counts as "one of the rarest surviving pieces of British military in the world, a gun that actually dates to the realm of Oliver Cromwell, a fabulous item," says Fort York program development officer Kevin Hebib. It is called a Commonwealth Culverin Drake. It was cast in the 1650s, considered obsolete by the War of 1812, but was nevertheless pressed into service for the 1813 Battle of York, becoming the most effective British gun against the American navy at the Western Battery. Afterward, it served humbly as a bumper to prevent wagons from rolling too close to one of the soldiers' barracks. In the 1930s somebody dug it up and put it on display.

Stone Magazine
Gunpowder barrels of the type that blew up the Grand Magazine in 1813 occupy the replacement stone magazine. Notice the bands of metal that wrap around the wooden barrels to hold them together. Archeologists have dug up scores of twisted barrel bands dating to the explosion, several of which occupy a glass case here.

The highly engineered stone magazine features a vaulted bomb-proof ceiling, walls two metres thick, and a sophisticated ventilation system designed to keep the powder dry without leaving the magazine vulnerable. The magazine's builder, Lieutenant William M. Gossett, has left his initials in a far corner, along with the year of construction, 1815. His original keystone from above the entrance is on display, along with an engraving that alludes to the reign of King George III.

The Well

Several wells were sunk inside and outside the fort over its history to ensure a supply of clean drinking water during a potential siege. This one was constructed in 2007 from nineteenth-century timbers recovered by archeologists at nearby Queen's Wharf.

The Maple Tree

The large maple tree near the well at the south wall marks approximately where the Grand Magazine stood when it exploded in 1813, killing or seriously wounding 260 American soldiers and sending a shock wave through their entire ranks. A plaque commemorates the Rush-Bagot Treaty, signed between Britain and the United States after the War of 1812 to largely demilitarize the Great Lakes and Lake Champlain.

Soldiers' Barracks

So far, the tour has emphasized the fort's military history and capability. Beginning with the brick barracks parallel to the west wall, the focus shifts to domestic life.

The room at the northern end of the barracks, built in 1815, accommodated up to thirty-two people, including some wives and children. Double bunk-beds slept as many as eight. Soldiers took turns cooking for the group at the cookhouse and bringing the meals back to the room.

Over time, the army improved conditions for the common soldier. By the 1830s eighteen people shared the room. By the 1860s the same space served as married quarters for three soldiers and their families. Shortly afterward the unit housed one soldier, his wife, and children.

Captain Brunker's Apartment

By the time he died in 1867, James Robert Brunker had risen to become commander-in-chief of British forces at Hong Kong. In 1835, while still a captain, he arrived in Toronto with the Fifteenth Regiment of Foot, the East Yorkshire Regiment.

He took up quarters in the Officers' Barracks and Mess Establishment, the red-brick building with green shutters and chimney ladders. It is the fort's most complex structure, with officers' rooms, kitchens, a grand officers' dining hall, and other facilities. Curators have restored it to the period

1834 to 1837, from the time of York's incorporation as the City of Toronto to the Upper Canada Rebellion, coinciding with Brunker's residency.

Enter through the door at the middle of the building. The rooms to the left side of the corridor served as Brunker's apartment. The first room he used as a sitting room and office. "Army officers flourished their pens far more often than they brandished their swords," says the museum's portable audio guide. None of the objects on display belonged to Brunker, but the furnishings and artifacts are typical of such lodgings of the period.

In the captain's bedroom next door, a reproduction Fifteenth Regiment officer's coat hangs over a chair next to a simple wood stove. The chest of drawers along the right-hand wall was built to travel, either to such outposts as Toronto or to a tent during a military campaign. Reinforced corners and inset handles on either side contribute to the rugged design.

At the end of the hall, an army servant prepared Brunker's meals in a simple, utilitarian kitchen. "Officers were allowed to have servants, what they later called batmen in the army," says program officer Hebib, "but they still had to be good, trained soldiers, and keep their arms and equipment in good repair."

Officers' Mess Establishment Anteroom

Across the hall from Brunker's quarters, a door opens to the Officers' Mess Establishment. The first room, the anteroom, serves as the commissioned officers' living and recreation area, with a sofa, chairs, tables, and other furnishings. The walls are a bold mustard colour, typical of the period and similar to Brunker's rooms. On a small desk in the corner lies a thick hardcover book. It is the annual Army List. It gives the name of every British officer worldwide — age, rank, when enlisted, and where currently stationed. Any officer wishing to transfer to another post would not only request such a move, but also find somebody of similar rank and seniority with whom to trade.

Officers' Mess Establishment Dining Room

The fort's grandest surviving room functioned as a kind of gentlemen's club for all commissioned officers at the garrison. They gathered for dinners here on special occasions, such as the King's birthday, religious holidays, and when entertaining visiting dignitaries. The table is set in

the Georgian style. The mess president, not a servant, would ladle the soup from the tureen at the head of the table for others to pass around, and at the next course carve the beef as well — "something they often get wrong in historical fiction," Hebib says. The regiment, not the fort, owned the silverware, plates, serving dishes, and other table necessities. When the unit moved, their dining equipment moved with them.

Toronto's Oldest Kitchen

Past the dining-room pantry and a kitchen pantry, a steep staircase leads to the remains of the officers' 1815 basement kitchen, believed to be the oldest surviving kitchen in Toronto. It is not in use. The hearth and bake oven remain in place, but the floor has been torn up for archeological study. Two underground vaults can also be seen. During the 1837 Rebellion, the vaults kept money from the Bank of Upper Canada safe from insurgents.

Ground-Floor Kitchen

A ground-level kitchen was added in 1826, and continues to be used for historical cooking classes and demonstrations. Volunteer cooks include author, television personality, and former *Canadian Living* food editor Elizabeth Baird. From a food perspective, Toronto proved a good place to be a soldier in 1835, Hebib says, with its industrial bakeries, strong agricultural sector, and plentiful supply of fresh meat, both wild and domestic.

An exhibit off the kitchen portrays the room of the mess sergeant of the Fifteenth Regiment, responsible for the meals of the Officers' Mess Establishment. Behind a wall, hidden from public view, cooks in a modern industrial kitchen test historical recipes, feed overnighting schoolchildren, and stage full-course Georgian dinners for the Friends of Fort York volunteer society. Nearby nineteenth-century gardens help supply the kitchens.

The Blue Barracks

Built in 1814, and reconstructed on the same spot, the wooden Blue Barracks housed junior infantry officers, including ensigns, lieutenants, and a few captains. Today, the rooms provide space for meetings and receptions, and a few permanent exhibits. One highlights early French fur-trading routes. Another tells the story of the French fur-trading post Fort Rouille, also known as Fort Toronto, which stood from 1750 to 1759 on the current

Canadian National Exhibition grounds. Archeological finds in glass cases include early dinnerware, medicine bottles, buttons, thimbles, and pipes.

Brick Magazine

After Captain Tito LeLièvre and Sergeant Marshall blew up the Grand Magazine in the Battle of York, the British replaced it with a single-storey brick building. Within a year, a heavy roof and weak foundations led to structural problems and a decision to build a new stone magazine. Engineers converted the brick structure into a storehouse and added a second floor. Today, the former brick magazine serves as an exhibition space.

Blockhouse Number One

At the far end of the fort stands a second blockhouse, smaller than Number Two, designed to house 120 people. Curators have stripped it to its essentials — bunks, communal tables, and lanterns — leaving space for children to run around, and others to imagine what barracks life might have been like in the early 1800s for the common British soldier.

KING'S REGIMENT CROSS-BELT PLATE

A British soldier wore two white belts across his chest. One supported an ammunition pouch on the right side, the other a bayonet on the left. To lock the belts together, square at the centre of the chest, a soldier wore a buckle of cast brass, with two studs on the bottom and a hook at the back. It was called a "cross-belt plate," an essential piece of equipment. Without it, a soldier would be out of commission, with no way of holding his kit together. Being of cast brass, the plate would also be expensive to replace. To lose one carelessly counted as a punishable offence.

One particular cross-belt plate takes pride of place at Fort York Historic Site. The writing on it has faded. The brass has turned a moldy green. A crease in the lower half indicates a blow of some kind. Unprepossessing to the untrained eye, it nevertheless stands as one of the most emotionally touching material remnant of the 1813 Battle of York. During the bicentennial celebrations of the War of 1812, the plate lay under glass at the Brick Magazine. Its next home will likely be the new visitors' centre.

Photo courtesy of the City of Toronto, Museum Services, 11FY10A2.54

The lost cross-belt plate from a member of the red-coated Eighth Regiment, or King's Regiment, stands as one of the most emotionally charged material remnants from the 1813 Battle of York. A replica shows what the original once looked like.

The plate belonged to a member of the red-coated Eighth Regiment, or King's Regiment, led into battle by the heroic Captain Neal McNeale. As the captain assembled his troops to face overwhelming numbers of advancing American soldiers, McNeale took a bullet to the head and died instantly. His well-trained followers fired one simultaneous volley at their attackers and advanced with bayonets, but were soon "cut to ribbons," as Canadian historian Robert Malcomson puts it.

What damaged the belt plate on display, and how it got separated from its owner, can only be imagined. Staff archeologist David Spittal recovered it from the battlefield in 1995. In the exhibition case, the plate lies next to a shiny brass replica with clear markings. The crown of King George III appears at the top, and underneath it is the Horse of Hanover, signifying the king's lineage. The word *king* also explicitly appears. Around the centre runs the royal garter bearing a line from Middle French that reads, "*Honi soit qui mal y pense,*" which loosely translates as "Shame on the person who does evil."

NEIGHBOURING ATTRACTIONS

Victoria Memorial Square

Like a piece of public art, seventeen mounted gravestones form a line near the eastern edge of this neighbourhood park at Portland Street and Wellington Street West, a few blocks northeast of Fort York. The gravestones are badly weathered, most beyond legibility. Beneath the park's surface lie the remains of four hundred of the city's earliest inhabitants, the location of each still known thanks to a map drawn before the headstones and wooden markers were removed. It is the city's oldest surviving European cemetery. John Graves Simcoe, as lieutenant-governor of Upper Canada, had it cleared from the bush shortly after founding the original British garrison at York in 1793. Sadly, the cemetery's first documented grave is that of his own daughter, Katherine, dead at fifteen months of an undiagnosed illness accompanied by fever and convulsions.

"She was the sweetest tempered pretty child imaginable, just beginning to talk and walk, the suddenness of the event you may be sure shocked me inexpressibly," her mother Elizabeth Simcoe wrote in her diary. A small marble tombstone ordered from England, now lost, read "Katherine Simcoe, January 16, 1793 – April 19, 1794. Happy in the Lord."

The park also hosts a War of 1812 memorial. Architect Frank Darling designed the granite pedestal and sculptor Walter Allward fashioned the statue, entitled *The Old Soldier*. Featuring a balding man in uniform, with a missing left arm and eyes closed in sorrow, it stands in striking contrast to Allward's triumphant Boer War memorial outside Campbell House on University Avenue. A poem below the figure elaborates on the mood of defeat:

> Dead in the battle — dead on the field;
> More than his life can a soldier yield?
> His blood has burnished his sabre bright;
> To his memory, honor: to him, good night.

Strachan Avenue Military Burying Grounds

To the west of the fort's main gate lies a cemetery used between 1863 and 1911 for soldiers and their family members. Thirty-two surviving

headstones have been mounted in a low brick wall surrounding a small gravel square. Every November 11, a Remembrance Day service includes tributes to those who fell in the Battle of York.

Monument to the War of 1812

American forces defeated the British in the Battle of York, but a monument near the fort shows the reverse. Vancouver sculptor, novelist, and revisionist historian Douglas Coupland shows the British defeating the Americans.

The statue stands at the corner of Bathurst Street and Lake Shore Boulevard West. Coupland depicts two figures as toy soldiers, four metres high. One, painted silver and wearing the uniform of the U.S. Sixteenth Infantry Regiment, lies on the ground face up. The other, painted gold and wearing the Royal Newfoundland Regiment uniform, stands victorious over the fallen enemy. The two regiments faced each other in the Battle of York, and the Americans won.

"I've grown up, and a lot of people have grown up, thinking, 'Oh, Americans lost that one didn't they?'" Coupland told a CBC reporter at the time, speaking of the War of 1812 generally, and explaining why he showed the British as victorious.

Photo by John Goddard

A giant toy-soldier figure wearing the Royal Newfoundland Regiment uniform from the Battle of York stands victoriously over a fallen American Sixteenth Infantry Regiment soldier in Douglas Coupland's revisionist Monument to the War of 1812. The sculpture appears at Bathurst Street and Lake Shore Boulevard West, within a couple of blocks of the Fort York battleground.

Wheat Sheaf Tavern

More than one Fort York soldier has raised a pint at the Wheat Sheaf — "A Toronto tradition since 1849," as the front overhanging sign says. The tavern counts as one of the city's oldest drinking spots, its name unchanged since its founding at the corner of King and Bathurst Streets, a location handy both to Fort York and Victoria Memorial Square.

The tavern's website sums up the Wheat Sheaf in one long sentence: "As any excellent tavern would, this place features heavy wooden tables bowing under the weight of frothy pitchers and stacks of sticky wings (sold at half price on Sunday through Tuesday), a kickin' jukebox, a rollicking atmosphere, loving tributes to its storied history and celebrity patronage on the walls, televised sporting events spooling out from a whack of flat screens, a popular 60-seat patio for warm-weather imbibing and a multitude of fiercely loyal patrons."

BIBLIOGRAPHY

Armstrong, Christopher. "James Austin." In *Dictionary of Canadian Biography*, vol. 12. University of Toronto/Université Laval, 2003–. *www.biographi.ca/en/bio/austin_james_12E.html*.

Careless, J.M.S. "Responsible Government." In *The Canadian Encyclopedia*. Historica Foundation, 2013. *www.thecanadianencyclopedia.com/en/article/responsible-government*.

Cathcart, Ruth. *Jacques & Hay: 19th Century Toronto Furniture Makers*. Erin, ON: Boston Mills Press, 1986.

Colombo, John Robert, and William Lyon Mackenzie. *The Mackenzie Poems*. Toronto: Swan Publishing, 1966.

Cook, Ramsey. "Goldwin Smith." In *Dictionary of Canadian Biography*, vol. 13. University of Toronto/Université Laval, 2003–. *www.biographi.ca/en/bio/smith_goldwin_13E.html*.

Cross, Michael S., and Robert Lochiel Fraser. "Robert Baldwin." In *Dictionary of Canadian Biography*, vol. 8. University of Toronto/Université Laval, 2003. *www.biographi.ca/en/bio/baldwin_robert_8E.html*.

Dent, John Charles. *The Story of the Upper Canadian Rebellion*. Toronto: C. Blackett Robinson, 1885.

Driver, Elizabeth. *Culinary Landmarks: A Bibliography of Canadian Cookbooks, 1825–1949*. Toronto: University of Toronto Press, 2008.

Durand, Charles. *Reminiscences of Charles Durand of Toronto, Barrister*. Toronto: The Hunter, Rose Co. Ltd., 1897.

Finan, Patrick. *Journal of a Voyage to Quebec in the Year 1825, with Recollections of Canada During the Late American War in the Years 1812–13*. Newry (Ireland): Alexander Peacock, 1828.

Fraser, Robert L. "William Warren Baldwin." In *Dictionary of Canadian Biography*, vol. 7. University of Toronto/Université Laval, 2003. *www.biographi.ca/en/bio/baldwin_william_warren_7E.html*.

Fyfe, Douglas. "David Gibson's Involvement in the Rebellion in Upper Canada." In *1837 Rebellion Remembered*. Toronto: Ontario Historical Society, 1988.

Goddard, John, and Richard Crouse. *Rock and Roll Toronto: From Alanis to Zeppelin*. Toronto: Doubleday Canada Limited, 1997.

Godfrey, Sheldon, and Judy Godfrey. *Stones, Bricks and History: The Corner of "Duke and George," 1798–1984, The North-East Corner of Adelaide Street East and George Street, Toronto*. Toronto: Lester & Orphen Dennys, 1984.

Gray, Charlotte. "At Home on The Grange." In *House Guests: The Grange 1817 to Today*. Toronto: Art Gallery of Ontario, 2001.

_____. *Mrs. King: The Life & Times of Isabel Mackenzie King*. Toronto: Penguin Canada, 2008.

Haultain, Arnold. *Goldwin Smith: His Life and Opinions*. London: T. Werner Laurie, Ltd., 1914.

Henry, Dr. Walter. *Trifles from My Portfolio; or, Recollections of Scenes and Small Adventures ... Upper and Lower Canada*. Quebec: William Neilson, 1839.

Howard, James Scott. *A Statement of Facts Relative to the Dismissal of James S. Howard, Esq., Late Postmaster of the City of Toronto, U.C.* Toronto: J.H. Lawrence, printer, 1839.

Howard, John George. *Incidents in the Life of John G. Howard, esq. of Colborne Lodge, High Park near Toronto: Chiefly Adapted from His Journals*. Toronto: Copp, Clark & Co., 1885.

Hykel, Bev, and Carl Benn. "Thomas Montgomery: Portrait of a Nineteenth Century Businessman." Ring-bound, Etobicoke Historical Board, 1980.

Kilbourn, William. *The Firebrand: William Lyon Mackenzie and the Rebellion in Upper Canada*. Toronto: Clarke, Irwin, 1956.

Lindsey, Charles. *The Life and Times of Wm. Lyon Mackenzie: With an Account of the Canadian Rebellion and the Subsequent Frontier Disturbances, Chiefly from Unpublished Documents* (two volumes). Toronto: P.R. Randall, 1862.

Lownsbrough, John. *The Privileged Few: The Grange & its People in Nineteenth Century Toronto*. Toronto: Art Gallery of Ontario, 1980.

Malcomson, Robert. *Capital in Flames: The American Attack on York, 1813*. Montreal: R. Brass Studio, 2008.

Morgan, R.J., and Robert Lochiel Fraser. "Sir William Campbell." In *Dictionary of Canadian Biography*, vol. 6, University of Toronto/ Université Laval, 2003. *www.biographi.ca/en/bio/campbell_william_6E. html*.

Raible, Charles. *From Hands Now Striving to be Free: Boxes Crafted by 1837 Rebellion Prisoners: An Analysis and Inventory of 94 Boxes*. Toronto: York Pioneer & Historical Society, 2009.

_____. *Muddy York Mud: Scandal & Scurrility in Upper Canada*. Creemore, ON: Curiosity House, 1992.

Roberts, Julia. *In Mixed Company: Taverns and Public Life in Upper Canada*. Vancouver: UBC Press, 2009.

Robertson, John Ross. *Landmarks of Toronto: A Collection of Historical Sketches of the Old Town of York from 1792 until 1833, and of Toronto from 1834 to [1914], (six volumes)*. Toronto: J. Ross Robertson, 1894.

Russell, Victor Loring. *Mayors of Toronto*. Erin, ON: Boston Mills Press, 1982.

Scadding, Henry. *Toronto of Old: Collections and Recollections, Illustrative of the Early Settlement and Social Life of the Capital of Ontario*. Toronto: Adam, Stevenson & Co., 1873.

Senior, Hereward. "William Henry Boulton." In *Dictionary of Canadian Biography*, vol. 10, University of Toronto/Université Laval, 2003. *www.biographi.ca/en/bio/boulton_william_henry_10E.html*.

Sewell, John. *Mackenzie: A Political Biography of William Lyon Mackenzie*. Toronto: James Lorimer & Company Ltd., 2002.

Southgate, Henry. *Things a Lady Would Like to Know, Concerning Domestic Management and Expenditure: Arranged for Daily Reference with Hints Regarding the Intellectual as well as the Physical Life*. London and Edinburgh: William P. Nimmo, 1875.

Stacey, C.P. (Charles Perry). *The Battle of Little York*. Toronto: Toronto Historical Board, 1963.

Thompson, Austin Seton. *Spadina: A Story of Old Toronto*. Erin, ON: Boston Mills Press, 2000.

INDEX